Step into the world of a new generation of modern gypsies: a range of professionals and creatives who have ditched conventional houses for the freedom of the road and the beauty of the outdoors. *Vanlife Diaries* celebrates the nomadic lifestyle and community through interviews, advice for living on the road, and more than two hundred photos of these tiny rolling homes. The book features vanlifers, their pets, and their converted vans and buses—VWs, Sprinters, Toyotas, and more—as well as the stunning natural locations that are part of the movement's inspiration. Interviews and narrative captions share the stories of these dreamers and seekers, their inspiration for downsizing, how they found and converted their vehicle, and what it's like to work and live on the road.

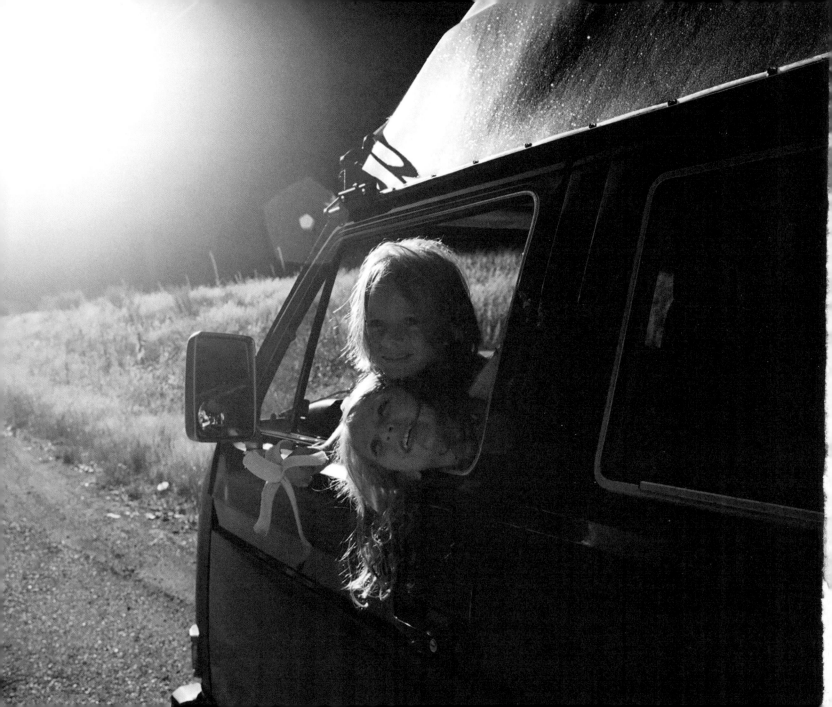

Vanlife Diaries

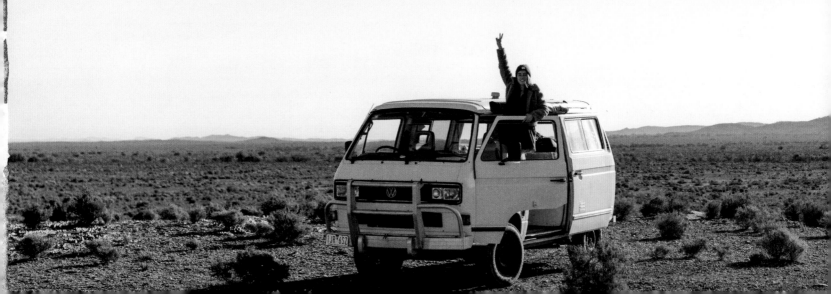

To all you wanderers who call the road home, we dedicate
this book to you. Vanlife Diaries are the stories we tell
around the fire, the ones that ignite hope and propel us
into motion. This book wouldn't be anything without our
community; we owe it all to you.

Vanlife Diaries

Finding Freedom on the Open Road

Kathleen Morton, Jonny Dustow,
and Jared Melrose

TEN SPEED PRESS
California | New York

Contents

Why Vanlife?

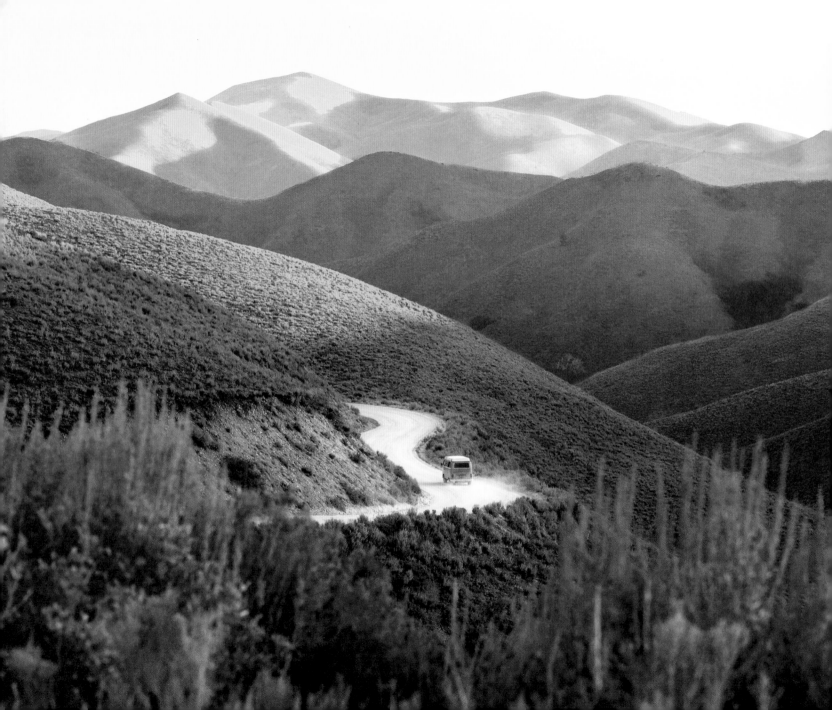

foreword

I've been living on the open road for five years. That's half a decade. One thousand, eight hundred days of unfamiliar camp spots and roadside epiphanies and so many strangers that they now cease to be strange.

My partner J. R. and I travel in our VW bus full time, calling the wild places of North America home. Right now, in fact, I write this from northern Nevada, where the Indian summer is yellowed in light, kindly warming our camp in a wide desert valley.

Outside, the westward wind blows, and I sit on the vinyl seat of my bus, reflecting. This book, the book you are holding in your hands, will soon exist. It's hard to believe that only five years ago, I couldn't tell a soul that I lived in a vehicle. No one knew about my lack of address. I lost friends and wounded relationships with family because I walked away from their advice and their ways of life. J. R. and I had only each other then, and that was lonely in the most exhilarating of ways.

As recently as five years ago, when I went on the road, living in a van was by no means a trend. At that time, people who discovered our vagrant ways told us we were a drag on society, or selfish, or mentally unstable, or strung out on drugs. And look at vanlife now. Just last week, five articles were run in major publications, all featuring this van-dwelling movement, all discussing how privileged and unrealistic and glamorous it is. What a shift! It's amazing to think that within a five-year period, a movement could be conceived of, borne out, and proliferate around the civilized world. Look at us: published, acknowledged, accepted. Living in a van, living with less, has become something to aspire to, instead of a lazy, or insane, avoidance of "real life."

When J. R. and I set out on the road, we were running from what we considered to be the oppressive nature of modern society. The recession had hit full force, and employment options didn't look favorable. Neither did

1

trying to fit into a world of student loans and mortgages and meaningless struggles. None of it was tempting. In fact, it seemed like a trap—the unaffordable home, the debt, the empty promise of social security. "Security?" we asked. "Who needs that? We'd rather have freedom any day."

In the beginning, a specific kind of freedom was very important to us. You could say it was the "why" of our travels. We wanted to be free of the so-called oppression of work. We had created our Idle Theory, the theory that modern humans were lacking in idleness, or time for doing nothing. So we hit the road seeking the freedom to do just that: nothing at all. We worked, sure, but only enough to cover our living expenses. We learned how to survive on minimum-wage farm jobs, on next to nothing, below the poverty line. We thought that if we could reduce labor to a minimum, we'd find the source of all happiness.

That, of course, proved to be empty, too. Freedom isn't a worthy goal, not long term at least. Nothing is

completely free and, as we realized on the road, freedom is the ability to accept insecurity. The day we walked out on our jobs and hit the road, we entered the scary domain of the unknown. That was when freedom rushed to our sides.

So we've come a long way from that infant stage of nomadism. We've adopted new goals. Now, we believe that the purpose of being on the road is to search for a saner life. I truly believe that our modern world breeds a deep hollowness. It has erased the very attributes that make us human, and yet it expects us to carry on as though we're still fulfilled. We are told that we have everything we need. And physically, that may be true. But, spiritually, we are lacking, and because of that, we are surrounded by insanity.

Figuring this out has taken a lot of time. These last five years have been twisted by frustration, even with all the joys we've gained. We were carving out a new road. We were out in front, rogue, alone, trying to figure things out.

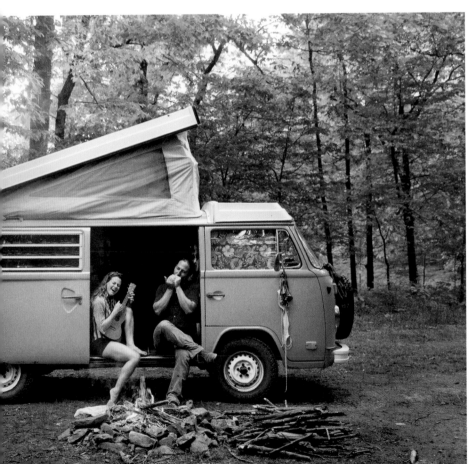

Kit and J. R. take a break from tending the fire to play music with each other. A few years back, Kit made a vow that she would create something everyday. "The act of creation, in itself, is enough, because when I'm creating, I'm my fullest self, and that's what makes me wake up every morning to greet the gold light of day."

And now this is a movement. People heard our calls, they listened to our musings. Today, we are part of a rumble, an uprising that will soon explode. Modern life as it's "supposed to be" has been deconstructed. Now, we survey the raw materials that remain. We long to utilize our resources more responsibly.

3

It's an exciting time to be alive. This community is seeking out alternatives to the debt-work-consume cycle that rules life in the new millennium. We live out of vehicles to have time to chase our passions. We choose to live on less. Off the grid of normalcy we venture, hoping in our quest to construct a *new* normal. Out on our own terms, we're discovering a better, saner way to live.

This search isn't anything new. It's a continuation of something so much older than any of us. There have always been travelers and seekers, in every culture, from every walk of life. They, too, wandered the open roads. Those young idealists spotted glimmers of hope, forged paths to a saner life. Now, we've been handed their vision. It is our duty to continue their search.

Kit and J. R. are happiest with nothing ahead of them but open road and the horizon. Here, they scale the hills of Nevada in Sunshine, their 1976 VW bus, which has taken them to wild places all around the United States.

What I hope of us, of this movement, is that we can learn from our history and the utopian pioneers who came before us. Through their life stories, we can find real-world applications for our beliefs. Let's do the work of applying them. I want this momentum to spread far beyond our niche community. After all, the point of this isn't recognition or success. This is about creating a new reality, a world that values sanity, balance, and wholeness.

Because, really, this isn't about a van. The van—the camper, the vehicle—is only a physical manifestation of the movement, a tangible object onto which we project our hopes, dreams, and ideals. And that's okay. We all need our symbols.

But no matter how many photos we take of them, the movement isn't about the van. If it was, the lifestyle wouldn't stick. Vanlife would be nothing more than a fashion, a trend, a momentary fad. This is about grassroots change, transformation that begins on the individual level and then expands into all of society.

I hope that the meet ups and the build-outs never overshadow what our vans stand for. I am on fire and so optimistic about the future of vanlife. By uniting our many reasons for van dwelling, we are creating a beautiful new society. I hope that through these photos and essays, the transformative nature of this community can bear fruit in many ways. It takes a diverse culture of radical idealists to change the world. There is room for many definitions of happiness, even within a lifestyle. After all, there are a million gorgeous ways to live.

Kit Whistler
Backroads of Nevada, USA
@idletheorybus

5

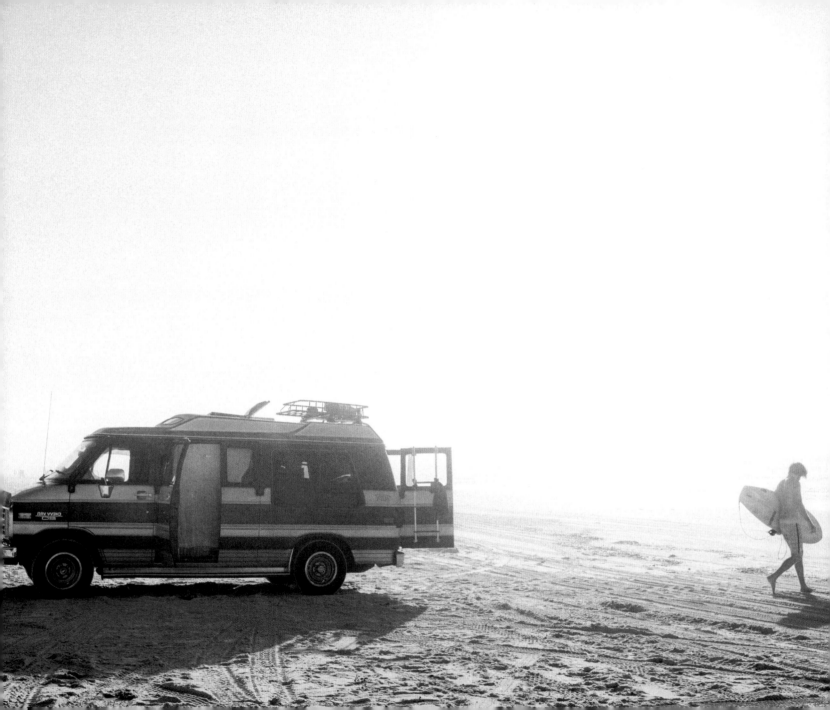

introduction

Vanlife looks like a dream. And in many ways it is. But dreams take time to build and can appear quite messy in their conception.

For me, vanlife didn't begin with a van. In fact, it wasn't something I dreamed of doing. Instead, I fell into it. My journey into tiny living started with a 1969 Terry Travel trailer, with 140-square-feet of living space inside to be exact. I left my apartment in Denver to experiment with living more environmentally and off the grid while still working a full-time office job. And a camper trailer seemed like the Goldilocks way of doing just that.

Moving into a camper trailer meant adapting to a more primal way of living. Without running water, I filled up gallon jugs at local grocery stores. With one electrical plug, I limited what I powered at any given time. A composting toilet made me rethink waste and ways it could be recycled for agricultural purposes instead of putting it into the septic system.

All of these adjustments went against a traditional way of living and weren't easy to implement. They took extra time and dedication. But in turn, I was able to live more intentionally and reduce my carbon footprint.

Like many others my age, I grew up thinking success was measured by the size of your house and the amount of money you made in your profession. But the people I knew who were pursuing this version of success weren't happy. They were spending so much time working that they didn't have much time to explore their passions.

The rising cost of living in popular metropolitan areas forced me, like so many others, to use a majority of each paycheck for rent and other living expenses. Working long days meant extra pay, but it gave me less time to get outside and connect to the natural world.

It seemed confusing, this version of success that I grew up believing. I wanted to redefine the American Dream to mean something different—something that spoke to me.

Living tiny opened up my eyes to time and space for being in nature and pursuing creativity. I began to be wild in my own skin, using rivers as baths and going on solo adventures into the wilderness with my dog, Peaches.

Yet even though I felt fulfilled on the surface, it still felt like something was missing. It was difficult to form relationships with other people who didn't understand tiny living. Back in those days, I had others tell me that they had no desire to live the way I did. Several saw it as a phase and thought I was struggling financially, and some thought I had nowhere else to live.

I started messaging anyone I could find online who was also living alternatively and would ask them questions. I wanted to share their stories on my website and Instagram in hope that I could find friends and build a community so others wouldn't feel so isolated. I called this project Tiny House, Tiny Footprint.

One of those early features on my blog was Jonny Dustow. During the time that I was leaving my apartment, Jonny was on the other side of the world in New South Wales, Australia, feeling disenchanted with society's version of success. He had everything he thought he wanted: a full-time job and investments in real estate. But the stress of managing it all impacted his mental health. He went from full-time to part-time as a high school teacher and he sold his properties. Now, all of a sudden, he had more time in his day to focus on what he loved: surfing, music, and fostering relationships.

Surfing was an activity Jonny grew up with, and something that provided a relief from stress. As he made more frequent trips to the beach, he started to notice more surfers traveling in vans that they had converted to livable spaces. Their built-out vans gave them the freedom to sleep in the parking lots of the best surf breaks and catch the early waves before the beach got too crowded.

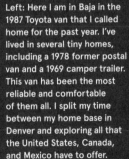

Left: Here I am in Baja in the 1987 Toyota van that I called home for the past year. I've lived in several tiny homes, including a 1978 former postal van and a 1969 camper trailer. This van has been the most reliable and comfortable of them all. I split my time between my home base in Denver and exploring all that the United States, Canada, and Mexico have to offer.

Above: Jonny Dustow (left) and Jared Melrose, my partners and cofounders of Vanlife Diaries, are musicians living on the east coast of Australia. Over the past two years, they have organized 12 gatherings internationally and fit out 30 vans.

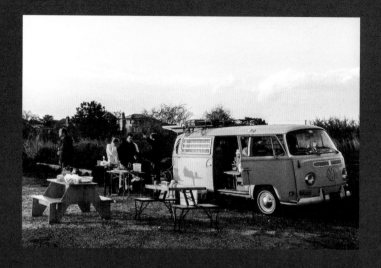

After Jonny saw those vans, he took some of the money left over from selling his properties and bought a Mercedes-Benz Vito van. He decided he would try to go a year without paying rent by living in a van. After that? He wasn't sure. He was going to see what happened.

Inside the van, Jonny carried some of his essentials: a surfboard, a guitar, and a saxophone that he would take out to jam by the ocean, and a camera for documenting interesting people and landscapes. He would play music with local surfers, and together they would share stories of traveling. Jonny was inspired to give these stories a voice, taking them beyond the parking lots and beaches and into an online space.

He created a website and called it Rebel on a Rainbow, giving voice to those who were going against society's norms and designing a life that suited them—one brighter and more colorful than their previous lives.

Jonny also began creating original music under the name Dusty Boots and toured the country by van. During a trip down to Melbourne to play a show, he

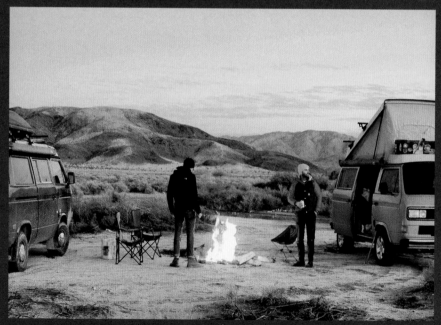

Top: Each summer, vanlifer Greg Mills and his friends get together for a cookout with their VW vans at Lido West Beach on Long Island in New York. The van pictured here belongs to one of Greg's good friends, Bill, who is a professional chef and founder of the gathering. Its license plate reads BUS-BBQ and it's the centerpiece of the meet up, carrying everything they need to cook a big bunch for friends and family.

Left: Pete Lapp and Greg Fitzpatrick enjoy the twilight by their campfire. Pete and his wife Shruthi have owned their 1987 Volkswagen Vanagon GL Westfalia for 11 years. Often they meet up with other van-lifers on the road and caravan. Greg and his wife Katie, who also roll in a Westfalia, are some of their favorite fellow vanlifers to travel with.

reached out to an old friend from primary school, Jared Melrose Campbell. When Jared heard Jonny was coming into town, he invited him over to his house to crash for the weekend. Jared filled Jonny in on what he had been up to recently.

After finishing high school, Jared had moved to Newcastle and performed as the lyricist and frontman of a band, the Evening Son. During the weekends, he would play in the band and manage events, and during the week, he would work in construction. Attaining happiness and financial mobility had been a constant compromise as he struggled to find the balance between making original music and making money as a construction worker, a trade he was losing interest in after more than a decade. But with the support of his partner, friends, and family, he continued working in construction and playing music on the side.

The band had enough success touring and recording that they were able to make the move to Melbourne—the cultural and artistic hub of Australia. It was here that

Jared redefined the skills he had learned from working in construction and started to experiment with converting vans into modern, beautifully designed spaces. With the help of his friend Sam, the drummer in their band, he started building out his VW Transporter van. It wasn't long before Sam and Jared were receiving requests from friends, and word spread quickly about their interesting designs and finishes. The two flirted with the idea of working together more permanently.

The next morning over breakfast, as Jonny and Jared were discussing their plans, a concept dawned on them: "What if we could build an online multifaceted platform where the international vanlife community could share stories and conversations, learn how to convert vans into homes, and organize meet ups to connect?" They needed it to be fun and reflect the social responsibilities they believed in. But most importantly, they wanted to do this so they could still do the things they loved such as getting into nature, playing music, and nurturing relationships.

They knew that minimalist living had gone on long before the late 1950s, when writers like Jack Kerouac inspired the younger generation to leave society for a life on the road. But now there were online forums and independent organizations and clubs for specific types of rigs, and #vanlife, a hashtag created by Foster Huntington, showcased interesting rigs in the early days of Instagram. But Jonny and Jared felt there was a need to create a place and a universal term for anyone living or looking to live an alternative lifestyle in any shaped vehicle. They wanted it to be a hub to share stories and promote nonprofit organizations that revolved around the traveling culture. So that afternoon, they went online and founded the first vanlife community: #vanlifediaries.

Within the first three months, their Instagram account drew a large following, and it continued to grow. It featured and unified travelers from across the globe, filling a void where no such forum existed. It spawned a multitude of other vanlife accounts, created a powerful social presence for people who weren't used to being in the spotlight, and began a vanlife uprising. It sparked a fire within Jonny, Jared, and Sam. And during that winter, Jared and Sam had moved out of their rented premises to join the road family.

Even though they were still working other jobs, Jonny and Jared put as much time and energy as they could manage into building Vanlife Diaries. But this became too much to do alone, and they realized it was time to branch out. They turned to their network to find someone with a similar vision for establishing community, someone who could help with the website and social media, and organize more vanlife events on the ground.

Even though I was living in a camper trailer at the time and not a van, I was still interested; I was passionate about spreading the word about the movement.

The three of us knew that together, we could create something that would resonate throughout the world. Propelled by Jonny and Jared's excitement to have me on board, I joined Vanlife Diaries.

13

14

Yet even with all our enthusiasm and drive to build Vanlife Diaries, the blog wouldn't be what it is today without our community. We find joy not just in sharing the photos of others, but in telling their stories in a more meaningful way. We give them a voice and a safe space to come together, providing a digital connection to other travelers. We're inclusive of all types of nomads, and we feel that we all have something in common and something to learn.

We use our online presence to advocate for eco-conscious companies and nonprofit organizations we believe in. And we bring people together outside social media at our gatherings so they can make face-to-face connections and create new relationships.

It's been a wild ride in so many ways. To think not so long ago, Jonny, Jared, Sam, and I were trying to make vanlife work when it wasn't widely accepted. We had to overcome financial obstacles and social expectations until we arrived at a place where we had enough support to live the way we envisioned.

Almost daily, I receive a message that goes a little something like this: "You're living the dream. How do I live a life like that?"

Sometimes I want to write back:

"Are you ready for a story? How much time do you have?"

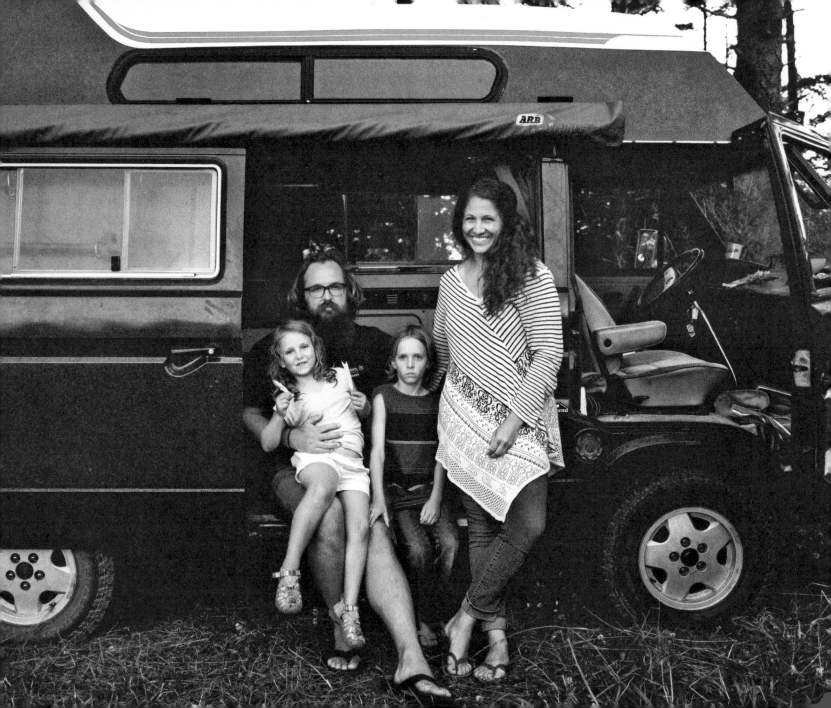

Does adventure have to stop when you have kids? Vanlife families will tell you that they don't let anything stop them from living their dreams and sharing these dreams with their children. All of these families have a common link and a shared understanding. They want their children to experience the world as fully as possible and to let nature be their classroom.

for **Family**

The Sellmeyer Family
in a
1985 VW Van

@poseidonsbeard

It's almost impossible not to smile when you see a colorful VW bus cruising down the highway. It embodies the spirit of festival season and summer surf trips. It's an icon of the counterculture movement, carrying those who seek a cross-country adventure. Its often distinctive colors—turquoise, velvet green, and bright orange—stand out in a sea of everyday hues. And even though it's small and boxy—with the engine in the back making a hood unnecessary—it's big enough for some to call home.

Ryan Sellmeyer has been a collector of these types of rigs for the past ten years, fixing them up in his driveway in the Olympic Mountains of Washington.

He's owned eight VW Vanagons, spotting them in driveways or following up on leads from friends. His latest van—a 1985 VW Westfalia—was spotted randomly on Craigslist by his wife, Christina. They flew out to Ventura, California, the next day before someone else could snag it. And before that, he recovered two vans from a friend whose father had been building them out for a big trip before he passed away.

"Three of the vans that I bought, I built and sold to people who I didn't know at all," Ryan says. "Those three people are now some of the closest friends that I have."

Ryan and Christina can't drive far from their house in their van without someone stopping to talk to them. At gas stations, in grocery store parking lots, and even in some of the remote places they visit, they have strangers sparking up conversations and people who recognize them by their van.

"It's a trap. I would love to go on a trip without [the VW] breaking down, but I feel entrenched in it."

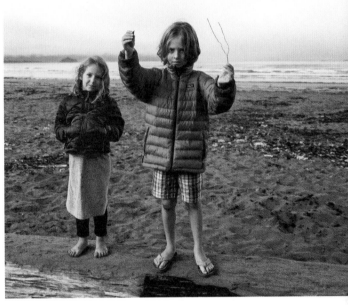

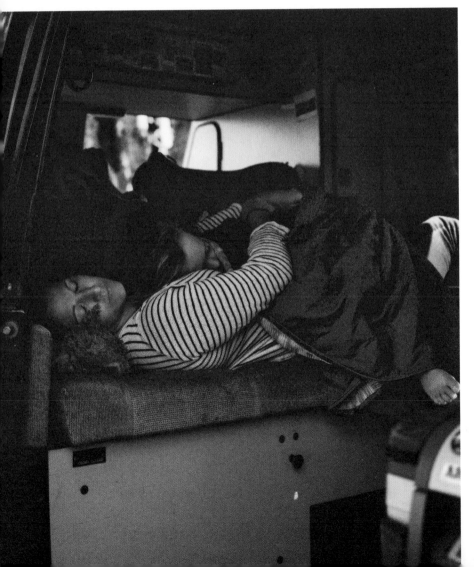

Left: Christina and Anela enjoy
some lazy afternoon snuggles
inside their 1985 VW Westfalia
van, Kona.

Above: Spending lots of time
in nature means Anela and
Benaiah have an eye for trea-
sures. When the time comes to
adventure, they always come
back with beautiful finds.

Wherever they go, the van goes with them. They take it on annual trips to Baja California, to a van gathering they host every year in Oregon called Descend on Bend, and on various shorter trips around the Olympic Peninsula.

"The point is to be outside constantly. I have this as a perfect place to crash on our soggy corner of the earth."

For the first seven years of their marriage, Ryan and Christina lived on the islands in Hawaii. After a day of surfing, they would walk up and down beaches and look at everyone's custom vans, daydreaming of owning their own one day. It was there that they test drove and bought their first Vanagon. It was also where their son, Benaiah, was born.

They used Oahu, Hawaii, as a home base while Christina completed a summer internship for her physical therapy program. During that summer, they decided to make the Pacific Northwest their home. They shipped their latest van from Hawaii to Washington and planted roots to raise a family. Benaiah was two years old, and shortly thereafter, Anela was born. Now, Ryan stays at home with their two children while Christina works full time as a physical therapist.

"I've grown to hate the stereotype of a stay-at-home dad (who) does dishes and stays at home," Ryan says. "I'm a stay-at-*roam* dad. I keep going."

Ryan takes the children camping any chance he can, even for short trips while Christina is working. Every trip starts with one of the children's favorite lines from the movie *Up*. While Ryan warms up the van, Christina hollers out, "Let me hear it!" And Benaiah and Anela answer, "Adventure is out there!"

The decibel level is loud when combined with high-pitched squeals and giggling from the children in the backseats, as well as the noises from the engine and passing trucks on the highway. Christina uses a pulley system with an Easter basket attached to send various items from the front to the back. Coloring books, giant homework books, puzzles, and chocolate get sent back, sketched pictures and handwritten notes to mom get sent up front.

From their base in the Olympic Mountains in WA, the Sellmeyer family is able to travel all around the West, including the beaches of Neah Bay, WA, right, a frequent destination for surf-lover Ryan.

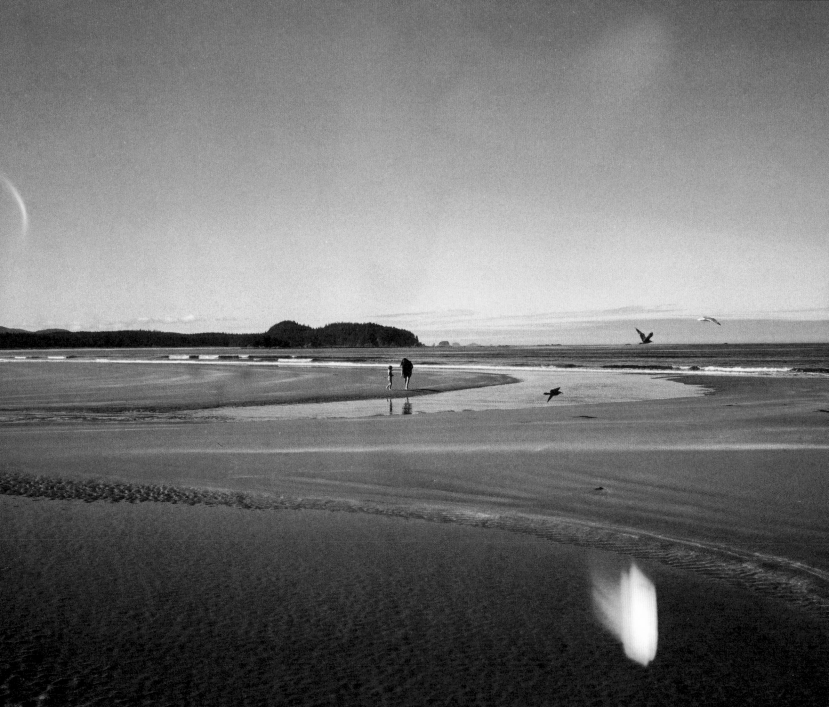

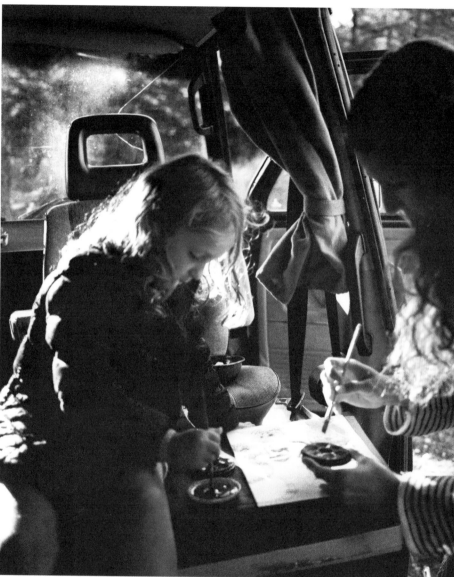

Though the natural world provides a near-endless distraction for the kids, Ryan and Christina have devised other activities to occupy them in quiet moments. Anela loves to paint, and the art materials can be easily stowed away when they're on the road.

When they get to their camp spot, Christina runs the children around like wild animals while Ryan sets up their gear and prepares meals. If they come across an ocean, the children run into the water, letting the waves crash over them. If it's the forest, target-practice training commences with a blowgun. And if it's the river, fishing poles are the first things to be unloaded.

Ryan and Christina use nature as a classroom, picking up anything they find on long walks or at campsites and making it a learning experience. Upon returning to camp, they lay out their treasure collections: spent shell casings and rocks are new toys with stories from the places where they were unearthed. Two children with wide eyes write in adventure journals about their day's discoveries, and they read them over a sparkling fire and gaze up at the starry night sky.

"We are not homeschooling our kids. But the greatest things they are going to learn aren't going to come from a classroom or a computer screen" says Ryan, who watches them around children their age and notices a

difference in appreciation for the outdoors. "It's really cool to me that my kid can name a tree, learn plant names, and go fishing. We just let it make them into who they are becoming. They love everything about being outside all the time."

Life on the road provides more than just practical lessons about botany and astronomy. Driving an old VW around the West tens of thousands of miles year in and year out teaches the whole family patience, even if sometimes it's tested in a fair share of meltdowns— both emotional and mechanical. They've also gone through several total van breakdowns, letting one die and introducing a new one to the family. Such losses are always imminent with these kinds of rigs, and their latest van has undergone an engine rebuild and a roof conversion from a pop top to a high top, which they received from a man who found it while dumpster diving.

Through their passion for all things Vanagon and unique self-converted rigs, they host Descend on Bend,

23

a weekend where hundreds of vans, primarily VWs, gather. Over a fire and a bottle of wine in 2014, the first year they held the event, they ended up hatching plans with another family to travel together. Four months later, they caravanned with the family for more than ten thousand miles and have stayed in touch ever since.

"It's changed our end game in a way that's more human than mechanical. The people we meet everywhere are such close friends. It blows my mind how willing people are to put you into their lives and do whatever it takes," says Ryan.

Their advice to families who want to take their children on long road trips in an old van that might break down at any time: "Don't quit your day job. Plan a big hiatus first and go. Wait until you've done it for at least six weeks straight with kids. Six weeks is a breaking point. Even if you think you have the rig dialed in, you're probably wrong. The kids are always like, 'What the hell are we doing?' so make sure to entertain the kids. Travel on the cheap to a national forest. Test it out first. Take

six weeks off work to do it. And don't forget, winter is coming always."

Living in a VW van means taking the slow road and dealing with those bumps along the way, but Ryan and Christina would agree that it wouldn't be as much fun to put their trust in a more reliable vehicle. While the vans might change throughout the years, with upgrades and repairs, what is constant is they will always have each other, and Benaiah and Anela.

Everyone has a role in this family. Benaiah ensures that Kona always stays muddy. Anela keeps everyone laughing with her sweet giggles. Christina picks the longest, most scenic roads to get to their destination. And Ryan is the main cook, mechanic, and good vibes technician. When asked how they raise a family while traveling, Ryan and Christina say, "Learn to view the world around you in nature as an extension of your little home on wheels, because 80 square feet is damn small."

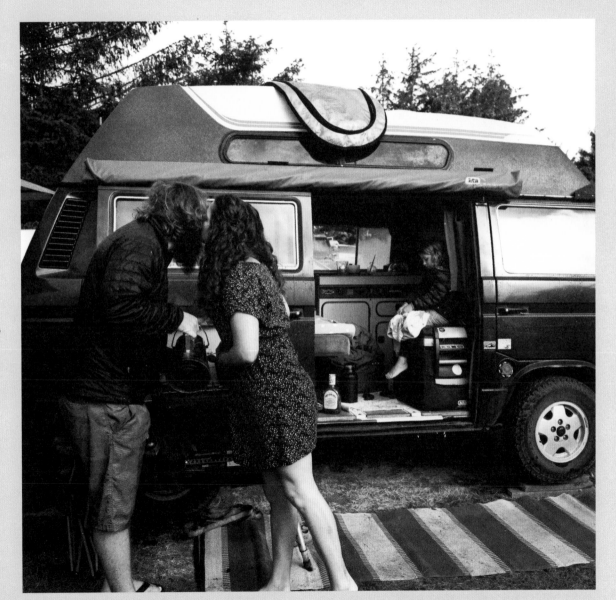

RYAN AND CHRISTINA'S GO-TO ITEMS

Coffee (preground, enough to last the trip): "We use a percolator over a cooking stove or over a fire outdoors. If you want to survive in the winter, get yourself a Snow Peak Folding Torch to help get the fire started."

Christina's journals: "We're super into travel journals, and we love looking back at them over time. Christina illustrates the trip we're on and documents the people we meet. We also tape the treasures we find inside so we have some souvenirs."

Coloring books and teddy bears: "This helps us get through any trip as the young ones entertain themselves in the back."

Vanlife families don't let anything stop them from living their dreams, and sharing these dreams with their children.

The Badger family (Amber and Keenan, and their daughters, Coco and Indigo) has been living in a 1975 Kombi for seven months. Their advice? "Adventure comes when you stretch yourself beyond what you ever thought possible, look over to new horizons, and take a little leap of faith."

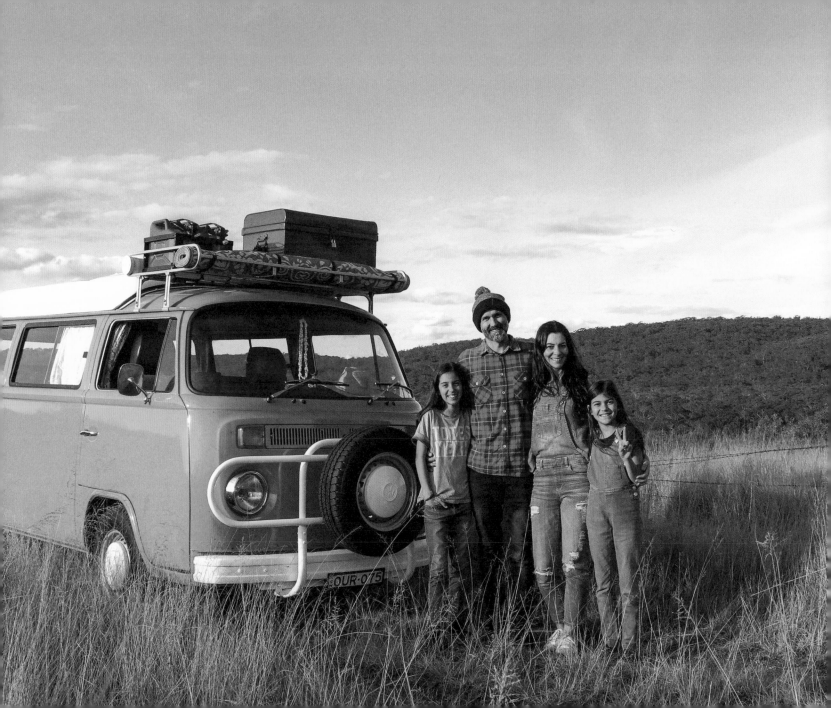

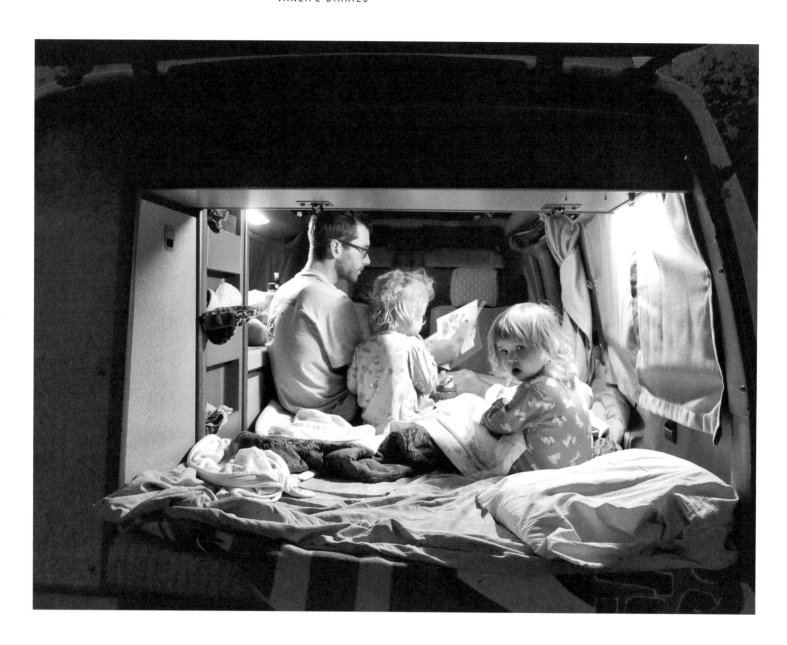

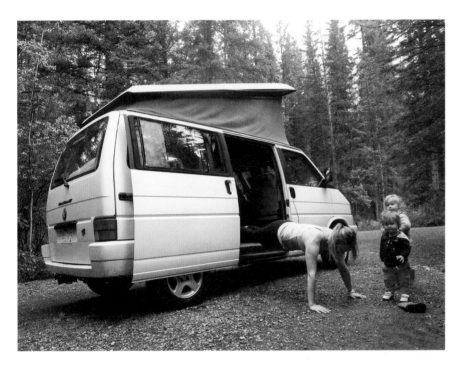

Annika and Cam believe that adventure doesn't have to end when you have children. Once their youngest was a year old, Annika took a break from full-time teaching so the family could travel and give the kids some uninterrupted time to explore their natural surroundings. Just like the Sellmeyers, they find the key to living in a small space with children is to take things outside whenever they can.

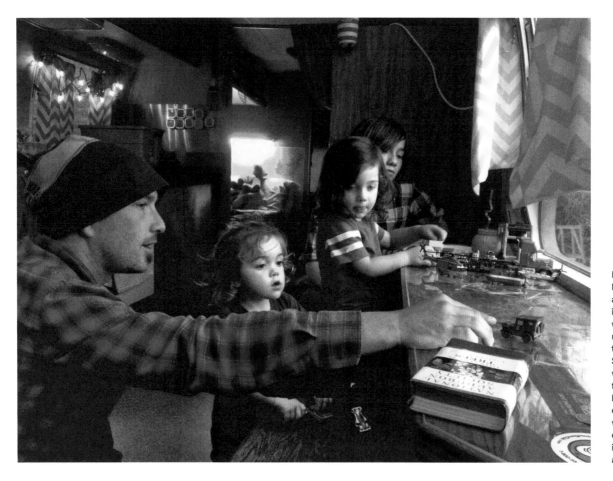

It all started with a question. Nathan, now Renee's partner, asked her, "Hey, lady, wanna live in this bus with me?" Saying yes was a smart gamble: they have now been living on the road together for almost 11 years. Sacrificing their nomadic life was never in question, and they find that traveling as a family brings them closer and affords educational opportunities they wouldn't otherwise have. They encourage their children to identify trees, watch birds, and write in a nature journal.

VANLIFE GUIDE TO SHOWERING

One of the most popular questions van owners get asked is, "Where do you shower and use the bathroom?" These are the issues you learn to address pretty quickly as there's just no getting around them. But truth be told, I don't worry too much about them. I prefer remote areas where I can dig a hole and bury my waste, and a lake or river can make the perfect shower on most warm days. But for other situations when you're between locations, here are a few options for scoring a hot shower and access to bathrooms.

Hot Springs & Spas

This is my favorite bathing hack because not only are you getting a shower and clean bathrooms, but you're also able to enjoy hot springs. While there's nothing that compares to visiting natural hot springs, I do enjoy developed hot springs and pools that offer access to other facilities. At Joyful Journey Hot Springs in Colorado, you can camp overnight, and the rate includes a pass to the pools inside the building. The facility also includes bathrooms, showers, sauna, and a community greenhouse and kitchen. If you visit hot springs with campsites during the winter months, ask about off-season discounts as not many people tend to camp there when it's cold outside.

Solar Showers

You don't need to install an indoor shower in your van to rinse off, especially if the weather is warm. Try a solar shower setup, which at its simplest is a large water bladder bag that heats up in the sun, but fancier models might include a mount for your roof rack and an attached hose. Like anything in vanlife, you'll find different levels of comfort based on what you're willing to spend. Danielle and Mat of @exploringalternatives use a Coleman solar shower (a black plastic bag with a nozzle), which they set outside their Ford van on sunny days when they're at a private campsite. Ben and Leah of @kombilifeadventures created their own pressurized roof rack solar shower using black PVC piping, a hose, a valve, and a showerhead. Even when they factored in all the small parts like adapters and mounting clips—turning this into a "luxury" DIY project—this entire setup cost them less than $120 to make from

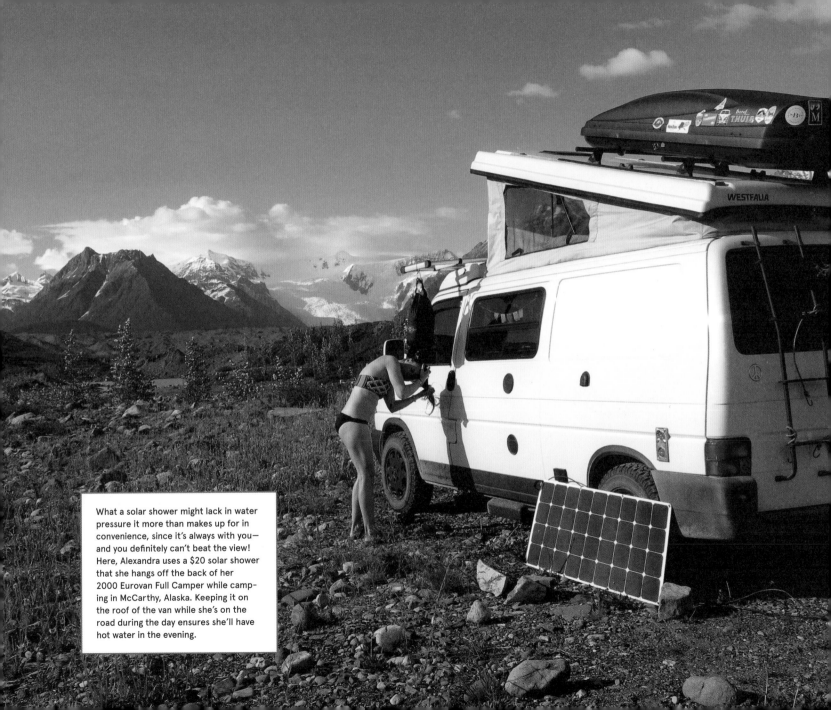

What a solar shower might lack in water pressure it more than makes up for in convenience, since it's always with you—and you definitely can't beat the view! Here, Alexandra uses a $20 solar shower that she hangs off the back of her 2000 Eurovan Full Camper while camping in McCarthy, Alaska. Keeping it on the roof of the van while she's on the road during the day ensures she'll have hot water in the evening.

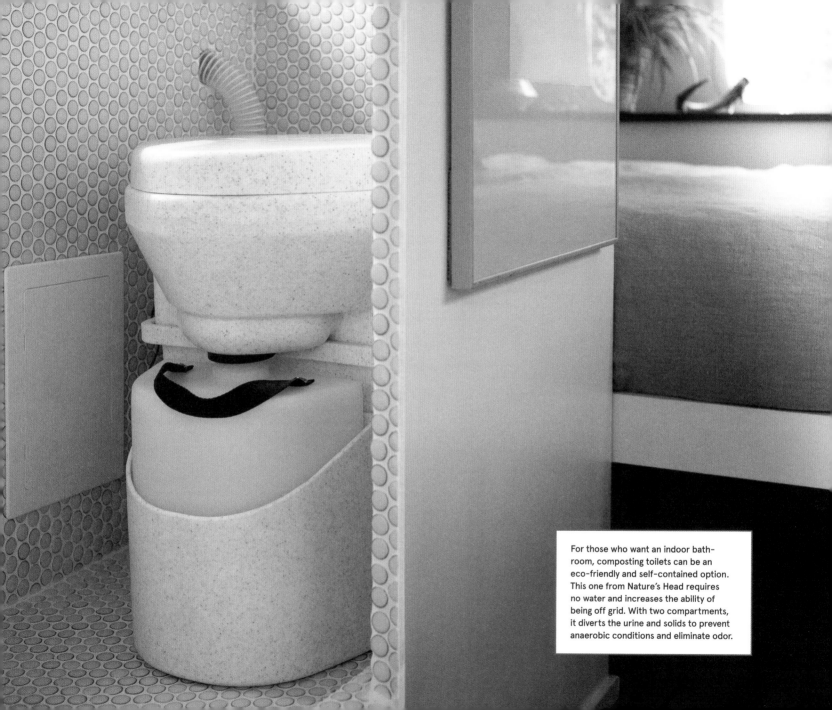

For those who want an indoor bathroom, composting toilets can be an eco-friendly and self-contained option. This one from Nature's Head requires no water and increases the ability of being off grid. With two compartments, it diverts the urine and solids to prevent anaerobic conditions and eliminate odor.

scratch. To take a shower, Ben and Leah make sure the pipe is filled with water, wait for the sun to heat up the temperature, turn on the hose, and stand underneath it.

Community & Recreation Centers

Most towns or cities that I have passed through have a community center or recreation center that offers public showers and restrooms. It's best to call and ask about prices before you get there. Some gyms might have a price for just a shower while others might require purchasing a day pass for full access to their facilities. I once had a free shower at a recreation center in Asheville, North Carolina, but I've also paid $10 for a day pass to take a shower at a YMCA in Boise, Idaho. You might decide that a day pass is worth it at a recreation center that offers workout classes, exercise equipment, and a swimming pool or sauna. Studios that offer hot yoga classes oftentimes have spacious changing rooms and showers with shampoo, conditioner, and soap.

Truck Stops

I was traveling near Black Canyon National Park in Montrose, Colorado, when I decided it was time for a shower. I called a few community centers, but their prices were a bit higher than I was anticipating. So I called a truck stop in town and asked if anyone could use the showers. With the good news, I paid $5 and was handed a fresh towel. When I walked into the shower area, I was amazed to find that each shower had its own private entry with a changing area, mirror, and sink. It was luxurious compared to some of the showers I've used at campgrounds, which just have a shower behind a curtain next to the bathrooms.

Campgrounds & Community Areas

In addition to recreation centers in towns and cities, there are a variety of outdoor community spaces that may provide bathroom and shower facilities. Among the less-obvious free places are beaches with outside showers to rinse off the sand. Armando and Mel of @westfalia_digital_nomads love using public swimming pools, because with just a few Euros, they can swim, lie on lounge chairs, and enjoy a hot shower. Campground showers are sometimes included with the price of your site, but oftentimes you may have to pay extra. I've seen shower prices at campgrounds range from $1 to $10, and some require coins; carrying quarters is a good idea. Again, I always recommend calling ahead to check on prices.

35

Below: Dan and Marlene Lin have spent 10 years exploring the country in several rigs. This photo is inside their 2016 Ford Truck Camper. They have traveled across the country from California to Florida's Key West twice, looped up to Canada, crossed the country to the tip of Maine and the entire Northeast, and spent a summer in Alaska. Their jobs allow them to work remotely, and Marlene is in charge of homeschooling the kids.

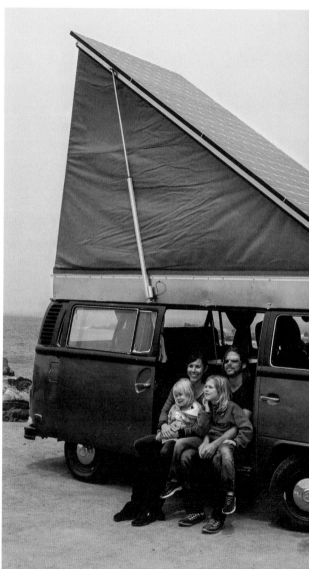

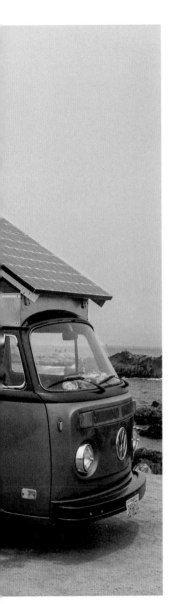

Left: Kira and Brett Belan and their two children are based in Ashland, OR, but spend plenty of time on the road in a fully solar-powered VW that Brett engineered.

Below: Australians Rob and Tracy Morris and their children Marli and Ziggy call their Jayco Outback Starcraft home. Many vanlife families find that learning through self-guided outdoor play gives kids the chance to learn at their own pace and can be as beneficial as traditional schooling.

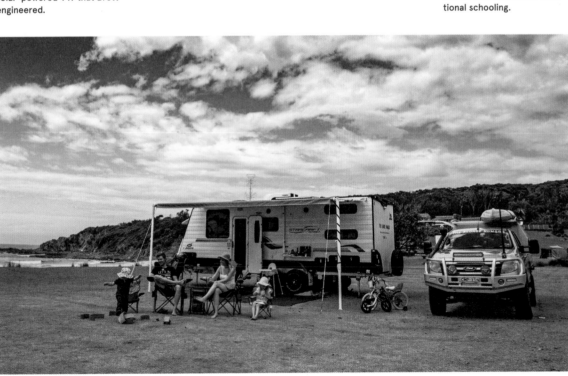

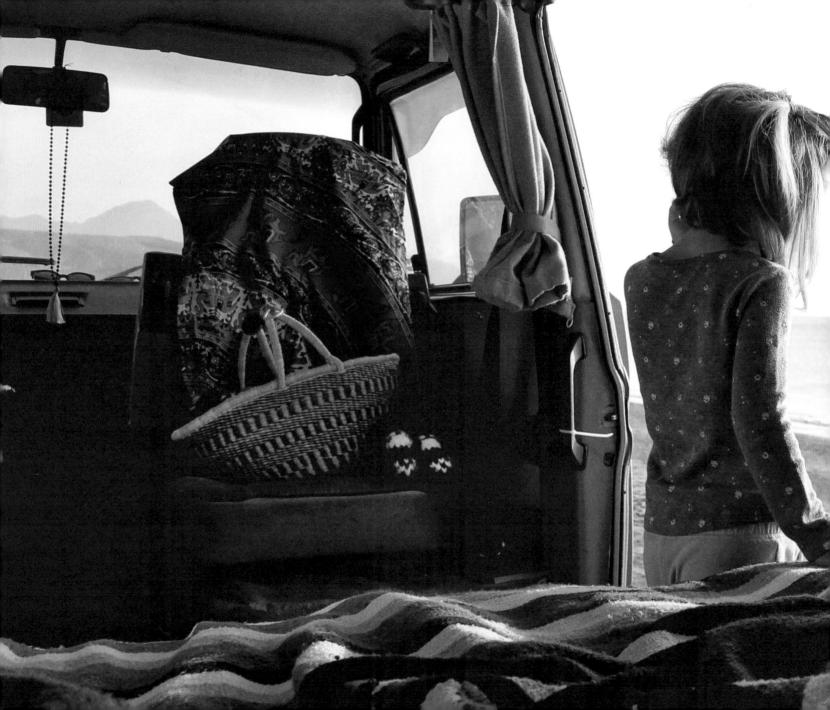

Jessica and Rob have a dream for their family: a year living on the road. They long to see the humdrum of day-to-day life become fresh in the microcosm of their van and discover the world through the eyes of their daughter, Henley. But most of all, they want to slow down and live simply.

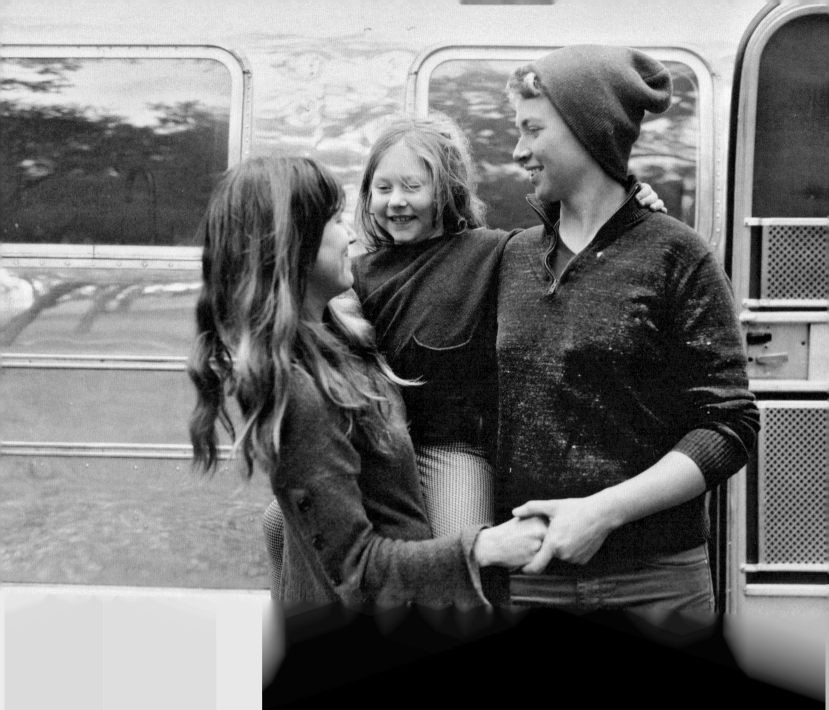

Coexisting in a small space can save or break a relationship. Oftentimes, couples fear that living tiny, with nowhere to escape, could allow arguments to grow bigger. For others, living on the road can be the missing link to improving a relationship. It can add adventure and an opportunity for two people to really get to know one another.

In some of the pictures and stories on social media and elsewhere, vanlife may appear glamorized. It's easy to get carried away by visions of romantic love and idealized relationships. But behind each photo is a story, and it's safe to say the real story may run deeper.

for Love

Kate & Ellen *in a* 1994 Airstream Classic

@themoderncaravan

The day Kate decided to take to the road, she had found a collection of film photographs by Micheal Newsted, who documented his band's tours across the states. Aboard one of the buses pictured, there was a little girl about Kate's daughter's age. As soon as Kate saw that little girl, she knew what she needed to do. She needed to travel.

Before Kate and her partner Ellen got together and before they bought an Airstream, they were living in two separate states. Back in 2010, Kate and her husband were living together in a house in Indiana and raising their daughter, Adelaide. Meanwhile, Ellen, a college friend, was living on her own in Kentucky and wasn't thinking much about Kate.

Kate had spent most of her marriage alone. A lot of the time, her husband was away, leaving her at home to raise Adelaide by herself.

Kate had been raised in the Midwest in a Baptist household, and her parents taught her that marriage was a sacred vow. When you say those vows, you say them for life. That message was ingrained in her, and she continued to try to make her marriage work even though she was unhappy and wanted a new life for Adelaide.

However the next year, when Adelaide was two years old, Kate decided to leave her unhappy marriage. She chopped off her hair, shedding her past and making room for a new, brave, courageous life for her and her daughter.

Seven months after Kate left her ex-husband, she was living in Indianapolis with Adelaide, and Kate's sister had moved in. Single motherhood was rough and Kate was still working on healing from the emotional abuse she had endured during her marriage.

She went back to school to study English literature and creative writing, and Adelaide went to day care. During that time, Kate got on Facebook and found herself

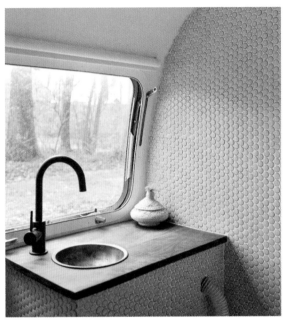

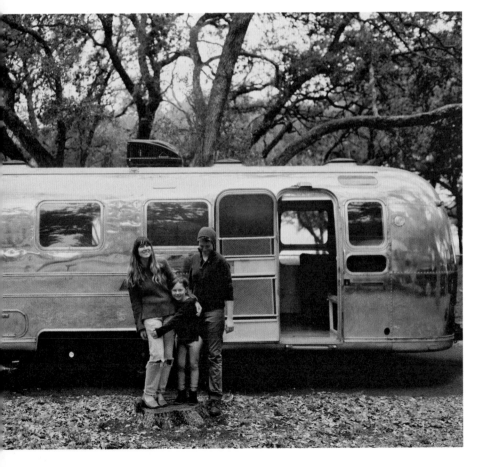

Kate and Ellen and their daughter in front of the Airstream they recently renovated. Like the trailers they design for their clients, it has a gorgeous custom interior, including touches like these tiled walls and copper hand sink, above.

Kate at her kitchen sink. She became interested in design at a very young age and remembers bringing home interior design books from the library instead of the typical children's classics. At 13, she subscribed to *Home* magazine, which featured beautifully designed, well-lived spaces. She still has the issues she received, and continues to use them as inspiration for her Airstream renovations.

looking at pictures of her college best friend, Ellen. She was drawn to her profile and couldn't stop staring at this person she hadn't talked to in seven years. She began dropping hints on Ellen's Facebook wall that she was into her. And one day—Kate remembers the date exactly: May 6, 2012—Ellen responded to a flirtatious comment Kate left.

"I texted my cousin Robin what I was sending Ellen and asked if it was flirting. She said, 'If you think you are, you probably are.'"

They spoke on Facebook messenger, then on the phone, and then on Skype. And they didn't stop talking after that.

"When I think about all the ways the second conversation might not have happened," Kate says. "I had to overcome my fear of messaging her and face [that] I could be with a woman and what that would mean for me. I had to face what my family would say. It wasn't just a simple: 'I'm interested in someone.' It was like: My whole life was going to change."

A month into dating through Skype calls, they decided it was time for an in-person date. With Kate in Indianapolis and Ellen in Lexington, Kentucky, they met halfway.

"We had our first kiss in the parking garage" Kate says. "That was it. You think about the best first kiss you've ever had. I still think about it. We still talk about it all the time."

For nine months, Kate and Ellen conducted their new relationship long distance, and they incurred some challenges about being gay.

"It didn't go well coming out to my parents," Kate says. "My dad said some mean things, and my mom was crying. They thought, 'That seals the deal. She can't come back from that.' It was really rough. They didn't want to face it. They were quiet a lot in those first couple of years when they had to be around me and Ellen."

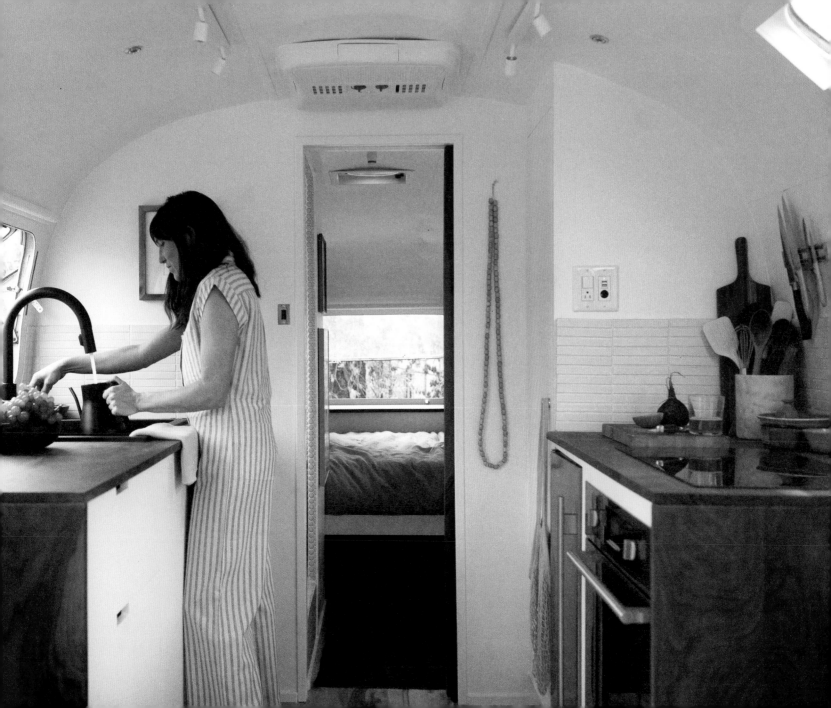

The built-in benches around the dining table double as a comfy seating area and a hideaway for storage baskets. The dual-burner induction cooktop in their kitchen can also be used as counter space.

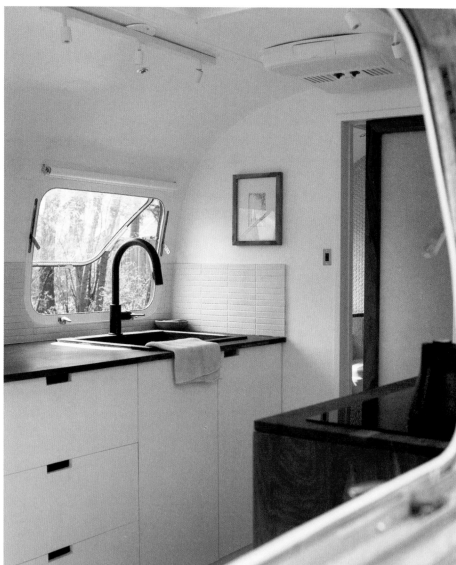

After Kate finished school, she and Adelaide moved from Indiana to Kentucky so they could be with Ellen. While Ellen taught art at the high school she used to attend, Kate stayed at home with Adelaide. Ellen was commuting three hours a day for work and wanted to leave her job, but she stayed on so she and Kate could afford to stay in their home, a 1,600-square-foot house that needed renovations. They worked together to remodel the living room, with exposed brick on the walls and a floating staircase to the upper level.

"We started questioning this. 'Is this the life we want?'" Kate says. "This doesn't feel good or feel right. Those conversations led us to want to travel."

Initially, Kate and Ellen looked into school bus conversions, but ultimately, decided on an Airstream, which would allow them to tow it with their truck, giving them the flexibility of having the smaller vehicle to drive separately when needed. They also thought that Airstreams from the 1950s and 1960s were aesthetically beautiful.

"We realized if we had a school bus, a lot of campgrounds wouldn't allow us in," Kate says. "We didn't want to limit where we should go. A Westy (VW Vanagon Westfalia) was too small for us. So we started to look into a pull-behind trailer, and all of the trailer options seemed bleak except for the Airstream."

In order to tow it with a Toyota 4Runner, Kate and Ellen needed an Airstream that weighed less than 5,000 pounds, so they were looking for one from the period between 1955 and 1960, when Airstreams were manufactured to be lighter in weight. A week later, after searching online ads, Kate and Ellen found an ad for a 1957 Airstream Overlander parked ten hours north of them in Michigan. Kate, Ellen, and Adelaide hopped in their truck and drove up the same day to check it out. This could be their ticket to travel around as a family, they thought—a symbol of freedom and a chance to finally be living their dream.

The Airstream had everything original still inside it, but the mice had moved in as well. It had serious water damage, the cabinets were moldy, and none of the electrical equipment was working. If they were going to buy the trailer, they would have to completely gut it. Nothing was salvageable.

They had never done an Airstream renovation before, but they knew a thing or two about remodeling houses. On the ten-hour ride back with their newly bought rig, they talked about their plans to build it into something that they could both live and travel in.

Kate and Ellen built out the Airstream together. One piece at a time, they added new flooring, installed electrical and plumbing, and built out cabinets and closets from inexpensive birch plywood.

After a year, they finished the build, held eight garage sales, sold their house, and moved into their Airstream. The downsize took them from 1,600 to 160 square feet.

48

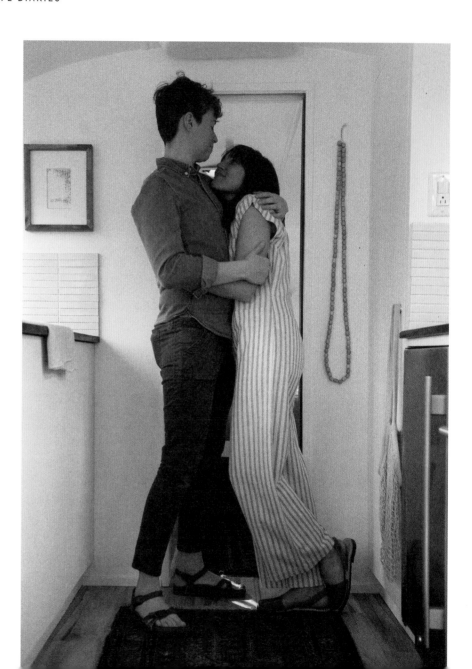

**KATE AND ELLEN'S
GO-TO ITEMS**

Table: "It's a place to gather. It's critical for us to have a place to sit and look at one other. The other night we were creating art together. We were just sitting there together, creating together. The table is central to our family."

Propane range/propane water heater/full solar system: "These items allow us to go off grid for long periods of time. We're now combining our existing black water and gray water tanks because we use a composting toilet. Our fridge runs on AC/DC power, so we don't go through too much propane. These things allow us to be in a national forest, unplugged and without a worry in the world."

Queen-size bed (comfort is a must!): "As parents and business owners, we need our sleep! And it makes us better people to hang out with."

For six months, they traveled from Kentucky to California and up to Alaska. In South Dakota, they visited Badlands National Park and from a camp spot outside the park, they watched the most incredible morning storm roll in. In the Yukon Territory in northwest Canada, they cried looking at the beauty around them.

"I kept thinking, 'This has always been here for us, and we've been missing it. For thirty years, we've been missing this,'" Kate says. "It was beautiful and sad at the same time."

While they traveled, Adelaide participated in Junior Rangers at the National Parks they visited. A program for children between ages 5 and 12, Junior Rangers helps kids learn and explore through activity booklets offered at visitor centers. It encourages them to hike, go on ranger talks, ask questions, and fill out workbooks to earn badges. Kate and Ellen used the program as part of Adelaide's un-schooling curriculum as a way for her

to gain understanding of the parks they visited. In turn, they were able to discover each park through the eyes of Adelaide and learn more about their surroundings themselves.

Traveling and living small became a part of who they were. The Airstream was evidence of the year's worth of backbreaking, heartbreaking work that made it their home, a constant while they traveled. Their trip was a blur of excitement and magic until it was halted abruptly. On a snowy day in Colorado, they faced some messy news. There were circumstances at home that called them back and caused them not to be able to travel any longer. They weren't ready to leave the road as a family, but as they talked it through, they discovered they didn't have another option. Facing this setback, Kate and Ellen sat teary eyed as they drove east to plant roots and park the Airstream in one place.

They quickly went back to their previous routine. They rented a house in Indiana, filling it with rugs, chairs, tables, plants, dishes, and candles. Tucked inside that house was every convenience—things the Airstream was lacking. But even with all the discomforts of their Airstream—its lack of a heat source, the windows that didn't shut all the way, cold water, and the composting toilet—Kate had felt a joy she had never experienced in her life before.

In November 2015, they decided to sell their first Airstream to a friend they had met on the road who would use it as an Airbnb on land in Washington. Less than two months after the sale was finalized, Kate and Ellen found another Airstream on Craigslist in Louisville, Kentucky. This second one, a 1977 Overlander, was a symbol of hope during a tough time. At the time, they didn't know how they were going to use the Airstream, but they saw it as a project they could look forward to working on, something to ease their anxieties about their family's future.

Building out Airstreams makes Kate and Ellen come alive. There is something special about the work they do and the feeling that a project is made by people who really love each other.

Kate and Ellen looked back at their first Airstream rebuild and remembered the inexpensive materials they bought and the basic design they put together. They thought they could build this second Airstream even better and use it in hopes that they'd be able to start a business renovating Airstreams.

It was an intense renovation, with custom-designed and built-out cabinetry, walnut countertops with waterfall edges, a pocket door, and an engineered wet bath with penny tiles.

The rebuild kept them quite busy, and it ignited a fire under them. When they neared the end of the renovation, they named the Airstream "June," after the month it would be completed. As the Airstream came alive, so did they, and they wanted others to experience the same elation. That's how they came up with an idea for a business called The Modern Caravan, a full-service Airstream design and renovation company run by two women. They would turn other Airstreams into beautifully designed, well-lived spaces.

51

Kate says she was meant to live on the road. "I couldn't have known it until I got on the road. This makes sense to me. This is why I didn't fit in all these other boxes."

Within a month, they had booked their first client and had three others on the waitlist. As they continued to get inquiries, they knew that in order to be successful, they would have to travel to their clients and build on their properties. That meant leaving the Midwest and it meant separating Adelaide from Kate's ex-husband. It was a difficult conversation, but Kate's ex agreed, knowing that it would help Kate and Ellen pursue their business and their passion.

Kate says she was meant to live on the road. "I couldn't have known it until I got on the road. This makes sense to me. This is why I didn't fit in all these other boxes."

Now, Kate and Ellen both renovate Airstreams to sell to customers and offer courses for DIY renovators. One of their latest projects was an Airstream for themselves, a new version of home, a 1994 Airstream Classic that they've named "Hawk." As they undertook the new business, they saw the appearance of hawks as symbolic of their success in the light of a big risk.

That risk has paid off as they are not only living a more meaningful life but also inspiring others to live tiny. Their custom vintage Airstream designs are unique and modern, and reflect the personality of two people who really love both one another and the work that they are doing. There's grit behind the layers in the walls and love in every seam.

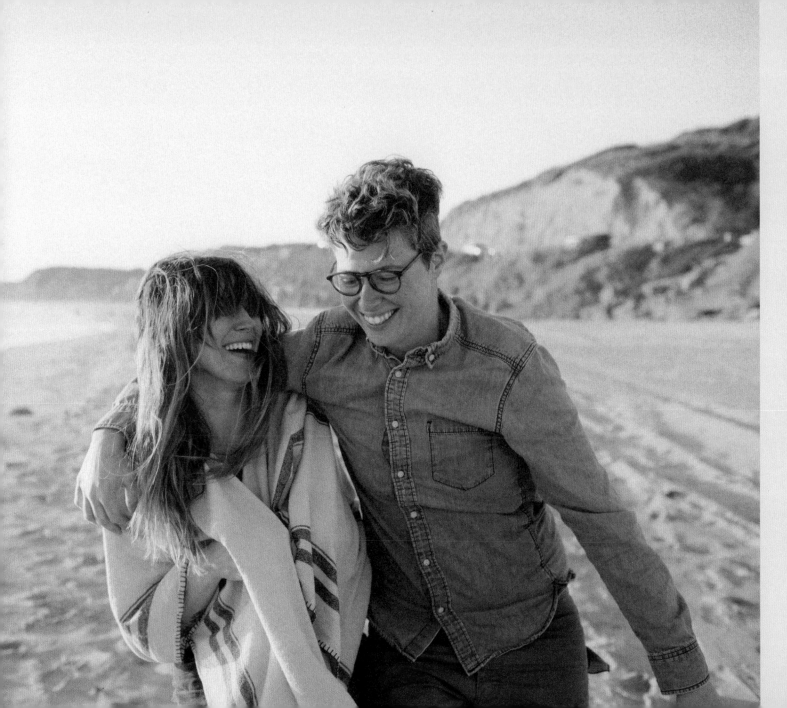

Living in a small space is a crash course in finding out if you're truly meant to be together.

Right: Hawk Tennis and Kenz Kraut are from the foothills of California and have been living out of their van for the past six years. "We are not hiding behind our van; rather we are using it to deliver us to the places where we can encounter our fears and then conquer them by moving forward."

54

Right: Greg Mills and Michelle Romero are seasonal travelers, spending time in the United States and Canada in their 1982 VW Vanagon Camper Van. They return to Long Island, New York each year from the months of May to September for Greg's job as a Professional Rescuer and Ocean Lifeguard at Jones Beach State Park, one of the top ten busiest beaches in the country.

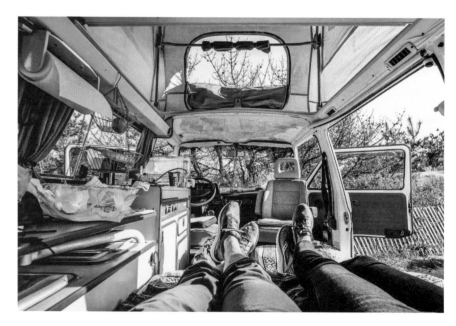

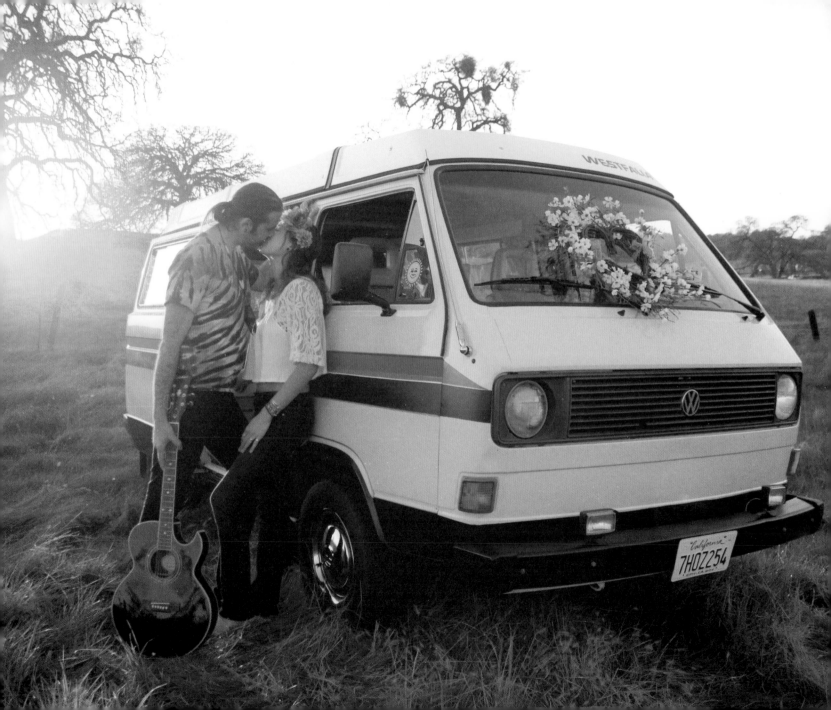

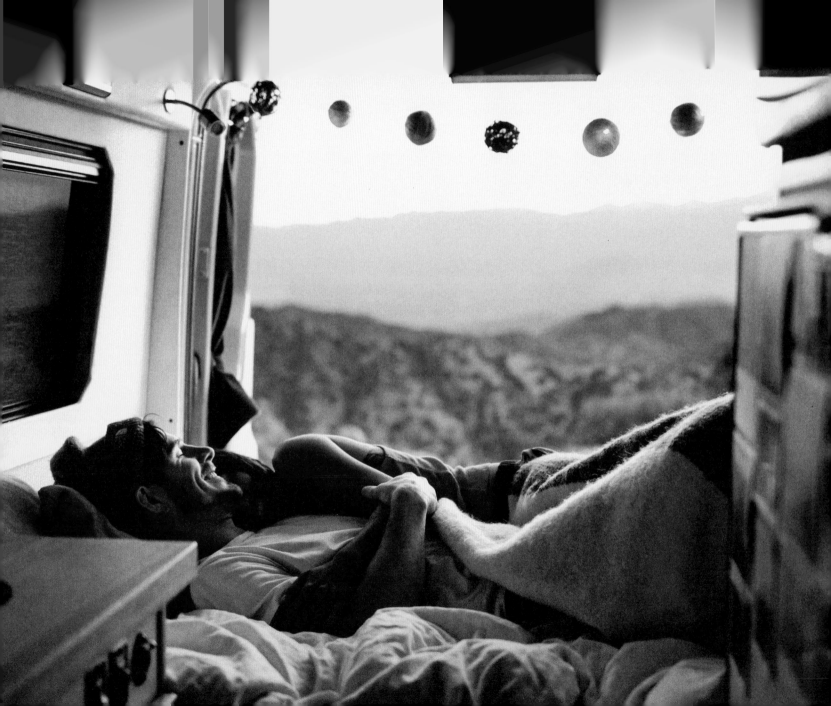

Far left: Photographer Katch Silva and her husband, Ben Sasso, in their 2016 Mercedes Sprinter Sportsmobile.

Left: While Kyle Murphy was traveling in Vietnam as a photographer, he met Jodie Morse. Jodie was living in a rooftop tent with her two dogs. Kyle was attracted to her love of minimalism, and they now live together in a renovated 1955 Airstream Flying Cloud.

Below: Just five days after Brittany Rouille and Drew Newmann got married, they flew to London and rented a campervan for their honeymoon. That experience led them to research what type of rig they wanted for their rolling home. It didn't take long for them to find a custom-converted Ford Transit, and for 2½ years they adventured across England, Ireland, Scotland, Holland, Germany, Austria, France, Switzerland, Italy, Croatia, Scandinavia, and Morocco.

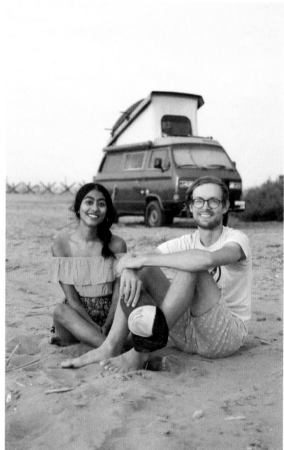

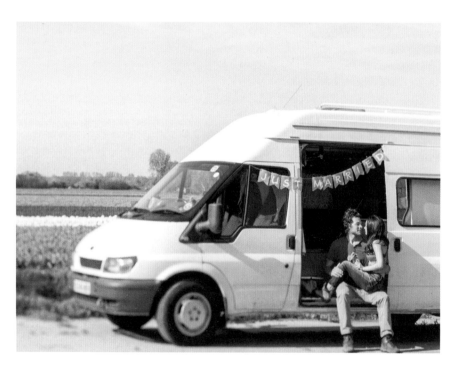

Above and right: For Pete and Shruthi Lapp, the van was a place to occasionally visit and be together throughout their long-distance relationship. It was also a safe haven and a free place to stay when visiting disgruntled parents who disapproved of them being together. Little did they know that, over the years, the van would become a permanent home and a vessel for adventure.

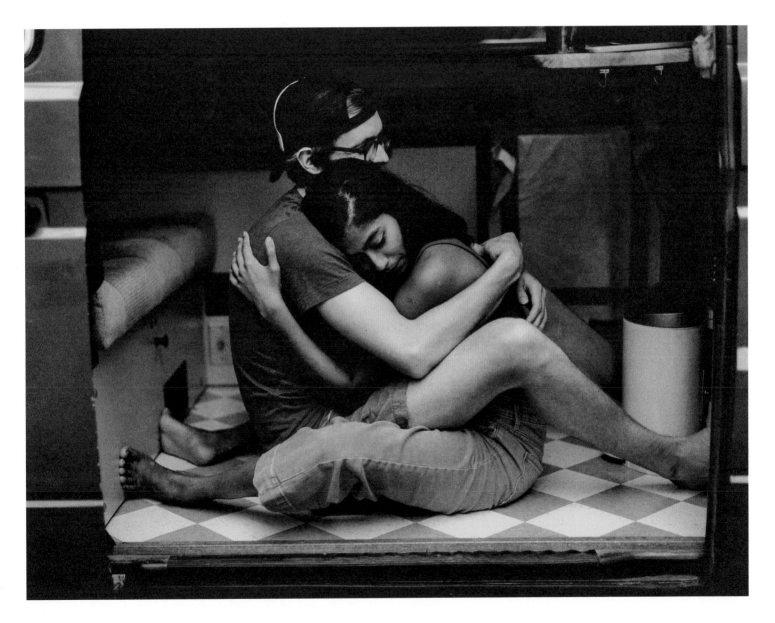

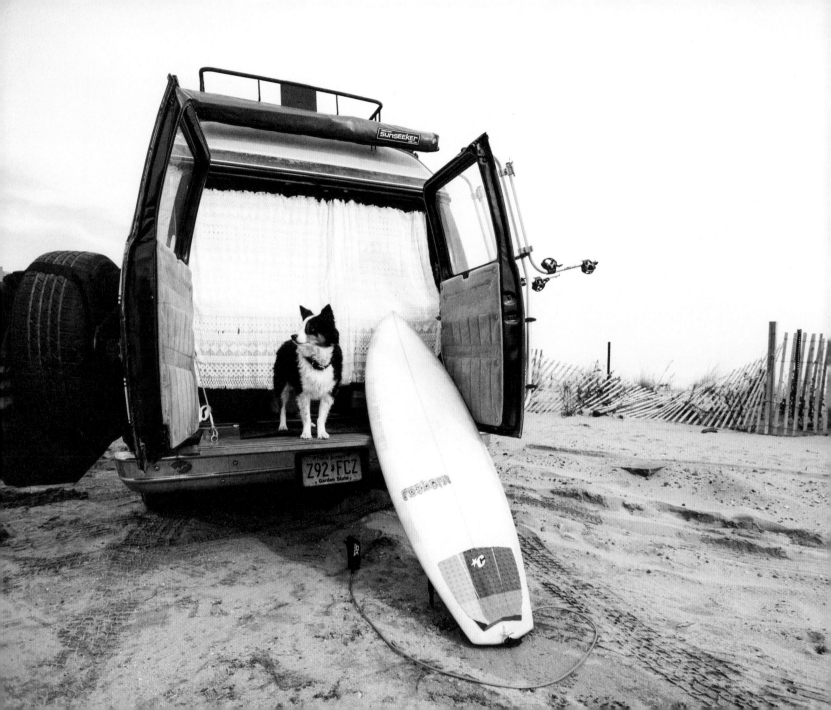

VANLIFE GUIDE TO
TRAVELING WITH PETS

—

I may be a bit biased, but I think the best thing you can do as a pet owner is to take your pet on outdoor adventures. When traveling, there are always new smells, new people, new pets, and new places. For your pet, it can keep life exciting to be moving and to have your backyard constantly changing. However, it can also be a big shift for a pet to uproot from the comfort of a home into a small space. Always remember to leave enough fresh water available for your pet (even in the winter months when you have to deal with freezing temperatures). And make sure to apply the same Leave No Trace principles to your pet as you would to yourself. The following list is for dog owners mostly, but it could apply to most other pets that you can't live without in a rolling home.

Install a Ceiling Vent

According to the American Veterinary Medical Association, every year hundreds of pets die from heat exhaustion because they are left in parked vehicles. While cracked windows might seem like a solution, heat can still rise to more than 40 degrees higher than the outside temperature inside a small space. Putting in a good ventilation system will benefit both you and your pet. A ceiling vent will keep air circulating, sucking hot air out and pulling cool air in. It can be a lifesaver in hot weather when you're spending a lot of time inside your van. Jayme and John of @gnomad_home recommend ventilation fans with built-in rain covers. If you choose a model without a built-in rain cover, you'll end up buying an aftermarket attachment anyway, to keep water from leaking through during inclement weather. These add-ons, often not designed specifically for your fan, can be bulky, causing wind drag and, ultimately, higher fuel costs.

61

Attach a Lead Line to Your Rig

It wasn't until I spent a season working on a farm that I realized how life changing owning a lead line could be. Since my van was parked in one location for two months in a safe spot, I wanted to give Peaches the option to roam while keeping her in the vicinity of the van. Now, I can keep all my doors open with plenty of water on hand and work while she stays close with the option of being inside or outside the van. It works great tied to camp chairs, trees, or screwed into the ground so that your pets can stretch their legs but can't go too far or roam into the wilderness at night.

Add a Light or Tracker to Your Pet's Collar

Even if you have a pet who does well staying close by at night, having a collar that lights up or flashes can ease your mind. In remote areas, it can be hard to see where your pet is headed. If you can spot your pet's light, you will know where to go to call the pet back. In addition, a GPS tracking device can help you keep tabs on your pet. Some of these devices are just as advanced as those designed for humans and can measure temperature, resting heart and respiratory rates, for intensity of activity, calories burned, and distance. Living in a van allows you the flexibility to be in places where your dog can roam free, but you still want to make sure they respect the wildlife, stay on the trail, and not bother other people or animals. With a light or a GPS tracker, they can enjoy their freedom while you're still in control.

Fill Airtight Food Containers with Pet Food & Treats

My number-one recommendation for all food storage is airtight containers. They are particularly useful for pet food since most pet food bags are bulky and can spill pretty easily. You don't want to deal with critters in any form coming into your van to see what goodies you have. Mason jars work great for spices and snacks but not always for larger quantities of pet food. Check your local pet store for a kibble carrier. These bags can keep your food secure and prevent spilling. You can also use a dry sack, similar to one you might use rafting. Keeping food tucked away and out of sight and smell will also help prevent bears from breaking into your vehicle.

Trade National Parks for National Forests/BLM Land

When you're planning an outdoor adventure, you may find that a lot of areas are restricted for pets. Most trails in national parks don't allow dogs, but you are allowed to bring your pet into the park if you leave it in your rig. Because I would rather share the experience with my pet, I tend to stick to national forests and land owned by the Bureau of Land Management (BLM). These lands are managed by the U.S. Forest Service, a division of the Department of Agriculture. In national forests, pets must be kept on a leash no longer than six feet at all times while in developed recreation areas and on interpretive trails, but most other areas do not require a leash. Though the majority of BLM land has a tolerant policy about dogs off leash, check local regulations before you travel. You should also check local rules before bringing dogs on backcountry trails.

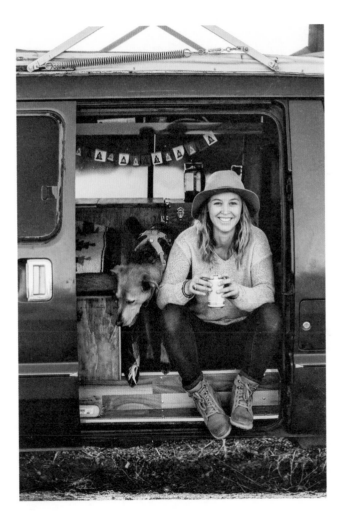

63

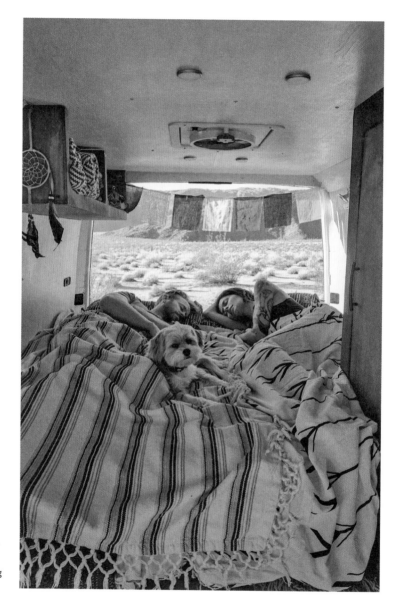

Noel Russell and her husband, Jonnie, are part-time vanlifers, working at nonprofit organizations during the week at their base in Oakland, CA, and escaping to the mountains on the weekend. They travel with their two rescue dogs, Fin and Lohtse. Pictured here is their second van out of three rigs during a campout in Lone Pine, CA. Vanlife is constantly evolving for this family of four.

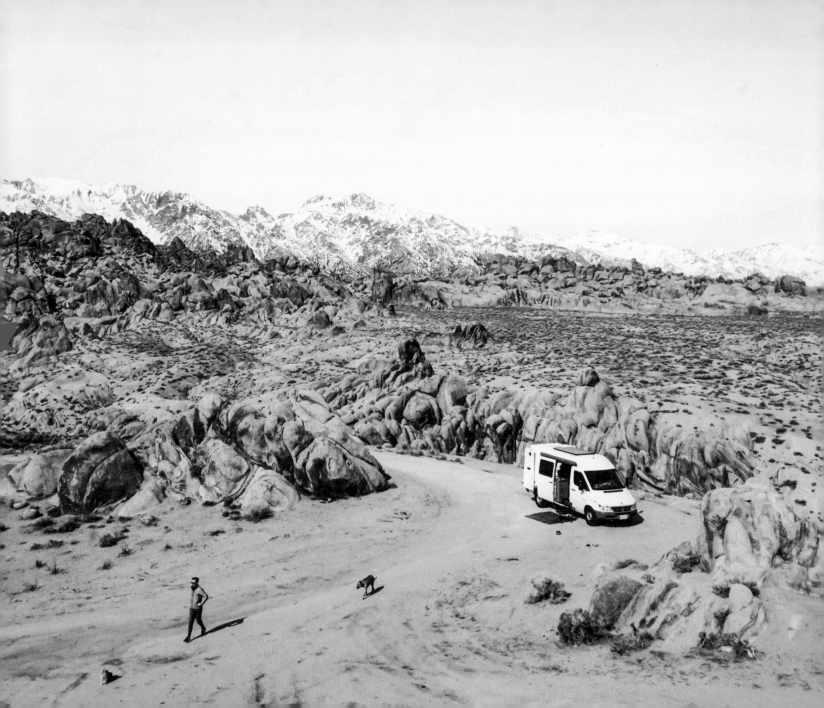

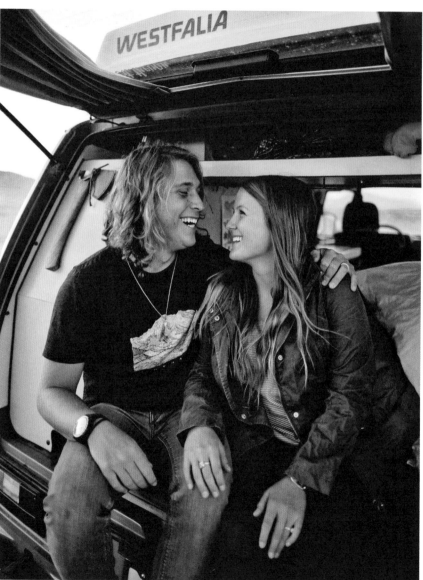

Love comes in all different shapes and sizes of vans. For these partners, the van gives them a space to connect more deeply with each other.

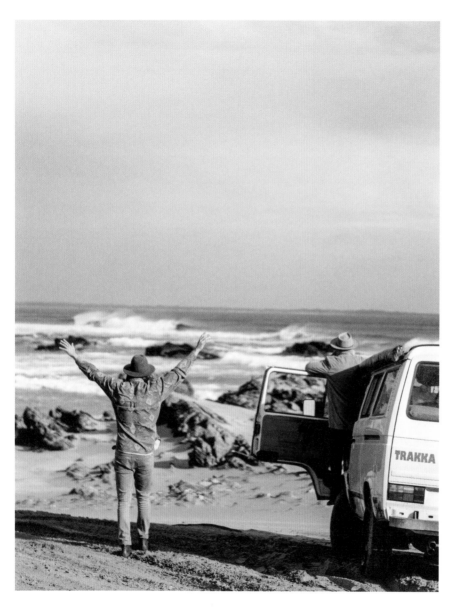

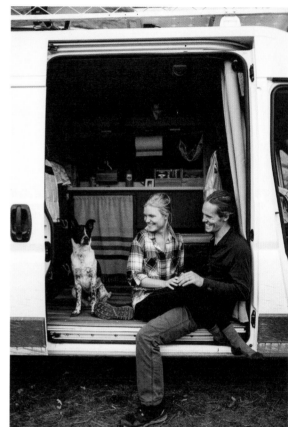

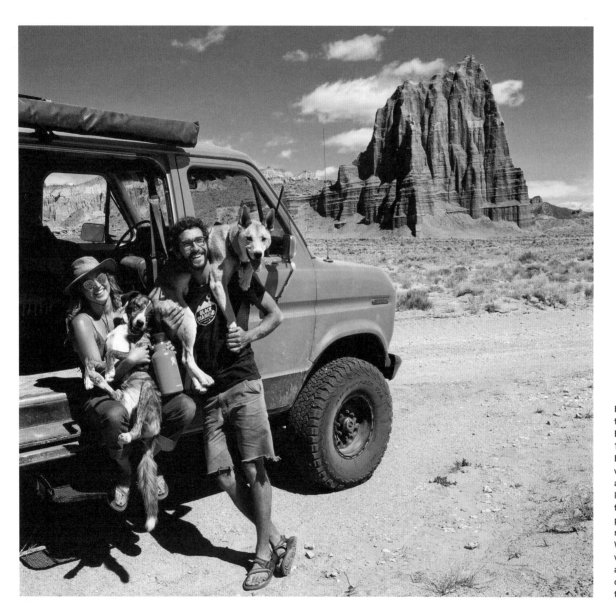

Brianna and Keith Madia travel with their two dogs, Bucket and Dagwood, in a 1990 Ford E350 van named Bertha. Bertha is the escape vehicle from the lives Brianna and Keith could have been living—doing things because they thought they were supposed to be doing them and meeting certain milestones. When they saw the big orange van, they found a life loophole and hopped in their getaway car. Here they are in Utah, their home base.

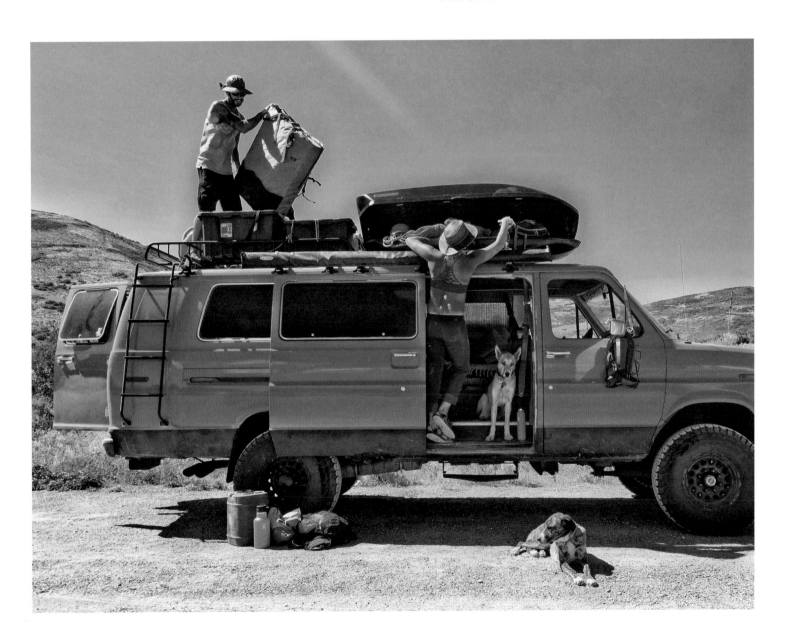

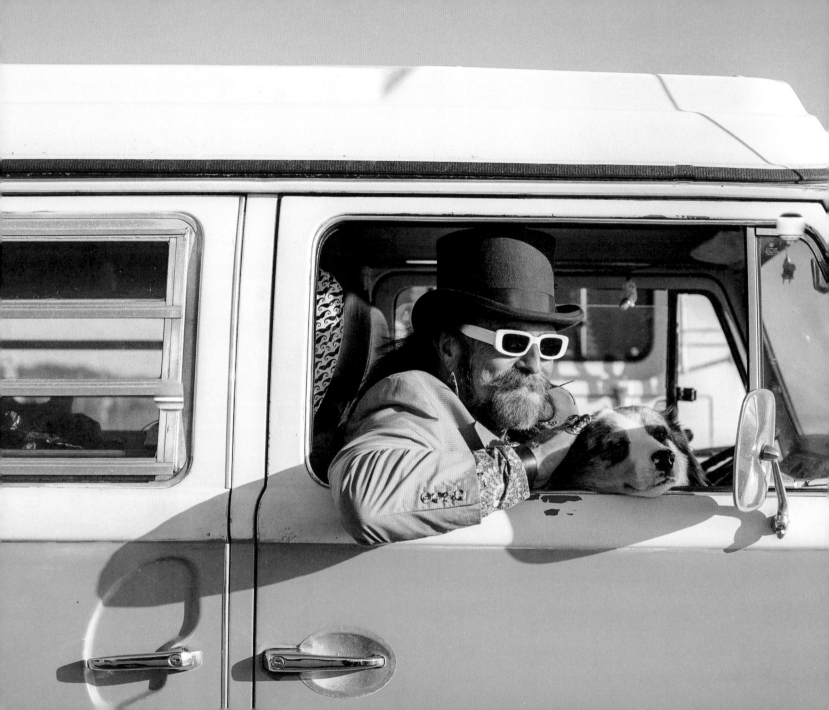

Mark and his partner Robert hanging out in their Shark Bus in the Ocean Beach parking lot in San Diego, CA. This spot is a place for local part-time van dwellers to hang out together in their rigs during the day. They park with their open doors facing the waves to get a mini version of vanlife.

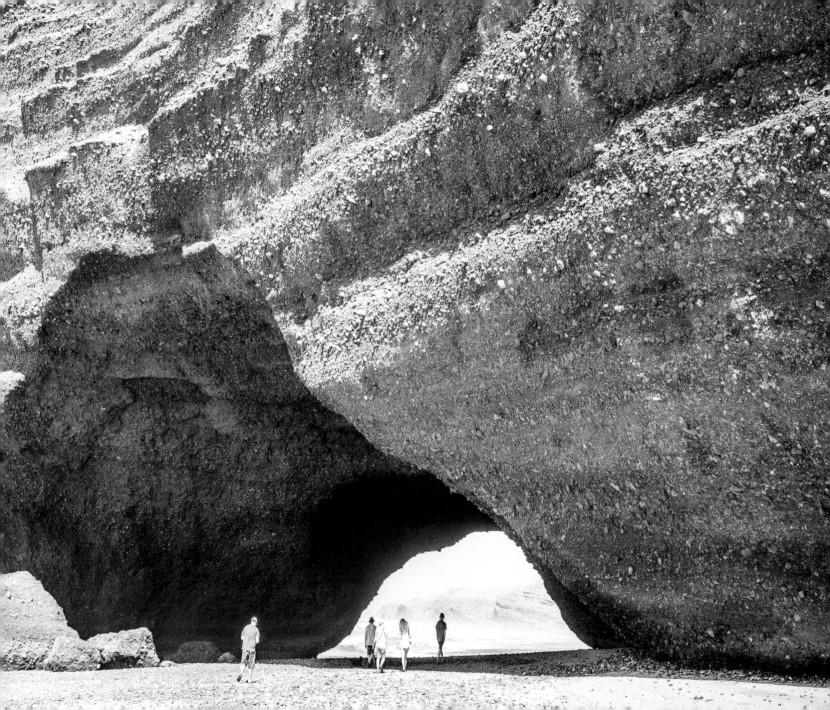

If you've ever run through a wildflower field, bathed in a hot spring, or cooked a meal over a fire in the backcountry, you know what it feels like to live wild and free. And there's no better way to do all that than when you have your home to take you there. The van is the vehicle that takes us down dirt roads to trailheads. We use our feet to go farther, and tents are extra rooms we carry with us deeper into nature.

Vanlife expands our backyard into the outdoors. We're able to use our surroundings as a playground for adventure, an edible garden, or an outdoor shower.

for Nature

Genevieve *in a* 1985 Toyota Camper

@joie_de_vieve

Parked next to a creek down a washboard road sits a 1985 Toyota Bandit camper. Peer inside, and it might look quite unused, almost abandoned. But if you look closer you will see a husky named Sailor rising from his slumber to size up this new stranger coming into his territory.

Rubbing her eyes, Genevieve Jahn comes out the back door. She's not used to seeing other travelers where she sleeps for the night. She seeks out places where no one else is around—places where the sunrise and birdsong are morning wake-up calls, alpine creeks are baths, and rocks and mountains are local climbing gyms.

It's easy to fantasize about a life like this, but it's more difficult for women to embrace it. Myths and media perceptions make women fearful for their safety and wary of people they meet in the backcountry.

Genevieve has learned to practice awareness and follow her intuition if she feels anxious. Over the past three years, she's become more comfortable meeting strangers and encourages them to join her at her camp by messaging them on Instagram.

Living off the grid on her own as a nomad is a change of pace from Genevieve's younger days. She grew up dancing, competing in beauty pageants, and worrying about her appearance and body weight. Raised in Florida in an Italian Catholic family, she was taught to grow up, get a job, buy a house, and support a family. With her professional dancing career not sustainable, she rented an apartment and found work at a corporate marketing agency. But the more money Genevieve was making, the less she was able to travel.

"My freedom was restricted," Genevieve says. "I got disillusioned by the corporate mentality. I didn't want to sit at a desk anymore, and I started taking long weekend trips . . . as many trips as I could without pay."

With so many days gone from work, the company fired Genevieve from her full-time position. But she

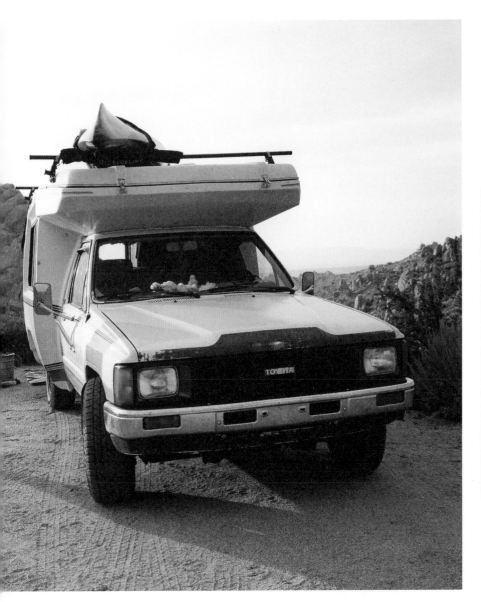

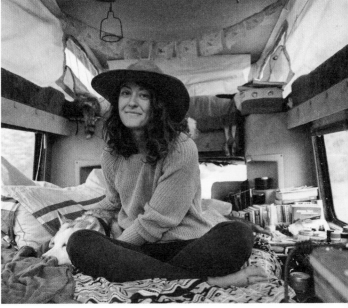

was surprised when they decided to hire her on as a contractor to work from home.

"It was crazy. They were going to pay me more money per hour to work from home, and I could travel as much as I wanted."

At the same time, Genevieve began connecting with other free-spirited enthusiasts on social media. Instagram became an optimistic window into a life outside Florida. She discovered an account that inspired her called @longroadtonowhere, run by Tommy Erst. She found herself interested in the photos that showed him traveling, camping, cliff diving, soaking in hot springs, and rock climbing. Genevieve befriended him through Instagram messages, and through their lust for adventure, they decided to meet in Hawaii and spend a week traveling there.

The trip inspired her to rethink her job and the house she was renting. On the flight back, she made a six-month plan to travel cross-country. The goal? Buy a rig and drive west.

In September 2015, with no road life experience other than weekend camping trips, Genevieve packed up her newly purchased Toyota Bandit and left her native Florida for a cross-country road trip with no end date. Her first night on the road, she camped at a Savannah, Georgia-area RV park to get her feet wet. Since that night, she has never again parked the Willie Rose at an RV park or even a Walmart—save for the occasional day use—in more than a year and a half on the road.

She began searching Craigslist ads for mini-RVs and old Chevy camper conversions. Genevieve was looking for something small and eco-friendly and priced for less than $5,000. One ad she kept returning to featured a Toyota Chinook, and she was drawn to the idea of having a separate space she could access from the front two seats. She found an online forum specifically for Toyota motor homes and jotted down all the information she could. She was drawn to the pop top, thinking of all the Florida nights that were humid and buggy. Sleeping up top could give her more ventilation, and tent-screen windows could shelter her from mosquitoes.

With a renewed search process, Genevieve kept her eye on her criteria until she saw an ad for her current rig. It was 45 minutes away in a town called Lakeland, and it was owned by a former Toyota mechanic who barely drove it. It was the perfect scenario, and even though it was slightly above her price at $6,000, Genevieve trusted her gut and snatched it.

She sold and donated the majority of her personal items, canceled utilities and subscriptions, set up paperless automatic bill payments, and moved from her rented apartment into her new rig.

Within the first few months, Genevieve stuck to her plans. She drove to California and ended up spending several months at a time there, calling some of the state's best rock-climbing destinations home: Joshua Tree National Park, Indian Creek, and the eastern Sierra Nevada.

Nature is Genevieve's way of escaping stresses. She has the freedom to live her days and nights however she chooses, and she chooses to spend them in naturally beautiful places. There have been moments in her journey that have tested Genevieve's patience and commitment to this lifestyle. But whether it was getting two flat tires on a desert backroad on the way to Black Rock Desert in Nevada, being stuck in a monsoon with

landslides on the trail during a mountainside hike, or being stranded with multiple vehicular repairs in a small high-desert town, she chooses to stay calm. Genevieve is always searching for the beauty in what surrounds her in every moment, no matter how challenging, and not just in the less-hectic times.

After spending so much time in these natural surroundings, she's become more conscious about the human impact on nature and the ecosystem, a lesson that was not as easily learned when she still lived in the city. She tries to take these lessons with her and act in stewardship of the natural world.

"The big thing I've realized about being in nature is how much we're all connected to it. The impact we have on nature impacts who we are as human beings."

She uses her social media presence to educate others in eco-friendly practices when visiting outdoor spaces. Often you will find her spreading awareness to new

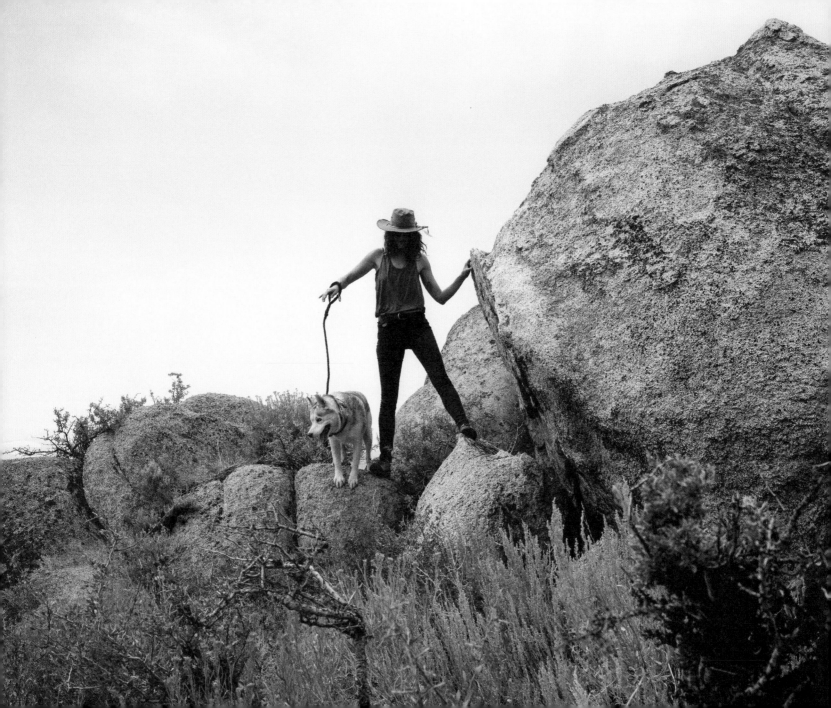

vanlifers about Leave No Trace Principles, seven ethical guidelines that promote conservation in the outdoors, including directives like respecting wildlife and packing out trash. She practices those guidelines in everything, including cooking, which she does only outside since she doesn't have an indoor setup.

"Food is a theme in my life, and it brought the dirtbag [rock climbing] culture to my life. It was also a theme when I was a professional dancer. It has always been part of my life to be in a physical activity that I'm passionate about with my friends. When we take breaks, we eat."

Genevieve doesn't go anywhere without her cast-iron cooking setup: two skillets that she uses on the daily, a flat pan perfect for flatbread pizza, and a Dutch oven, which comes in handy for communal meals with new people she meets. She saves them mostly for her climbing family. They've become her core set of friends and her go-to community.

"I've realized the climbing culture is the closest thing I've found to the to dancing culture. It's physical activity during the day, but you're also living together and cooking together. It's become a society, and you have this community. You're taking care of each other."

Genevieve would like to tell her 25-year-old self that she would someday fork over all her money to take a risk and pursue her dream to be free. She would have had no idea that she would be doing it on her own, away from family, off the grid, and in nature, but she would always be near other like-minded people doing the same thing.

83

Genevieve's canine companion, Sailor, goes wherever she goes. Of adopting him, she says: "When I saw this face on an overcrowded city shelter's Facebook page, I just knew he was the rescue that was right for me. And when Sailor hopped right into my camper at the shelter and settled into vanlife, his smile said that my road home was the right home for him."

Let the wheels on your rolling home take you further into the outdoors.

Following spread: (Left) Under the stars in Tasmania, Lauren Williams and Alex Knorr camp out in Marty, a 1982 VW T3 Transporter Kombi. (Right) Jose Romero's 2015 Ford Transit van is dwarfed by the landscape at Capitol Reef National Park.

When you live in a van, your backyard is ever changing.

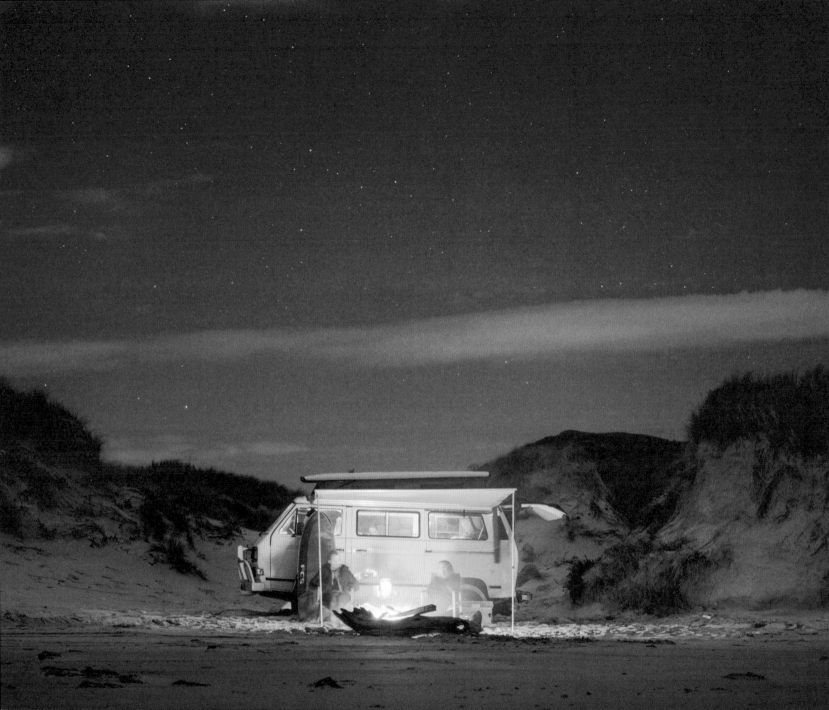

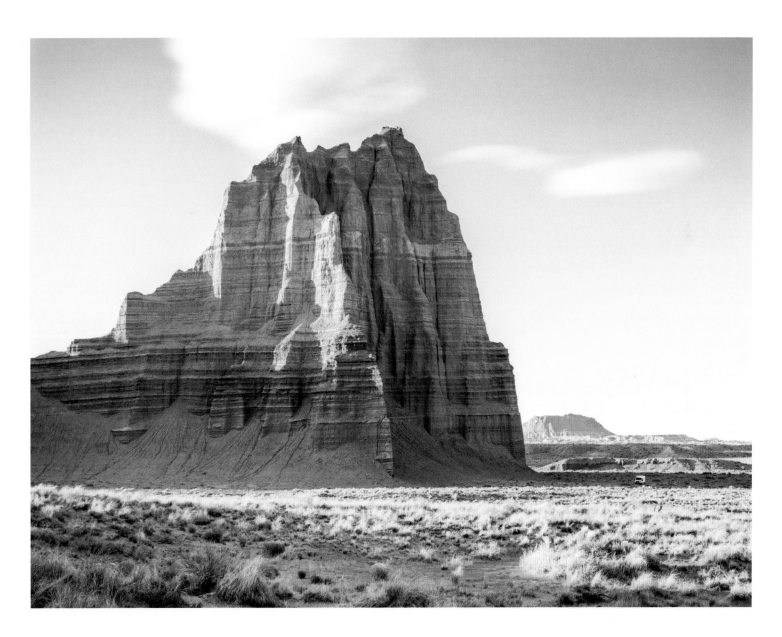

VANLIFE GUIDE TO FINDING PLACES TO PARK & CAMP

Find a Spot in National Forest & BLM Land

Not only are national forest and BLM land good places to take your pet, they're also great locations to camp for free for 14 days at a time. Oftentimes these areas are less populated, especially in areas outside the national parks, where park and national forest lands overlap. For example, while most people might be visiting Olympic National Park, you can explore Olympic National Forest, which consists of more than 628,000 acres that nearly surround the park. If you like to escape the crowds, this could be a better option. You can also find really beautiful scenic locations that the tourists don't know about. These areas usually don't have bathrooms, trash areas, or water-filling stations, but they do have a free price tag. Make sure to practice Leave No Trace Principles when wild camping, which include such guidelines as packing out your trash, minimizing fire impact, and respecting the wildlife.

Parking Lots

Folks in the vanlife community have mixed feelings about sleeping in Walmart parking lots. While Walmarts may not offer the solitude, nature sounds, or night skies that might be found in designated camping areas, they can be easy to find, relatively safe, and well lit at night. Check before you show up at a particular Walmart, as some are listed online in unofficial Walmart no-overnight-parking lists. Some Walmarts prohibit overnight parking because of such issues as drug trafficking and vandalism, which have made it an unsafe environment for travelers. For alternative options, consider casinos, rest stops, truck stops, park and rides, and even street parking. For these types of situations, it's best to do your research and ask others who know the area. It may be best to keep a low profile and not give away that you're sleeping in your rig.

Browse Online Resources

Freecampsites.net has become a go-to for travelers as it offers suggestions from the community on available overnight parking locations. On this website, you can search an area where you'd like to park and click on spots on the map for more information. Each spot comes with GPS coordinates and reviews from past campers. Sometimes users add photos so you can get a better idea of what the spot looks like. The available options can range from a parking spot at a trailhead to a remote area down a backroad. Sometimes an app makes it more convenient to locate spots on a map. The iOverlander app allows you to see not only the free camping areas but also the paid campgrounds. I've found that this app is useful for international travel and for viewing a more comprehensive list of options available. Wiki Camps is another good app for international travel, listing sites in Australia, New Zealand, Canada, and the United Kingdom in addition to the United States.

Explore Hipcamp & The Outbound Collective

It's called the Airbnb for camping and for good reason, as Hipcamp is a great resource for finding public campgrounds, ranches, farms, and private land. The website does a great job of providing stunning photographs and allows you to filter which ones have the amenities you might need. The Outbound Collective is a similar site, but it specializes in articles and adventures based on users' experiences. Type "camping" into the search bar, and you'll find several stories and adventures that contributors recommend. I like that they provide several photos, a pack list, and sometimes trails they like in the area. Unlike Freecampsites.net and the iOverlander app, most of the campsites available on these websites charge a fee. However, you're getting a different experience as these spots are provided by private landowners and campground hosts, and most of them have amenities like bathrooms and running water. Sometimes private landowners will offer an experience as part of the price, and some of the options I have seen included a vineyard or farm tour, or a boat or gear rental.

Ask Around

Some of the best parking-spot suggestions have come from other vanlifers who have secret spots that they share only with their friends. Particularly in a remote area, it can really ease your mind if someone gives you a heads up that where you are going to sleep is safe, quiet, and most likely has some amazing scenery that you will see when you wake up in the morning. Whenever I am headed to a new

location, I text my go-to van friends, and they send me Google pins. Sometimes they recommend a friend in the area who has land or a driveway to park in. Either way, this is the best way to find a spot that you might not normally find on a website or an app. And if you don't know whom to ask? Talk to the locals. Get to know people who like to camp in the same types of places and see if they have recommendations on some of their favorite places from their travels.

91

It's common for vanlifers to purchase an annual parks pass for $80, which covers entrance fees at national parks and national wildlife refuges; standard amenity fees at national forests and grasslands and at lands and waters managed by the Bureau of Land Management and the Bureau of Reclamation; and day use fees at U.S. Army Corps of Engineers sites.

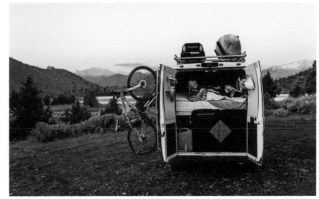

Overlooking Jedediah Smith
Redwoods State Park in
California, Kyle Murphy
captures his 1955 Flying Cloud
Airstream on the winding
roads below.

94

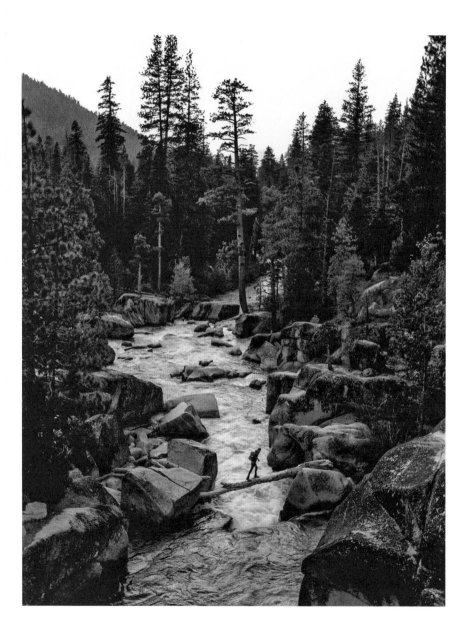

Left: In Truckee, California, Kyle Murphy escapes the city and abandons the van to find a local hiking trail.

Center: Leave it to the redwood forest to put things into perspective. Because Scott Adamson spends so much time alone, the world can start to shrink a bit. Going to this place reminds him that the world is enormous and to be open to all the possibilities that lie ahead.

Right: Yosemite National Park offers vanlifers a mix of work and play. With a hotspot, Pete and Shruthi Lapp can work in the van with an amazing backdrop and then spend the rest of the day climbing and hiking in the park.

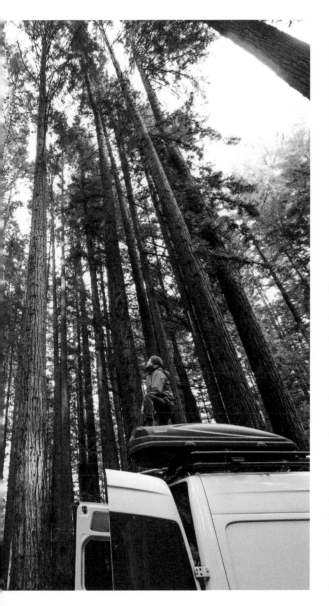

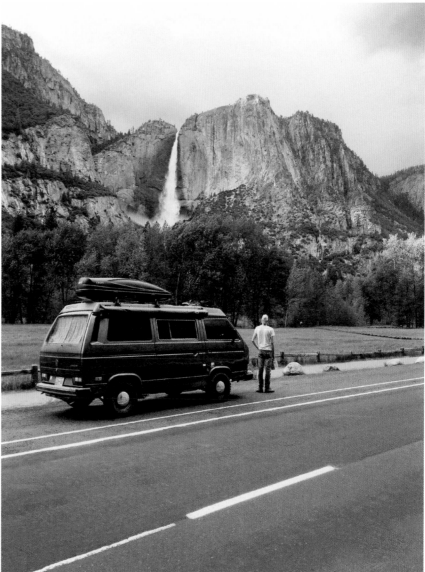

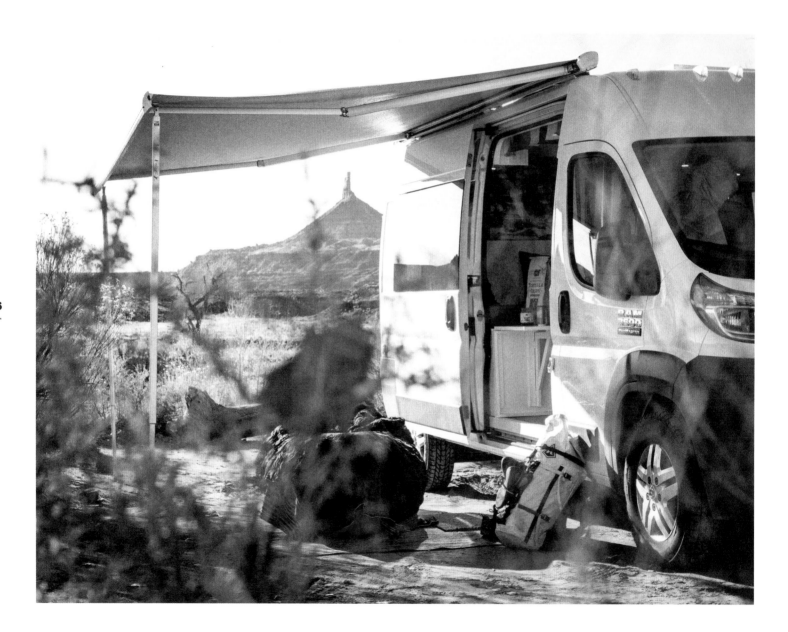

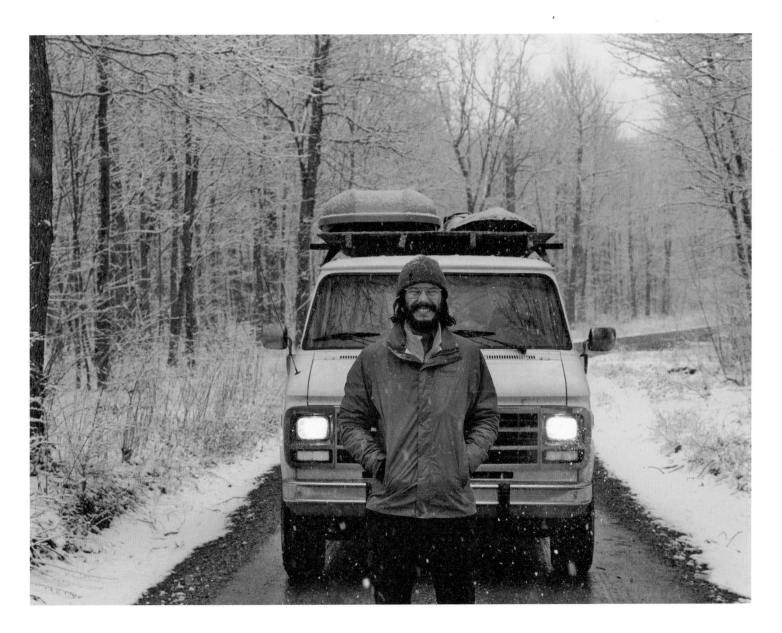

Previous spread: (Left) Thomas Woodson builds out vans, this one being his second conversion, a 2015 Ram Promaster 3500 Camper Van. With 470w of solar power, a gear garage, and a comfortable seating environment that transforms into a 6' x 4' bed, Thomas created the ultimate adventure rig. (Right) Rob Morgan traded a career in the Navy for a life of traveling in a Chevy van. His van, nicknamed Vanawhite, has given him opportunities and a life he didn't see for himself in the military.

The sound of crashing waves is a bedtime soundtrack that vanlifers crave, but these locations, while picturesque, are in high demand because they are relatively close to civilization and free to stay in. As more people catch on to the appeals of vanlife, more regulations have been put in place on overnight camping spots in areas where there's been too much human activity.

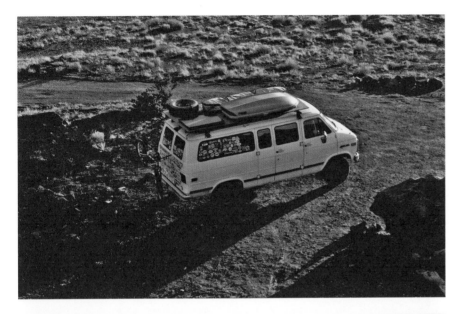

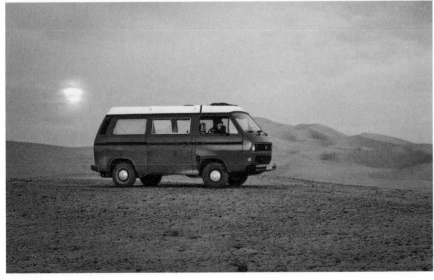

Getting away from the stresses of crowds and infrastructure in cities can be beneficial to one's mental health. Having a vehicle that can get you to remote places helps us experience these wonders, get better sleep, and understand our place in the universe. Unfortunately, as light pollution continues to spread from urban areas, some of these beautiful night skies are becoming endangered.

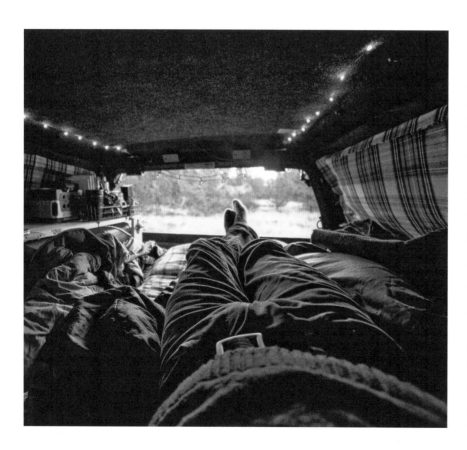

Left: Of vanlife Travis Wild says, "Something I've loved about it is the ability to get away. I've always said I'm not running from any problems but towards who I want to be, which is true, but a lot of who I want to be means spending time seeking beauty while also thinking a lot about issues I want to work through. Sometimes my life can get too wrapped up in those problems, so it's nice to have this place to both dig deep and do work, but also to get away when I need to."

Right: Austin White built out the bed of his Toyota pickup truck to have a platform for a mattress, with storage underneath. His inspiration for traveling began early: when he was young, his whole family lived on the road for close to ten years, and Austin's taste for nomadic life was born. He likes to say: "The smaller the house, the bigger the backyard."

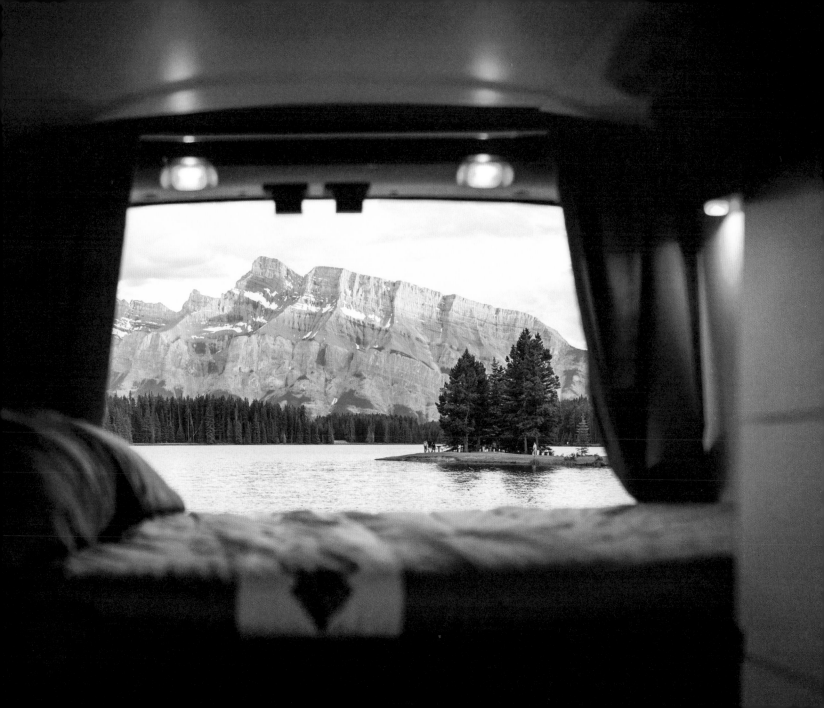

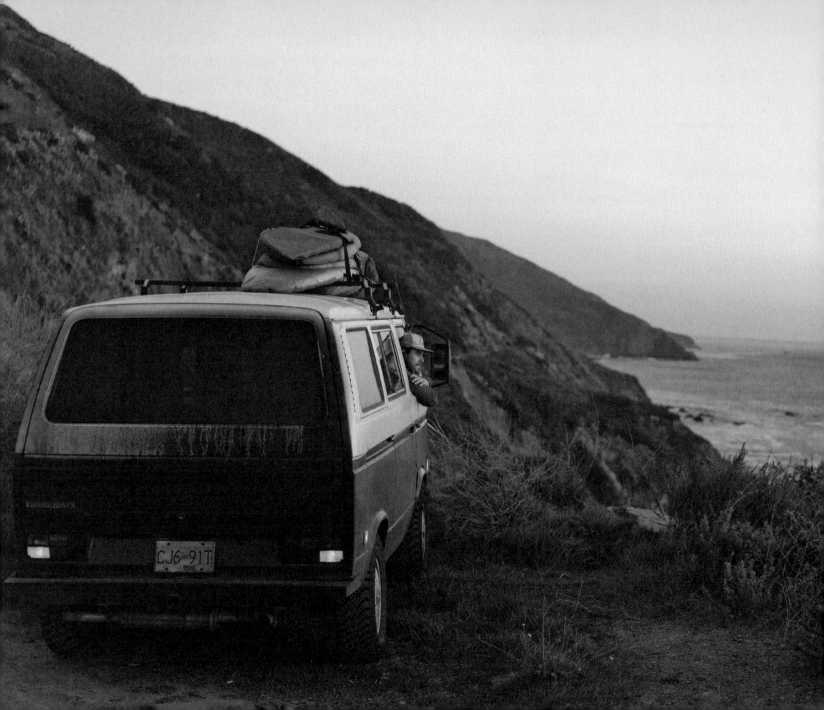

Left: Mackenzie Ducan has spent the last 12 years of his life pursuing his passion for photography and directing. Although he is based on the West Coast, his career has taken him from New Zealand to Nicaragua, Sweden to Switzerland, and many places in between. In his spare time, he can be found traveling the California coast in his VW van, Francine, in search of waves.

Right: Parker Hilton had been dating Jenelle Kappe for only two months before he asked her to live in a van with him. Parker had built out and outfitted his 1987 Chevy G20 Tern for a trip across the country. She said "yes" and they spent several months in the van adventuring across the United States.

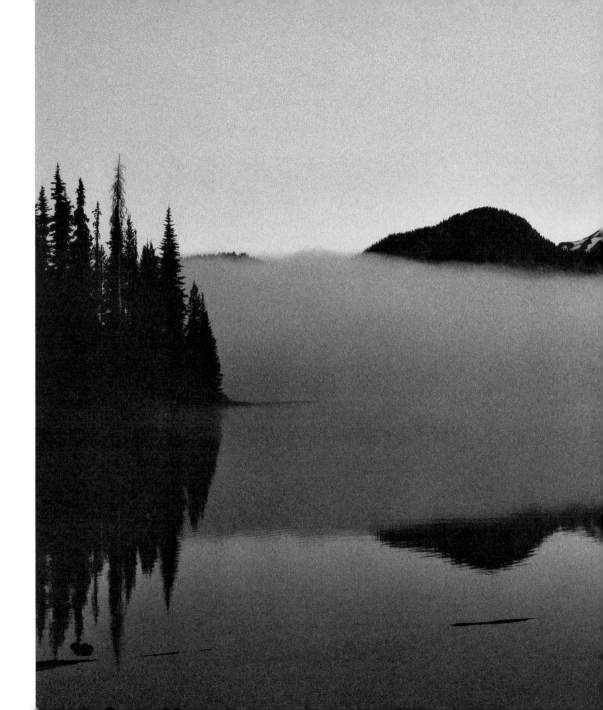

Mount Rainier, in Washington State, peeking through the mist is just one of the views available to vanlifers when they wake up in the morning.

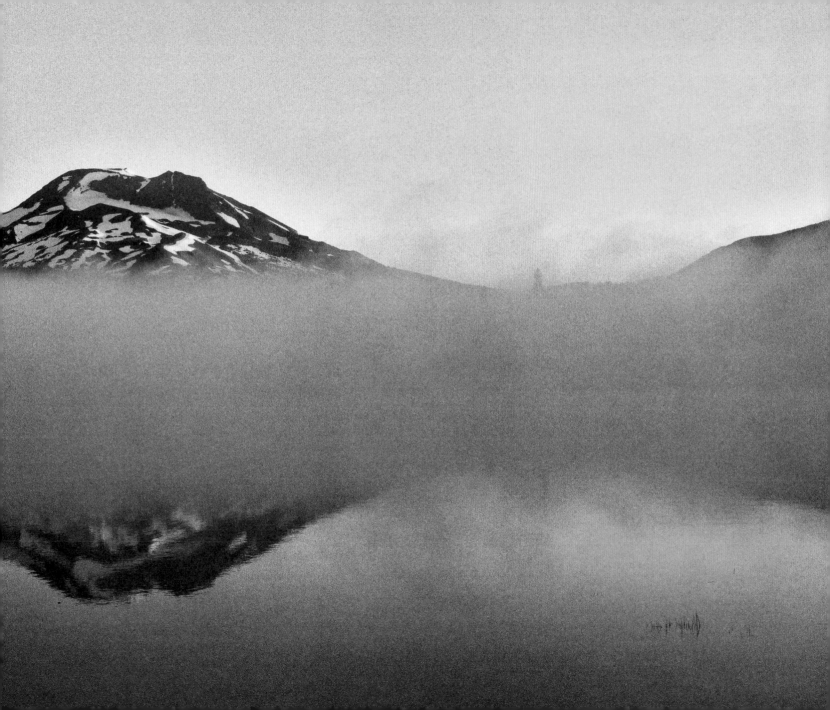

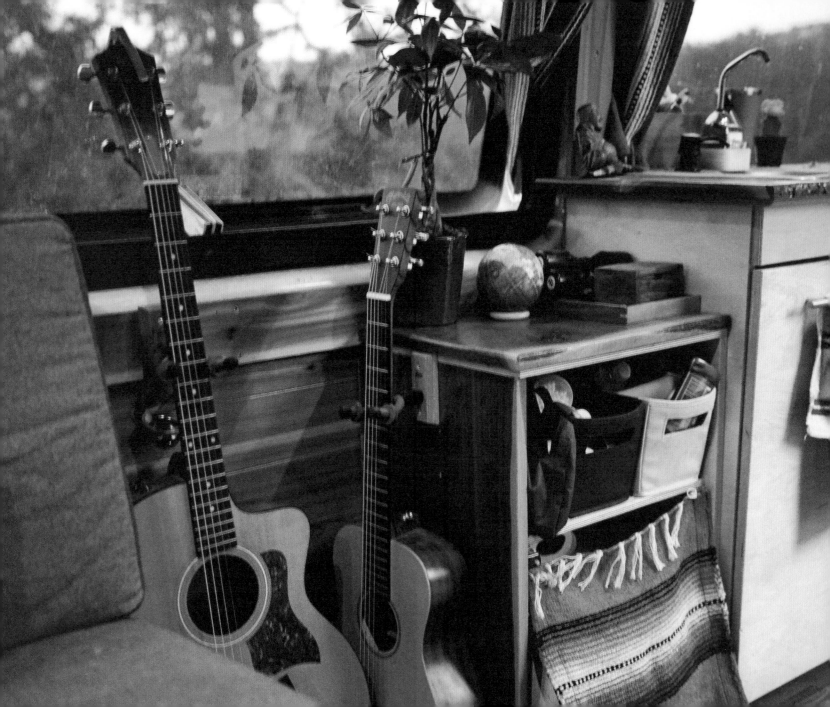

What inspires you to create? Where do you feel most alive? In the absence of everyday distractions, vanlife brings people closer to their inner creator and maker. Whether you're touring around in a mobile recording studio, illustrating custom van portraits, shooting film or video in nature, or creating photo collage wallpaper, this lifestyle makes it easy to bring your practice with you. These artists are people who need movement to be inspired.

Musicians who live on the road create road-trip playlists from songs they've written, played, and sung, inspired from their travels. The wilderness is their muse. Strangers become part of the lyrics in their songs, and their concert venue is ever changing with an audience of wildlife observers.

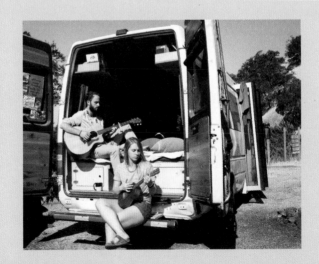

for Art

Pete & Taylor *in a* 2004 Sprinter Van

@alwaystheroad

We've climbed the palm trees in the middle of Rome/
We've laughed and cried in the warmth and the cold/
And I know more now than ever, well I've always
been home.

—*HOME*, ALWAYS THE ROAD

The home Taylor and Pete sing about in this song is a 2004 Dodge Sprinter, a former airport shuttle bus that they converted themselves. Their van allows them to travel, share, and write new music.

Pete and Taylor both grew up in musical families. Pete, who watched his older brother, Jim, write songs and perform in bands, was inspired to see if he could emulate his style.

"He's a huge inspiration," Pete says. "When I was in elementary school, he was playing in big punk rock bands and singing in the choir. Jim had an amazing voice and a natural talent for music. Everything he did was cool. I would sneak up to his band practices and watch him rock out. I wasn't supposed to be there. But I wanted to be just like him."

For her part, Taylor was inspired by the male members of her family who had musical abilities; she wanted to prove she could match them.

"We would have a family reunion every year," Taylor says. "After dinner, my uncle would grab his guitar, and my father would grab his. Every year, I wanted to be a part of it. I wanted to be the first girl in my family to play guitar. One year, I learned a song with my dad, and we played it at the reunion. No one knew I could sing or play guitar. They were amazed, and I thought, 'Yeah, I'm not going to stop doing this.'"

After high school, Pete and Taylor both attended the University of Wisconsin–Eau Claire. One Friday night, while Taylor was out with her girlfriends and Pete was out with his guy friends, they ended up meeting at the same campus bar. Pete saw her walk by and tried to get her attention, but Taylor initially thought he was rude because he was acting like a drunk. Later in the night, she left her friends and went up to him. That night they

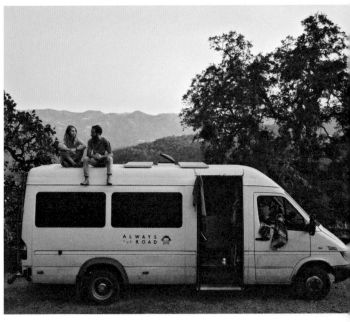

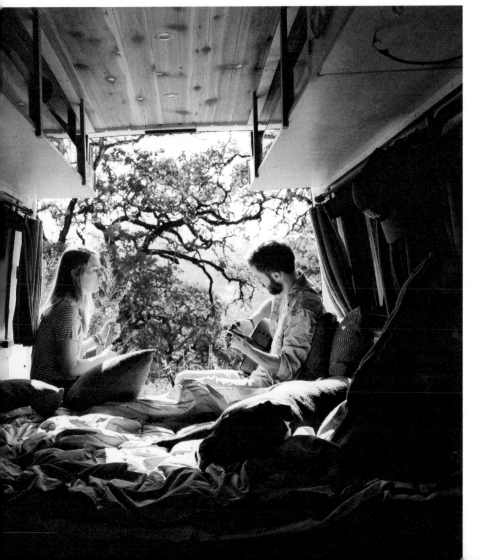

PETE AND TAYLOR'S GO-TO ITEMS

Guitar and ukulele: "Music is a passion of ours, and we would go crazy without them."

Road atlas: "We try to travel old school and use an atlas instead of a GPS. It's so much more fun to figure out the best route ourselves rather than listening to a device."

Baby wipes: "Sometimes you don't have the luxury of showering every day, or every three days for that matter. A hobo shower is better than no shower."

Towels: "We don't have waterproof floors, and our dog, Snoop's, water bowl seems to be a magnet for Pete's feet."

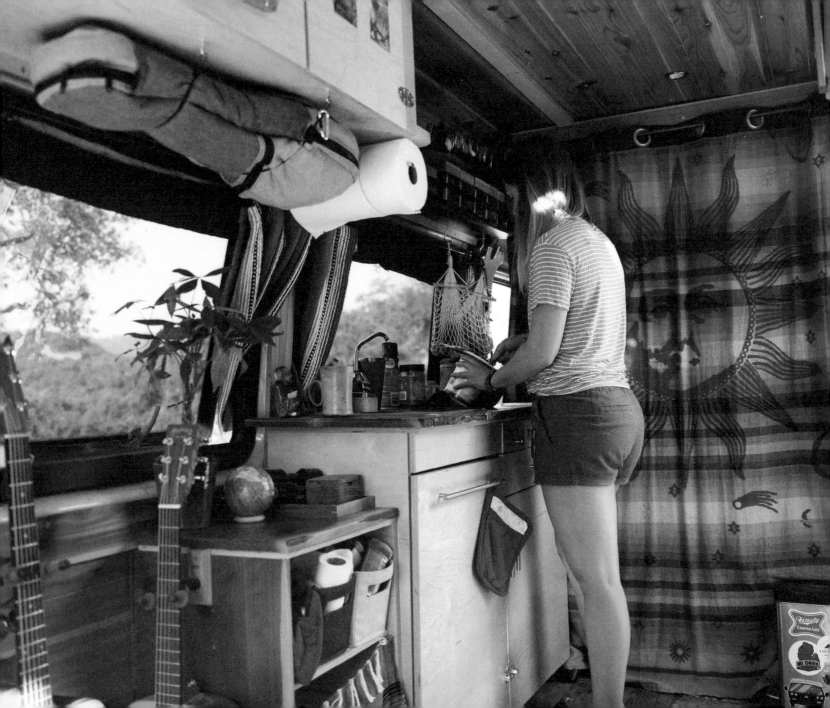

bonded over tequila shots and their shared love of '90s music. They continued to talk after that first night, and it wasn't long before they were dating.

But even though they were both musicians and enjoyed the same music, singing together wasn't something that came naturally. Pete would regularly play guitar for Taylor, confirming immediately why she was so into him from the time they first met.

"Pete was really great because he didn't pressure me," Taylor says. "He played in front of me the first day we hung out. I would always get so nervous thinking about playing in front of him. What would happen if I messed up? That stupid fear kept me from doing it."

After a few months and some alcohol courage, Taylor mustered up the strength to share her voice with him. While Pete and a group of friends were playing music around a campfire, she waited until Pete walked away to finally sing. When Pete came back, he was amazed to hear that she was hiding such an incredible voice. After

that night they made a pact that she would never stop sharing her voice.

Back then, their lyrics, scribbled in journals, would consist of their daydreams about traveling the world. Instead of waiting for graduation, they decided to skip class for nine months and head to Southeast Asia.

Before going, Pete had serious intestinal issues that almost postponed and could have canceled their trip entirely. After several doctors' visits, he received a fecal microbial transplant, which initially worked magic. With Pete feeling back to normal, they decided to keep their travel plans.

With just their backpacks, they explored Cambodia, Indonesia, and Thailand. They spent every day together, and when they needed some time to pursue their solo interests, Pete would surf and Taylor would devour a novel on white sand beaches. It was during that trip that they became intrigued with the nomadic lifestyle, meeting several people living out their backpacks, boats,

Pete and Taylor's van build took five months to complete, and throughout the process they documented each step in detail. They offer a van conversion ebook through their website (www.alwaystheroad. com) to help others with their van builds.

113

After Taylor and Pete left Dodgeville, Wisconsin, in the first week of December 2016 to begin their vanlife, they learned quickly how to adjust their setup for a life on the road. They were 30 minutes into the drive when they hit some exceptionally windy country roads. The first lesson they learned was magnets weren't strong enough to keep drawers and cabinets closed, and they eventually switched to painter's tape. They also learned to use push pins to keep their favorite letters and photos attached to their back van window.

and a variety of vehicles. They began to wonder if they could do something similar in the states.

Taylor cut the trip short for family reasons, and in the course of a single plane ride, they went from barely escaping each other to living on opposite sides of the world. They were apart for five months, and the distance took a toll on their communication.

When they reunited, they were determined not to be apart that long again. They wanted to continue to travel together and share their music with more people.

But after returning from their international trip, Pete was in serious pain. He was using the bathroom around thirty times a day and eventually, he ended up in the emergency room. The doctors determined that he had Crohn's disease, causing inflammation in his digestive tract.

He was put on steroids at first. When those didn't work, he began receiving Remicade infusions, a dose of medication given through an IV every eight weeks.

These infusions required them to be near Pete's hometown in Madison, Wisconsin.

They had always talked about traveling after graduation, which was just a few months away, but they realized they would have to stay in one location so that Pete could get the medical care he needed.

Pete was starting to feel guilty about his health and didn't want it to hold Taylor and him back from exploring new places. Determined not to let Pete's condition interfere with their plans, they decided that after graduation, they would move into Pete's family's house in southwest Wisconsin to save money while they looked for a van. It would also enable Pete to be close to where he could receive regular treatment.

They began looking into Sprinter vans because their higher roofs would allow them to stand up as well as provide extra room to house all their musical instruments. They narrowed their search for rigs made between 2004 and 2007, before stricter diesel

regulations were enacted. They searched Craigslist ads every day for nearly two months before Taylor spotted their current van.

"It was the first van we decided to see, and it was priced modestly," Taylor says. "It was rough on the inside. The vents were torn out. It was used as a construction van, and it was dusty. But there weren't any mechanical issues, and it seemed perfect. The guy who was selling it said he had a lot of calls and people were coming to see it. As soon as we told him our plans, he was interested, and we drove to the bank and took out cash."

For the next five months, Pete and Taylor worked full time at Pete's family's business. After they got off work, they would start their second job—converting their van. To get through the long days, they blared music, sang, and danced, while tearing the vinyl off the sides of the van, and staining and sanding custom wood pieces.

They built the van to reflect the houses they both grew up in—Midwestern log cabins tucked in the valleys of Wisconsin's rolling hills. With that inspiration,

115

Every dog owner thinks they have the greatest dog in the world, but if every dog owner could meet Snoop, they might change their mind. Snoop is the chillest, most loving and loyal dog to his owners Taylor and Pete. He needs to be on their laps at all times, even when they're driving, and he weighs almost 90 pounds.

they designed timeless pieces: a walnut and plywood kitchen unit equipped with a stainless steel sink and a hand-pump faucet; cupboards for water jugs, food, and cooking supplies; and a pullout maple cutting board to extend their kitchen space. They also designed and built a unique bed and bench system that allows them to turn their king-sized bed into benches that comfortably seat eight—perfect for jam sessions. Despite the constraints of designing an entire home in such a small space, they designated an entire corner near their kitchen as their music nook, with space for their two guitars, a ukulele, a harmonica, a foot tambourine, and even a cow bell.

When their van was finished, they had enough money to live comfortably on the road for a few months, but they couldn't help but think about their limitations. Every eight weeks, Pete would have to return to Madison to receive treatment. This would mean that no matter where they were in their travels, they would have to drive back.

But instead of letting the fear paralyze them, they harnessed the feeling and used it as motivation. They hit the road in winter and drove fast from Wisconsin, through Iowa, Kansas, Oklahoma, Texas, and New Mexico, until they settled down for a few days in Arizona. After that, they headed to San Diego, seeking warm weather and beaches where Pete could go surfing.

They didn't have a typical routine, but they did incorporate their music into every day of their travels. In fact, they sang about their lack of routine, the ups and downs of living on the road, or what it feels like to leave friends and family behind for several months at a time.

Though the van was their full-time home, it's their music that provides the comfort they need in uncomfortable situations. They can sing themselves through a breakdown, a fight or bad weather, and Pete's illness. With or without the van, you will find Pete and Taylor making music as a way to preserve memories from their travels and heal wounds from internal battles.

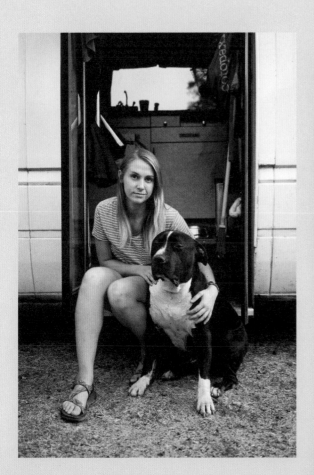
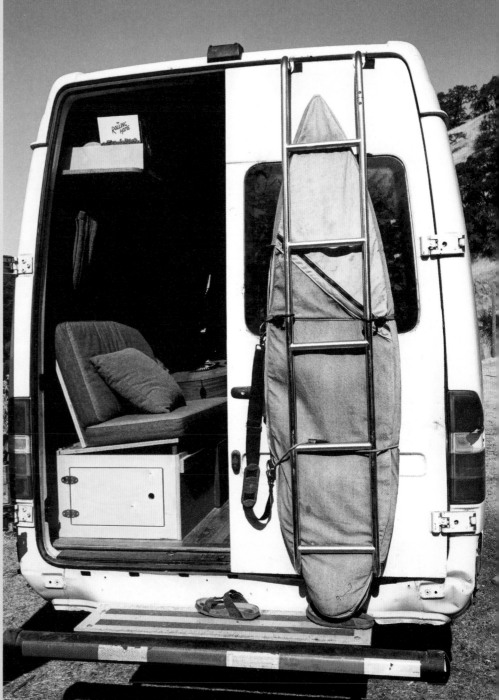

In the absence of everyday distractions, vanlife brings people closer to their inner creator and maker.

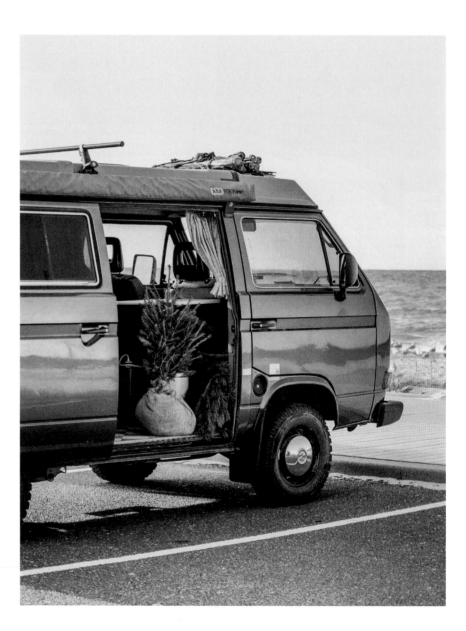

From van plants to colorful decor, mobile homes have become a space for self-expression and creative space-saving solutions. With a limited amount of space, every item chosen has a reason to be there, whether practical or emotional.

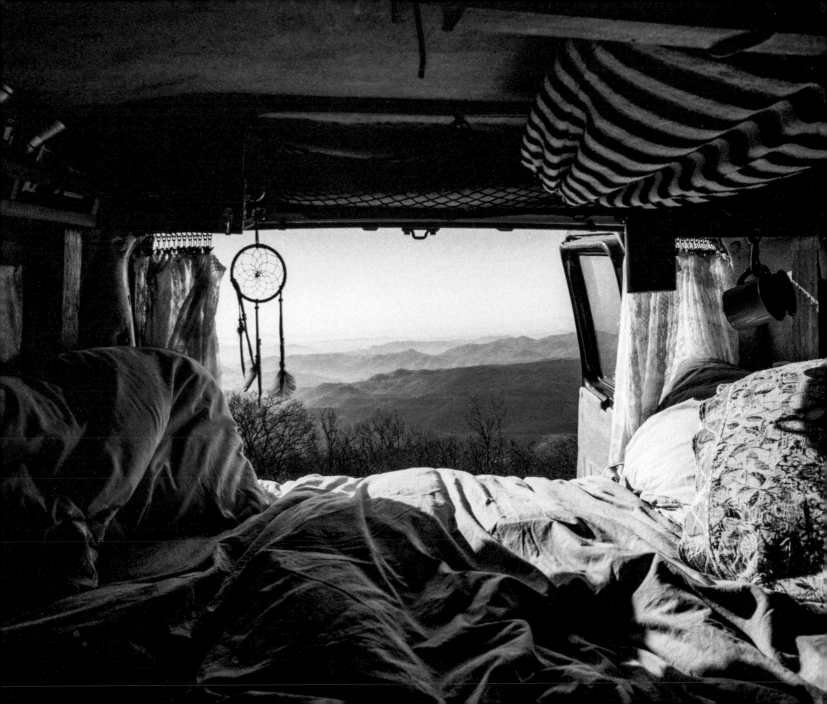

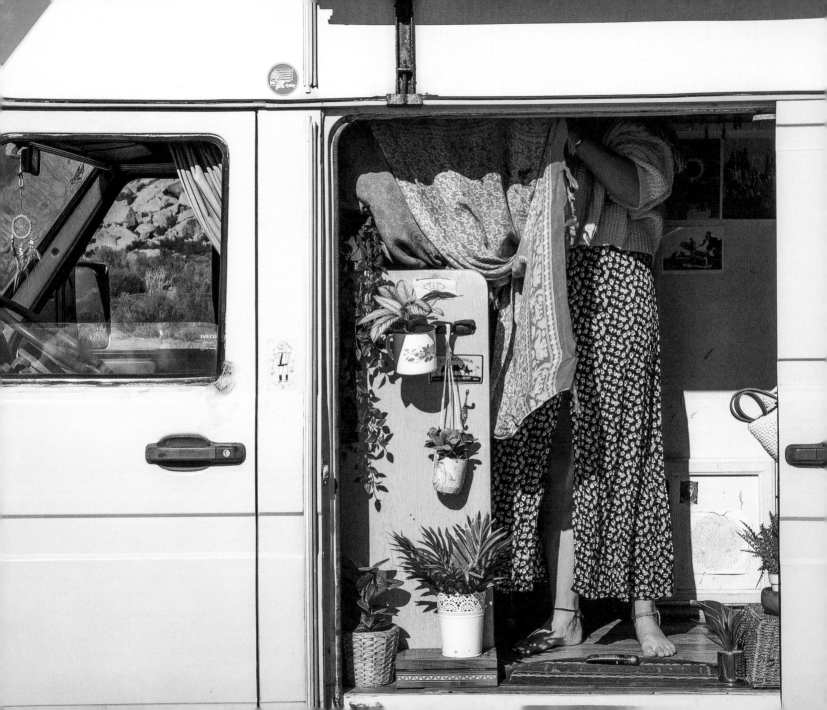

Artists find inspiration everywhere they go, and the same goes for vanlife creatives. But they need to carry all their tools for expression in a limited space. Kit Whistler and J. R. Switchgrass collect items (near left) from antique shops, vintage stores, and locals on their travels. They own countless outfits, and all of them fit in a compartment under the back seat in two suitcases. Most of the items they own have been worn dozens of times, including a dress that's 10 years old.

Following spread: (Left) Tess Ely and Dillon Vought make music in Peru. (Right) A camel blocks traffic in Morroco.

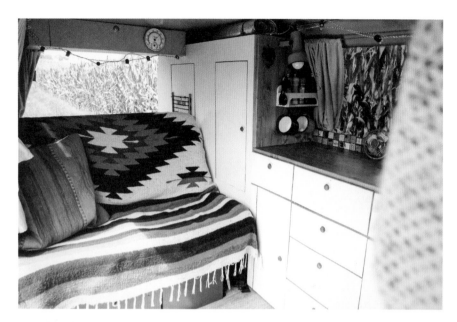

124

Left: The interior of Frank Stoll and Selina Mei's VW van named Rudi. Frank and Selina are German vanlifers and videographers who travel part-time. Rudi's interior sports custom cabinetry that holds everything they need for their getaways, and a multiuse countertop that can be a work surface or a kitchen.

Right: For some people, creative expression can be about what you take in, not just what you put out, and their homes are customized accordingly. Travis Wild built two shelves above the bed in his van to hold a library of more than 120 books, including classics by Ansel Adams and Ralph Waldo Emerson. So far, he's read about 95 of them. On the wall behind his passenger seat, he has a projector so he can host guests to watch movies while he's on the road.

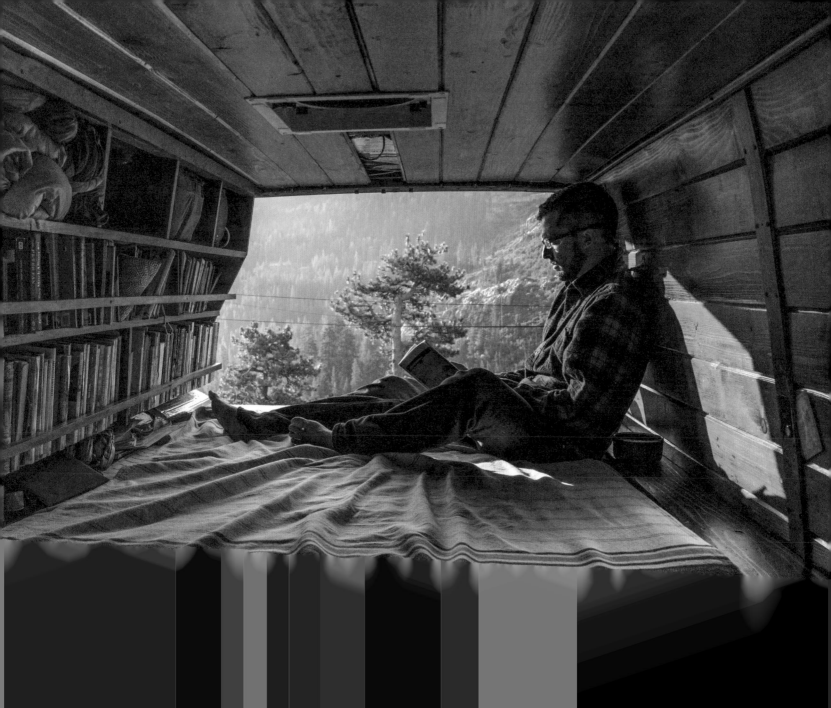

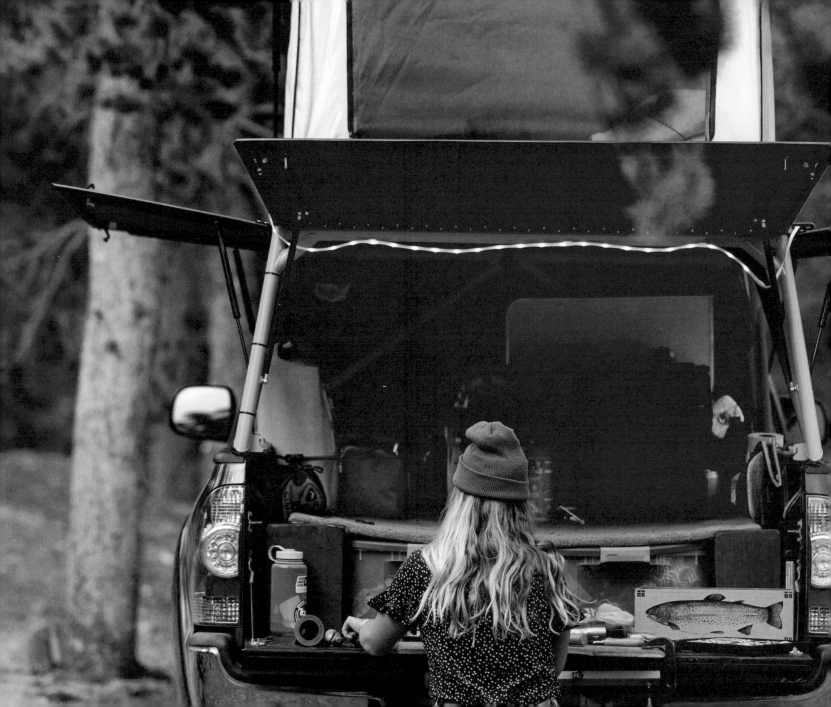

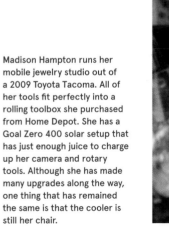

Madison Hampton runs her mobile jewelry studio out of a 2009 Toyota Tacoma. All of her tools fit perfectly into a rolling toolbox she purchased from Home Depot. She has a Goal Zero 400 solar setup that has just enough juice to charge up her camera and rotary tools. Although she has made many upgrades along the way, one thing that has remained the same is that the cooler is still her chair.

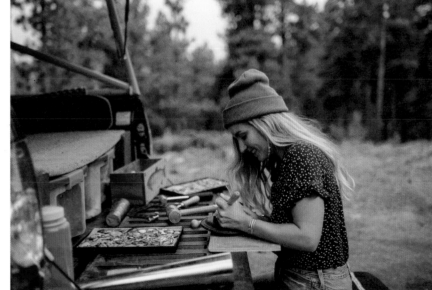

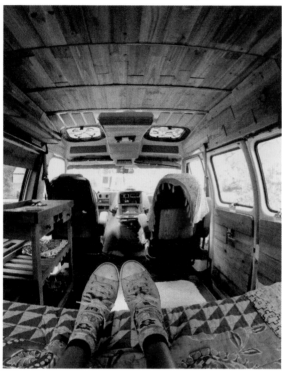

Adding cozy details like wood paneling to a van can make it feel more homey and expresses the vision of both builder and inhabitant. These flourishes are becoming more common as carpenters have been sourcing materials that are local to their workshops. Not to mention: cedar paneling smells amazing and reacts well to humidity—and you can source your building materials as you travel!

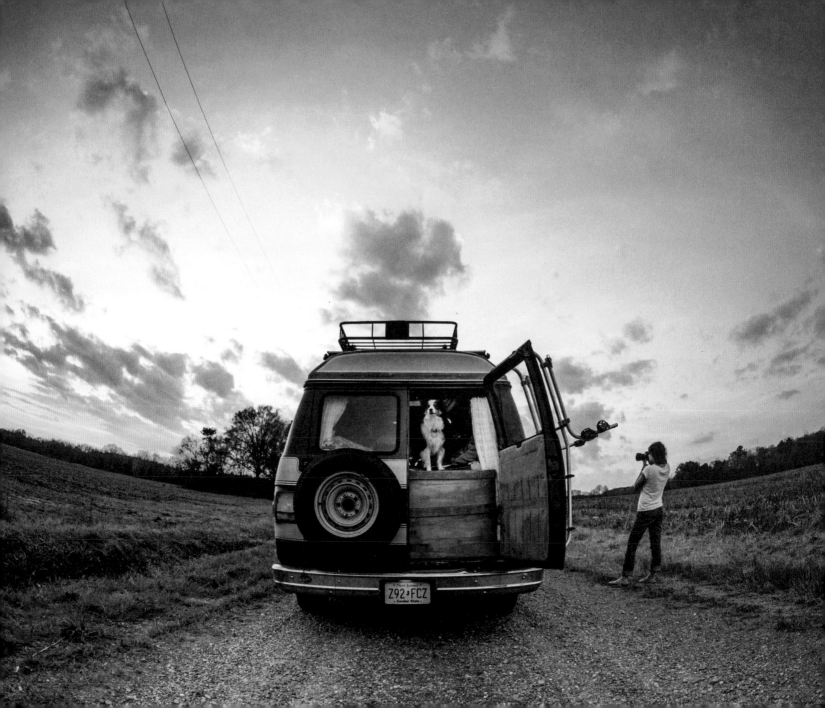

This tin can homestead belongs
to Kyle Murphy and Jodie Morse,
and their German shepherd,
Kashia. Kyle and Jodie are travel
photographers who live out of
this 1955 Airstream Flying Cloud.
They say they're from every-
where now, since their photog-
raphy careers have taken them
to places all over the world.

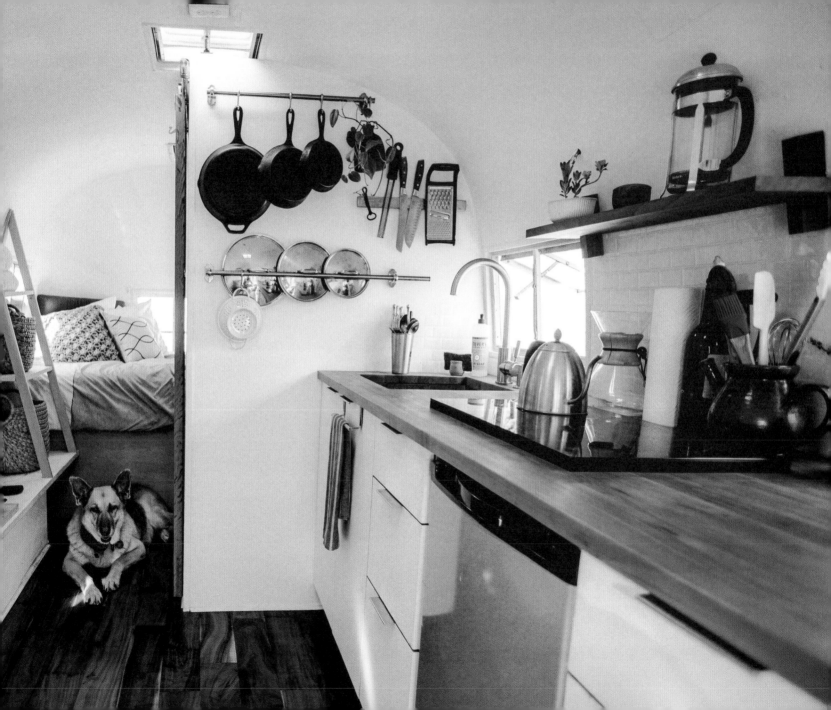

VANLIFE GUIDE TO COOKING IN SMALL SPACES

Cooking in a tiny space doesn't have to be much different from preparing a meal in an apartment. Fewer items may fit in your cooler, but, if you have the right tools, you should be able to create a similar experience. I don't consider myself a pro at cooking, but I have modeled some of what I prepare after meeting other vanlifers who are whipping up some amazing meals. It helps when you're able to stock your kitchen with long-lasting cookware that can be used for a variety of purposes. And it's good to have ingredients that can be used in more than one dish and can stay fresh in different weather conditions. A good solar and power station setup could give you the luxury of a fridge, so you don't have to worry about food going bad.

Reusable Cups & Utensils

I don't know what I would do without my insulated coffee mug and water bottle, as well as my bamboo travel utensils. For the longest time, I was using a regular coffee mug and a Nalgene bottle for water, but I was finding that they weren't keeping the temperature of my liquids consistent. Now I make coffee in the mornings, pour it into an insulated mug, and can sip it—still hot!—for hours on end. I can also toss it around in the van without it spilling because it has a locking flip lid. I keep a separate insulated mug for my drinking water, which keeps it cool on hot summer days. For the longest time, I was using plastic sporks or cutlery sets that would break on impact. Now I've switched over to bamboo silverware and cooking utensils.

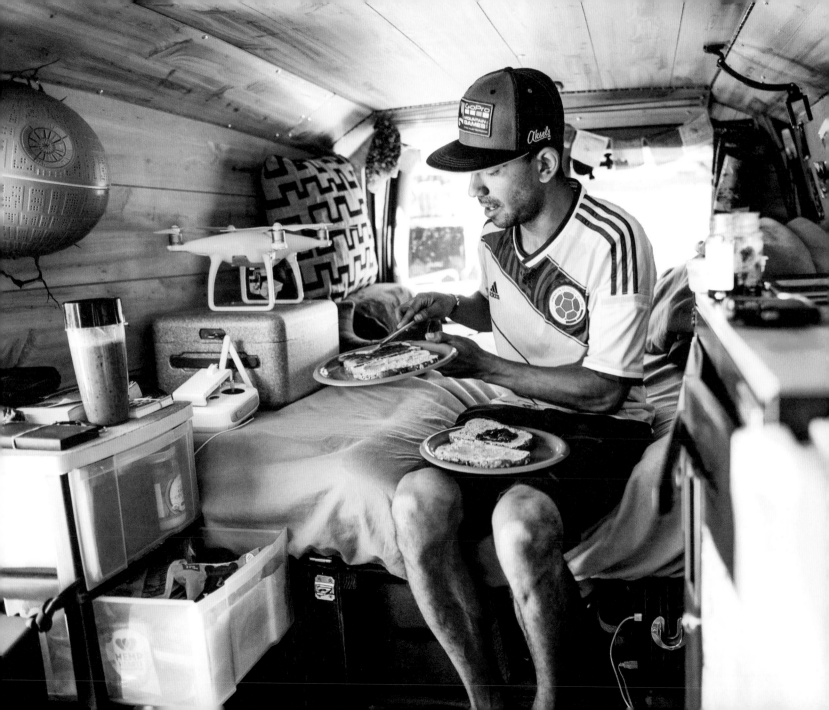

They are just as lightweight and more durable, and you don't have to worry about harmful chemicals. Some of the sets I've seen come in a little pouch, which makes it easy to bring them into restaurants. I also find that food tastes better with organic utensils (the bamboo is not as hard to bite down on, and it's stronger for cutting food).

Stock Up on Seasonings and Spices

As someone whose seasonings had been primarily salt and pepper, I didn't learn what I was missing out on until I received proper training. It took me two weeks with Emily and Corey of @wheresmyofficenow to expand my limited repertoire. They were whipping up quinoa bowls and curries and making desserts from scratch. I kept asking Emily, "What spice are you using? What dish should I use that in?" I made a list promptly after traveling with them, and now I've honed in on what spices I should carry in my van: cinnamon, turmeric, chili pepper, oregano, cardamom, cocoa powder, and cumin powder. What's important is that some of these everyday spices, when combined in a particular way, can help keep you healthy and prevent hospital visits. Turmeric contains the chemical curcumin that has beneficial anti-inflammatory effects. When black pepper is added to turmeric, it increases the absorption of curcumin. And when coconut oil is added, you

get a powerful trio. Curcumin is fat soluble, so by adding turmeric and black pepper to coconut oil, you are helping your digestion system. And when you're in a van and limited in what you can have in your kitchen, seasonings don't take up much room and can make an otherwise bland meal quite tasty. It takes a bit of practice and finding recipes you like, but after a while, you'll be the one making meals out of your van and impressing your friends.

Seeds & Nuts Make Tasty Snacks

Just as with seasonings and spices, there's no such thing as having too much dry food around when you live in a van. Or maybe there is, but I always seem to find a purpose for some of my go-to essentials such as nuts and seeds. The number-one reason to carry dry food in your van is that you don't have to worry about it spoiling quickly in extreme temperatures. My favorites include sunflower seeds, pumpkin seeds, sesame seeds, almonds, and cashews. These can be tasty treats when added to a bowl of yogurt in the mornings or sprinkled on salads. I put them in Mason jars so they don't spill and stay fresh. When I don't want to open my back door to make something on my cooking stove, I'll grab a handful of my dry goods, mix them together with some peanut butter and honey, and I've got a quick snack that's nutrient dense

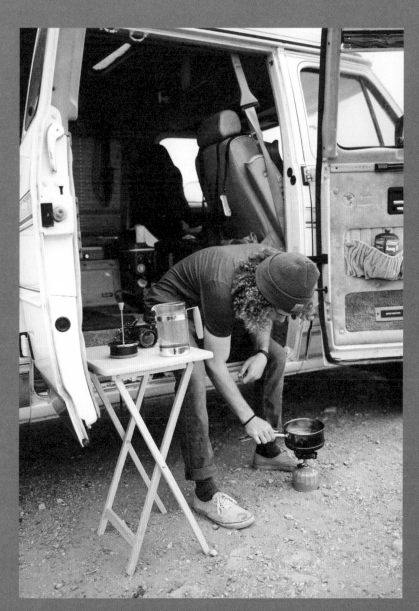

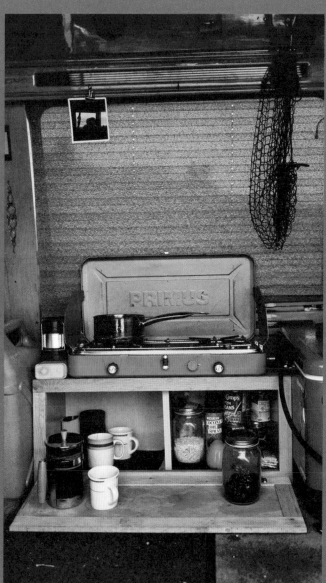

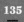

and flavorful. When you want to hit the backpacking trail, you can mix some of these items together in a small traveling container, and you've got trail mix on the go. The best part about these seeds and nuts? Your friends will thank you profusely when they hop in your van and ask if you have anything to snack on. No one has said "No" to my sunflower seeds yet.

Fridges Save Food & Money

I have done a lot of traveling using just a cooler and bagged ice, but now that I enjoy the simple luxury of a fridge in my van, I will never go back. Before, it was always a game to make sure food stayed cold until I was able to eat it. And it wasn't fun to have to make an extra stop at a gas station or grocery store for ice, knowing I had to pay whatever they were charging for it. Not to mention, after the ice melts in your cooler, your food sits in a pool of water and everything tastes soggy. This might be bearable on a camping trip, but for everyday vanlife, I would recommend investing in a fridge, especially if you're able to install a solar setup with a power station. While you're able to run fridges through engine batteries and generators, solar-powered fridges give you the convenience of staying off the grid for longer. Now, as long as I gain a little bit of solar input each day, I'm able to run my fridge

continuously. It's an amazing feeling to be parked on a beach with a cold drink in your hand. It's not such a great feeling to be sitting on a beach with the sun beating down and reaching in your cooler to find a warm beer.

Cast-Iron Pans & Dutch Ovens

One couple who always comes to mind when I think about making tasty meals outdoors or out of a vehicle is Megan and Michael of @freshoffthegrid, who cook out of their Ford hatchback. They are always sharing recipes that work with few ingredients, and they swear by their Dutch oven, one of their most versatile pieces of cooking equipment. It is hard to think of a meal that can't be cooked in a Dutch oven. It can steam rice, cook stew, and bake bread. I use my cast-iron skillet for everything else. Both of these cast-iron pans can be used on a camp stove, over the campfire, or on a grill, which is nice when the propane runs low. Everything seems to taste better when cooked in these pans, and they are very durable and easy to clean, which is all right in my book.

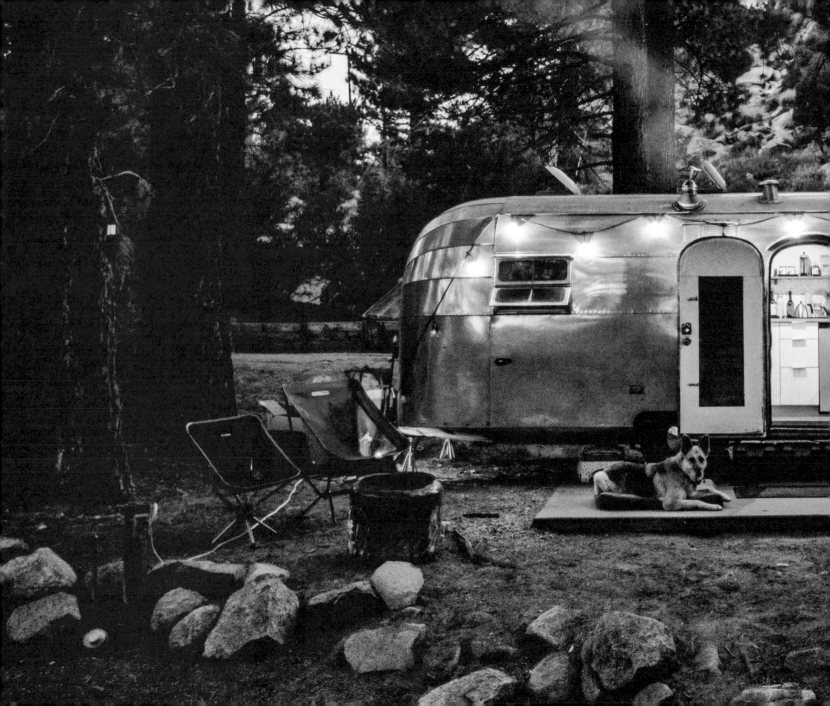

The appeal of having a mobile home you tow is that you can leave it in a campground, a remote spot, or several miles away while you explore an in another vehicle. Travelers who like going down backcountry roads are investing in towable homes so their daytime adventures aren't limited by where their vehicle can go.

The rig you own might determine in what seasons you travel or where you call home. Vanlife in the winter can be a struggle as most vehicles aren't insulted well enough to handle cold temperatures. On the other hand, when vehicles are well insulated, condensation or ice can become problem areas for mold. Investing in a propane heater and keeping a window cracked is a solution to staying warm while avoiding a moisture buildup on the walls.

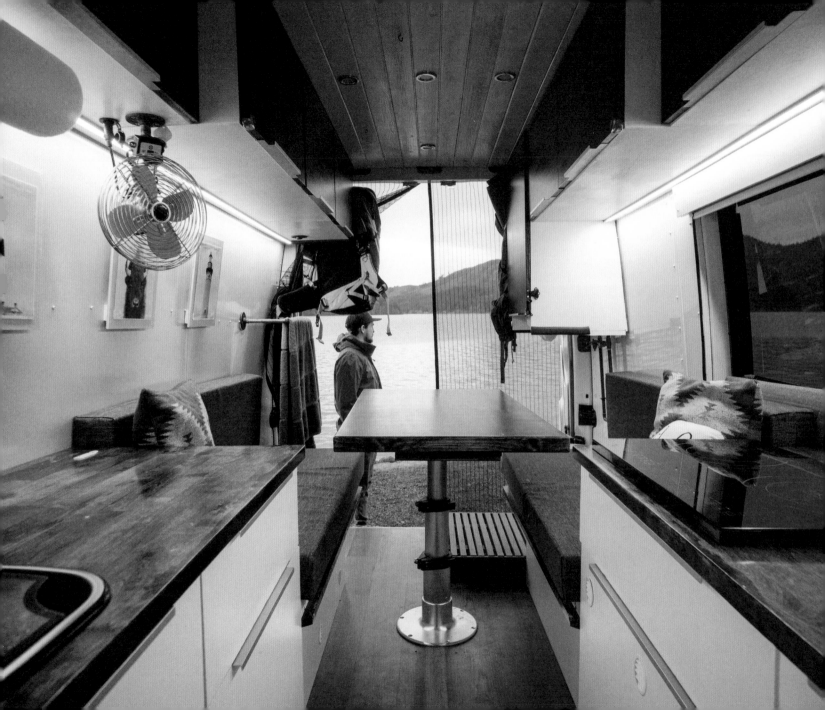

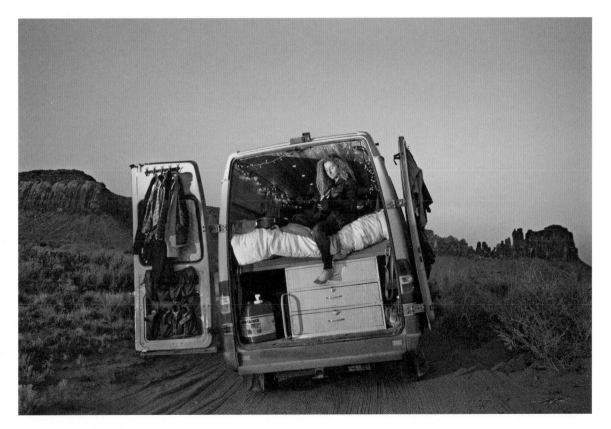

Solo traveling has been a vehicle for many for self-discovery and exploration. When you strip away the familiar comforts of a house and are left with only the bare minimums, you have a cleaner lens to examine your life and what's in front of it. Many solo travelers have gone through a big life change that prompted vanlife, such as a breakup, death, or loss of job.

Left: Jane Salee is the creator of Rock Meets Soil, a community-based blog and gallery sharing stories and artwork to broaden the circle of inspiration in the world. Based out of Colorado, she has been moving and traveling since she was 17, when she went to Spain as an exchange student. She has been full-time van living since November 2015, and has bought, sold, rented, or lived in four different vans.

Right: With the rise of people living on the road, van builders have been opening shops across the United States. These craftsman specialize in converting vans into beautiful, liveable spaces that reflect the personality of their owners, just as brick-and-mortar homes do. Pictured here is a van by builder Aaron Haack of Run Away Van.

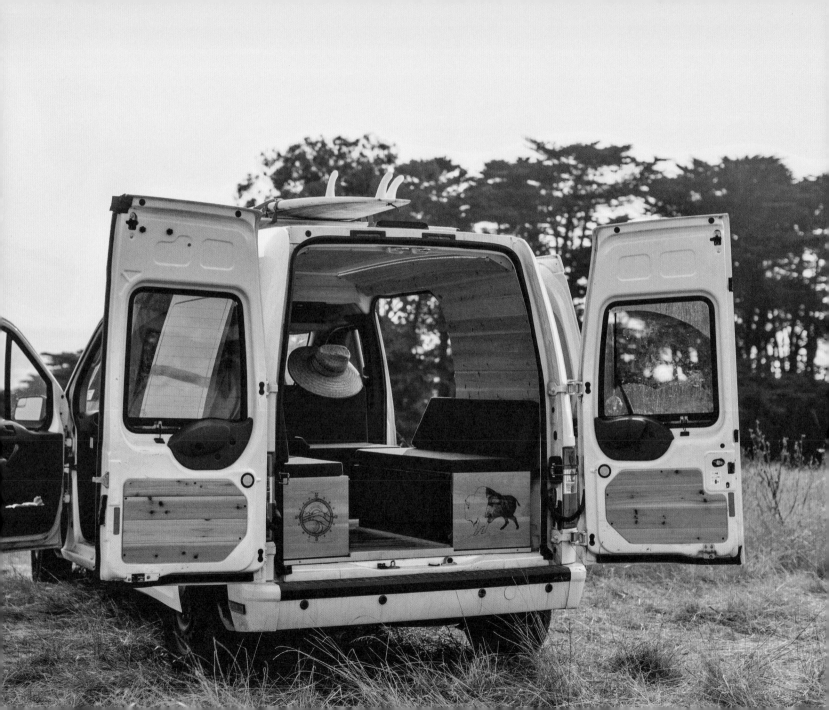

Finding a balance of work and play can be difficult on the road. Most vanlifers work remotely, allowing them to travel and play outdoors with a flexible schedule. Others mix work and play, creating businesses from their passions and selling products to people they meet along the way.

For these folks, a van is not always just a home. It might also be a coffee shop, a clothing store, an apothecary business, a photo booth, or a hair salon. And there's something unique about purchasing goods or services from a vintage van or a tiny storefront. There's a story behind what you purchase and how it got there, and you know you are supporting the smallest of small businesses

for Work

Frank & Tyler *in a* 2004 Chevy Van

@twoguysgoodbuys

Frank and Tyler feel as if they've struck gold. And not in the form of money but in doubling their van as both a home and a mobile business.

For two years, Frank and Tyler have been running their shop, Two Guys Good Buys, out of 80 square feet. Together, they sell vintage clothes they find from thrifting. It's an art form, and one they've perfected over time that requires them to go hunting for hidden treasures.

Frank and Tyler didn't realize they were into this kind of hobby right away. Growing up in Buffalo, New York, they attended the same kindergarten and were elementary school friends. In middle school, Frank moved to Florida for two years, but he moved back to Buffalo in tenth grade and ended up going to the same high school he would have attended had he stayed.

Four days after moving back, Frank injured his leg skateboarding and had to be on crutches. The whole ordeal rekindled their friendship.

"I remember one day, while I was getting dressed in gym class, all of the sudden I look over and there's Frank with a broken leg," Tyler says laughing. "He transferred to my high school, and he had a broken leg already."

In their after-school hangouts, Tyler would show Frank some items he had purchased at the local thrift store. They were both interested in fashion, and without a large income, they could afford to spend only a couple of dollars at the thrift store. It was a fun game, and they started to stock up an inventory that they stored in Tyler's mom's attic.

As a side business, Frank and Tyler would sell items from their inventory online on an Etsy shop. One of the earliest pieces they remember featuring was a Woolrich Mackinaw jacket from the 1930s.

"It's neat because they haven't changed. It's the same design you'd buy today, yet it's a different fabric. But it's essentially the same jacket," Tyler says.

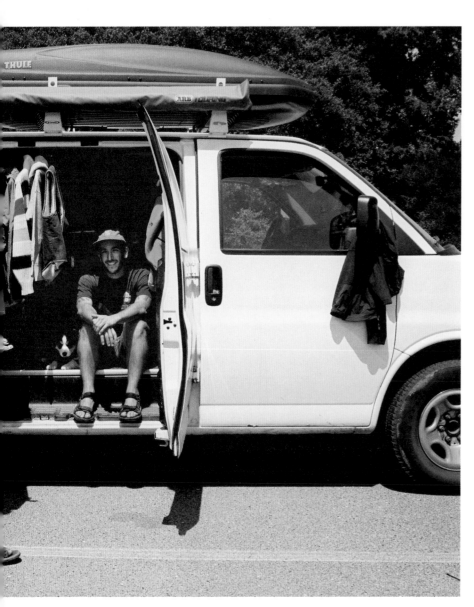

FRANK AND TYLER'S GO-TO ITEMS

Wool shirts: "They last forever, are cozy, and don't retain body odors! If you have quality wool, it isn't even itchy. With a Pendleton shirt, for example, it's virgin wool, so it's soft and comfortable. It doesn't smell."

French press or pour-over cone for coffee: "We just had a couple cups this morning. For a long time, we used a JetBoil stove because it had a built-in French press that was pretty convenient. We've moved onto the Snow Peak Titanium French Press now as it's easier to use separately.

Peanut butter: "It's a sweet snack, but healthy! Tyler got me into snacking out of the jar, and now I'm proud of it. The things that we picked up from one another are funny. We were really close friends before the van, but we've become that much closer—you end up passing things on as simple as a jar of peanut butter."

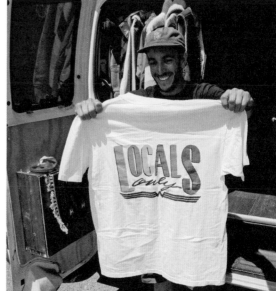

They would sell a few items here and there and continued to do so while working full-time jobs. Tyler worked as a bank analyst, and to keep his fashion fix going, he interned at a street wear company.

"I would wear a nautical jacket when I was interning," Tyler says. "I didn't have too much money, and the guys at the shop would comment and say, 'Where did you get that?' That jacket was a conversation piece. It was reassuring early on, and I had more confidence . . . that I could pick things out that other people are interested in."

After trying a few years of college, Frank wanted to do things differently. He dropped out and jumped into full-time maintenance work for a company that owned apartment complexes all over Buffalo. With the money he saved, he purchased a house when he was 22 years old, just a couple years out of high school.

While the two worked their full-time jobs, they also managed the shop. In those early days, they were

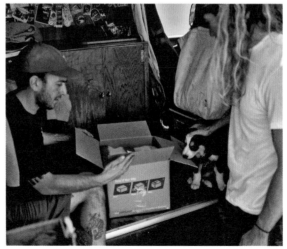

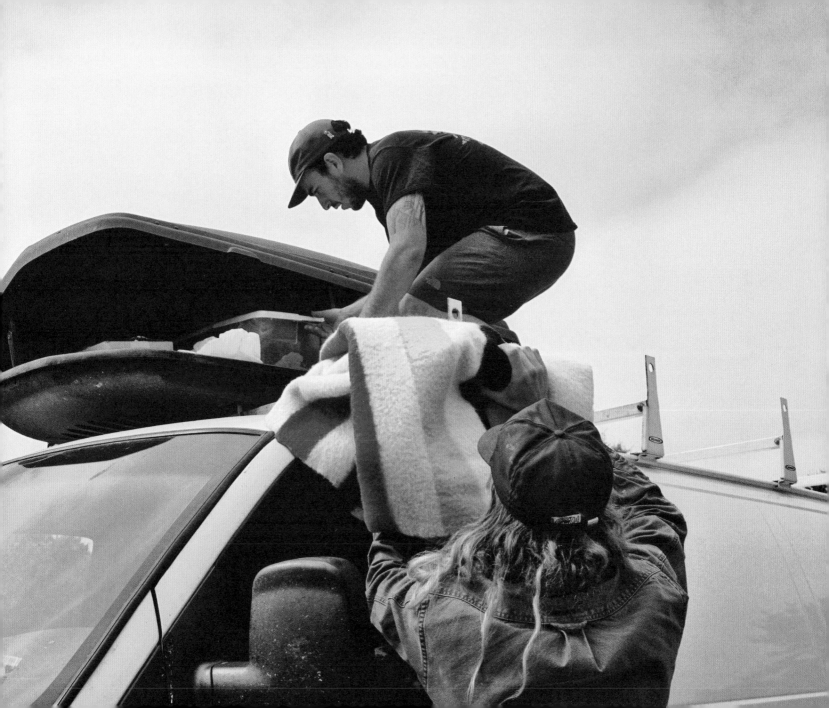

running their business with no intention of traveling full time. They got their fix from weekend camping trips and enjoyed backpacking in the Adirondack Mountains, about six hours from Buffalo.

"We really got into doing that," Frank says. "It came to this point where we both said, 'I want to do this every day.'" But with day jobs, they were limited to pursuing their travels on the weekends.

"One day, it clicked," Frank says. "The thrifting scene we were in wasn't all that saturated. I thought, 'If we can do this while having regular jobs, maybe one day we can do it outside of Buffalo.'"

Expanding their business beyond weekend trips would require a vehicle where they could both sleep as well as store all their clothing items. After doing some research, they determined that they needed a Chevy extended cargo van. Their number-one requirement was that the van be reliable, as they weren't mechanics, and if they stuck to a newer model, maybe they could avoid potential breakdowns.

It took eight months before they found their shop on wheels. Through a friend who attended regular car auctions, they received a call that a van that fit their criteria was available, and it was in their price range. It was a 2004 Chevy Express cargo van, and both Frank and Tyler remember stopping working to check their phone messages and view photos. They called each other and quickly told their friend to pull the trigger, even though it was a gamble to buy something sight unseen.

With only 88,000 miles on the odometer, they felt their Chevy was road ready. But what it didn't have was an interior built out for them to live in as well as a functional shop space.

These days, in carefully organized bins stored in the cargo box on the roof of their van, they pack no more than a hundred items of clothing, carefully hand selected from thrift stores, yard sales, flea markets, friends, and back alleys. Since vanlife means packing light and they can take only what fits, their collection is meticulously curated.

Frank and Tyler's interests are deeply rooted in the heritage items they collect and sell. They prize vintage pieces from brands like Pendleton, Woolrich, and Levi's because they see them as having shaped future fashion trends. There's an outdoorsy feel to everything in their collection.

"It goes along with everything we're about, traveling and outdoor brands we love," says Tyler. "We spend a lot of time outdoors and know what works regarding clothing and gear. It's part of who we are and our story."

And don't get them started on their wool collection. Items such as the steadfast Mackinaw jacket or the classic lumberjack shirt are sought after in the thrifting industry and timeless classics. Frank and Tyler look for ones from the 1930s and 1940s because they have the highest quality.

Frank and Tyler's passions lie in creating a sustainable lifestyle in order to live and travel full time. They hope that they can encourage others to do the same. Because their two passions work interdependently, one propelling the other, it allows them to never overlook the short term and stay true to themselves in the long run.

153

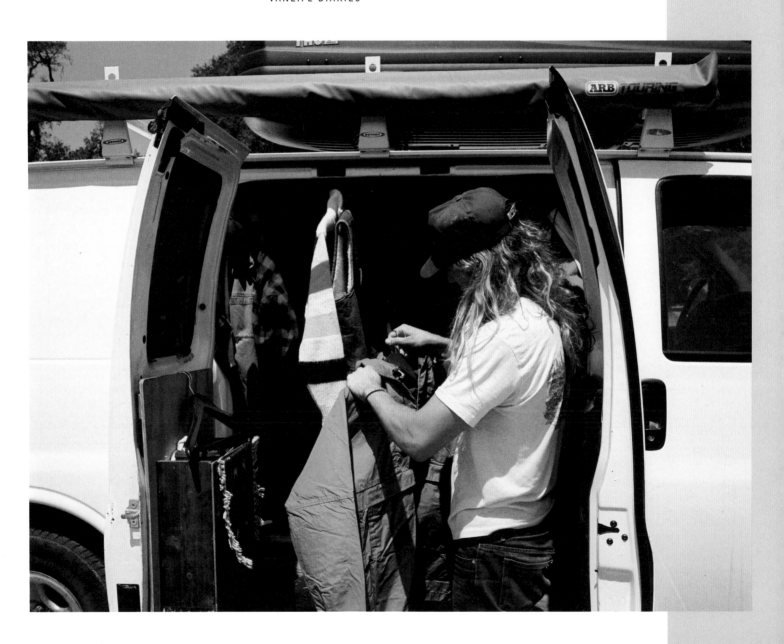

Their most memorable find has been a pair of 1940s Levi's selvage denim jeans from a thrift store in San Francisco—the very place Levi's jeans were created many years ago. And they felt that same thrill when they laid eyes on an original Hudson Bay striped blanket. While these blankets have been replicated and copied throughout the years, the originals have been out of production for quite some time, and finding one is rare.

But all the highs of vintage finds would not be so intense without their tiny shop on wheels. The road takes them to new thrift stores and estate sales and expands their relationships with business owners. Through every person they meet, they are spreading the word and making connections. And each person gives them a taste of inspiration. They play a game of trying to guess what that person may want to buy. It might be a sweater because it's cold outside. Or it could be a scarf because a woman may be looking for one to add to her wardrobe. A conversation may even spark them to run

back to the van to rummage through the bins and find that perfect item, the one that will bring a tiny bit of happiness to that one person's life.

Whatever it is, they know they'll find it someday if they haven't already.

As sales in their online store grow, they receive requests for pop-up shops. And they get asked all the time if they will open up a brick-and-mortar store for their company to expand.

"We plan on traveling for the rest of our lives and growing our business," Frank says. "So far we've been able to do that without a brick and mortar store. We want to continue moving around, but we don't know what the future might hold."

155

Sometimes conversations on the road lead to setting up a shop in a new area. It can also result in new places to see, areas to shop, coordinates to little-known gems, and the best camp spots.

Welcome to these tiny homes that double as mobile shops and studios.

156

Lauren and Alex, the founders of sustainably-focused fashion brand Will and Bear, use two vans: one as their second home and one as their office. The inspiration for their business came during a camping trip in wild Tasmania. They got to thinking about how they could give back to the places they love so much. They now create hats made from 100 percent Australian wool and pledge to plant ten trees for every sale.

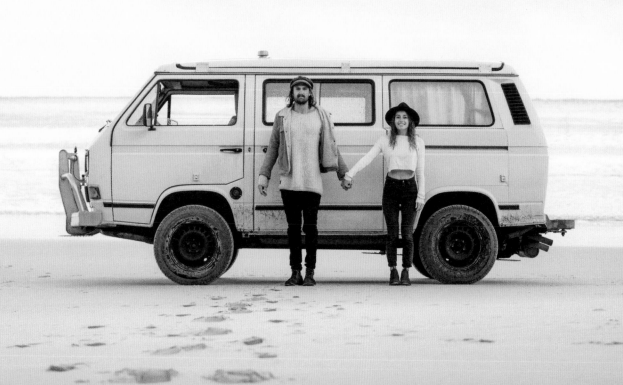

Katch Silva and Ben Sasso chose to live in a Mercedes Sprinter because they wanted to be mobile, but they also wanted to be able to go off-grid. The van also needed to be 100 percent reliable since it would be their transportation to weddings and other photography jobs. The only home bill they have is their cell phone, which is bundled with their Wi-Fi hotspot.

Raphaelle and Mark Pascale chose a rig that could take them deep into the wilderness to harvest the botanicals they use in their apothecary. In their workshop on wheels, they make natural products free of toxic chemicals and inspired by nature's wild beauty. Their shop is called Boreal Folk apothecary, after the subarctic climate of the remote Canadian wilderness where they harvest their materials.

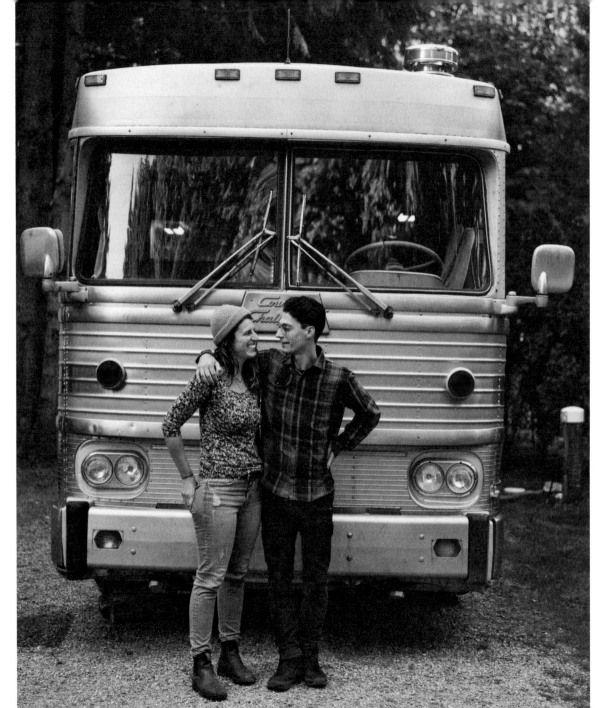

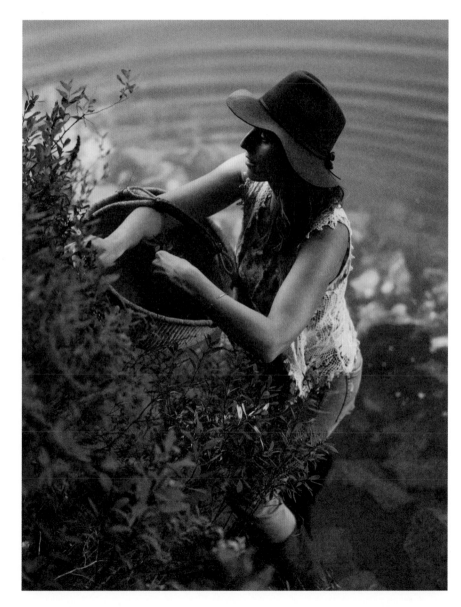

VANLIFE GUIDE TO FINDING WI-FI & WORKING REMOTELY

Even though vanlifers don't pay rent, traveling has its own expenses: food, gas, and sometimes camping, showers, or van improvements. In order to fund the journey, vanlifers are hustling to find work. The internet has opened up many possibilities for working on the road that just weren't available before. Instead of traveling between seasonal jobs or looking for short-term employment at different locations, if you can commit to having cellular or Wi-Fi service, you can work remotely. You can freelance or be an entrepreneur running a business from your computer. Working remotely has an appeal because it means the view from your office is ever changing. This list will help you break down how you can get a good connection even in places where you wouldn't expect it.

Find Free Wi-Fi When You Can

You don't have to visit a coffee shop to get Wi-Fi. If you can find a public library, you can post up while it's open without spending any money. And if you're already working out at a gym or recreation center, you may want to ask if that service is available to members. Bookstores, breweries, and restaurants are also great alternatives if you want a change of scenery while using Wi-Fi, but most of the time they expect you to make a purchase. But all in all, coffee shops are where you're most likely to find vanlifers getting work done while they're passing through cities.

Use a Hotspot

Just recently, I was at a coffee shop trying to get some work done when I discovered that the Wi-Fi was slow and kept cutting out. Instead of packing up and heading elsewhere, I turned on the hotspot on my phone, and

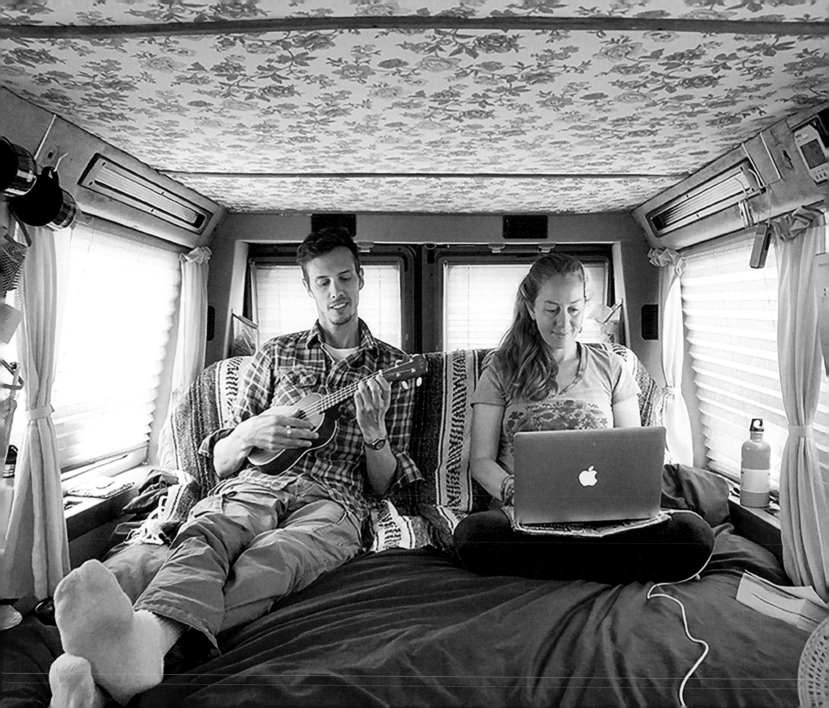

I was able to keep working on my computer. It's a nice feature to have whether you're camped out in the middle of nowhere or you're in a city. Your hotspot will tap into a 3G and/or 4G cellular network and then wirelessly share its data connection with other nearby (within 30 feet or so) Wi-Fi-enabled gadgets. If you think you'll often be in places without Wi-Fi but know you'll need reliable connectivity, you can also invest in a mobile hotspot device. The MiFi device that Theo and Bee of @theindieprojects use, for example, offers unlimited data for $50 a month. The downside of a hotspot? If you don't have an unlimited data plan, you can use up your allocated data pretty quickly and drain your battery life. Make sure to check your data usage and keep a plan that works for long periods of time if you'll need it often for working remotely. Keep your phone charged when using your hotspot for long periods.

Purchase a Signal Booster

A signal booster could be an additional way to capture an internet connection in remote areas. To get it to work, you have to install a roof-mounted antenna, which tries to detect a faint cellular signal, amplifies it, and then broadcasts the stronger signal inside your van. You can purchase a Wi-Fi booster with an extended antenna to receive greater range. Most likely, you'll be the vanlifer in a remote area with a signal while everyone else is out of service. But the downside of this is that you may be the only vanlifer feeling guilty if you don't catch up on work emails.

Get a Little Help from Your Friends

It really helps to have a community network in this lifestyle. Connecting with people on Instagram or at van gatherings can further increase your friends, and it will also put you in touch with more people who are willing to help you out. Parking in driveways is a great way to have a guaranteed spot to sleep, but it might also allow you to use some free Wi-Fi. And the great thing about Wi-Fi is that you can usually get a strong enough signal from just outside the building without having to come inside and bother your friends or post up in their space. Before I lived in a van, I lived in a house, and I offered parking to van people whom I knew only through Instagram. And most of the time, I ended up receiving beer, warm-cooked meals, and often payment. If you can do the same for the people you stay with, they will be grateful and continue to extend the offer each time you're in the area. And sometimes they might even let you into their homes so that you can post up on a couch or office to get some work done

without splurging at coffee shops. Networking with the vanlife community can also put you in contact with job opportunities that fit your skillset.

Look into Seasonal Work

When you're working a nine-to-five job, it may not be practical to leave for a few weeks or months at a time to pursue alternative forms of income. But when you are in vanlife and are looking for money to fund your travels or have a more flexible work schedule, you can say "Yes" to short-term jobs. Working intensely for a few months can give you the freedom to live off that income for an extended period of time after the job has ended. Farm work can be the perfect situation for making money and also having a free place to live on the property. Some other seasonal jobs to consider are national park rangers, summer camp counselors, outdoor guides, or festival photographers.

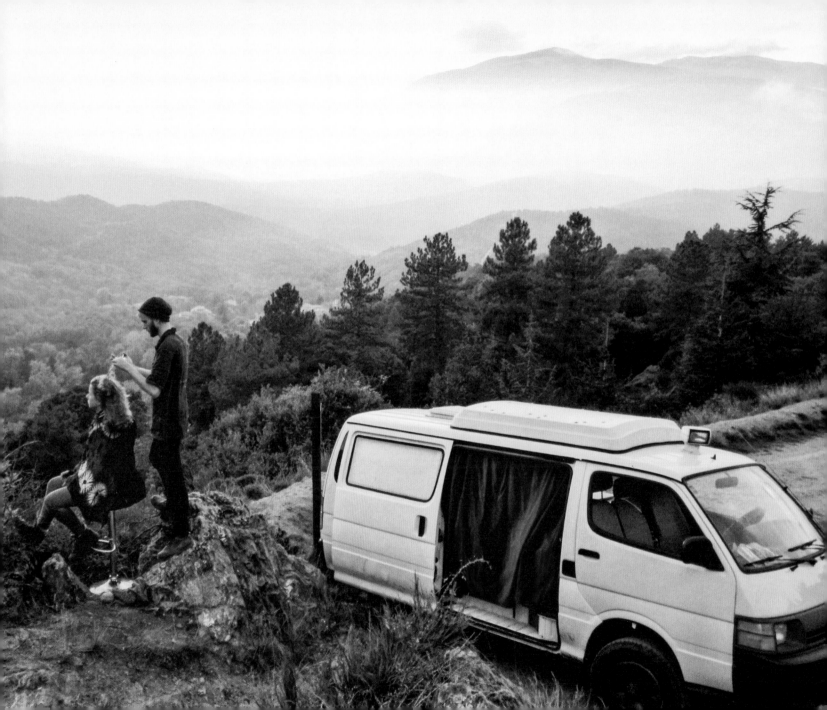

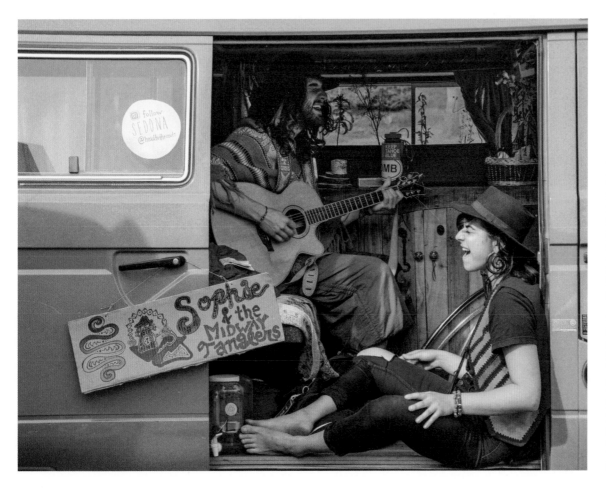

Far left: Matthew Jansen has been cutting hair out of his 1995 Toyota Hiace 4x4 for three years. The environment where Matthew works is important, and he likes to feel comfortable. The best spot for him is in front of his van. So far, he's styled and cut hair on mountain tops, in the snow, at student houses, farms, music venues, campsites, and hostels.

Left: Anthony Siciliano and his friend Sophie Brande sing one of Anthony's original songs from his band, Sophie & The Midway Tanglers, a name sparked from a trip up in the mountains. Traveling decompresses time in a way that allows Anthony to feel relaxed when he plays and writes. In this particular song, they sing about vanlife, "The road is fast, but my bus is slow."

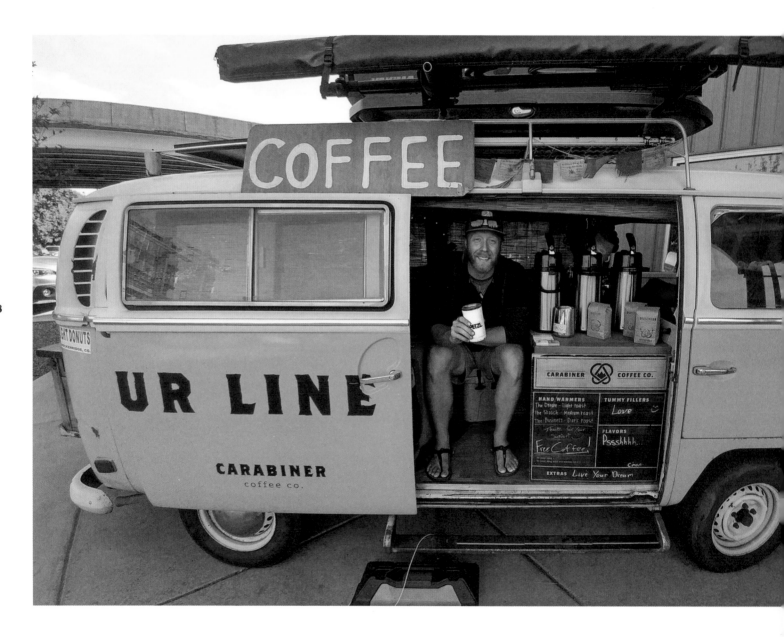

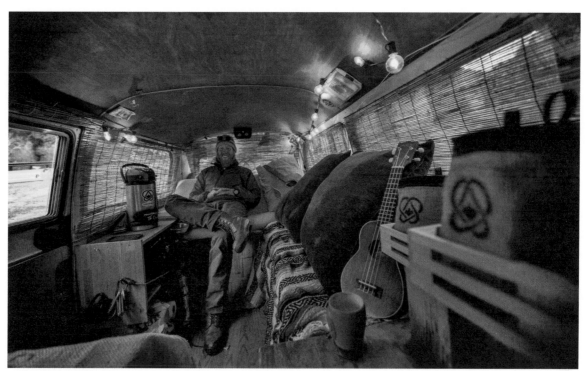

Coffee became a part of Erik Gordon's life when he was on a 4,000-mile solo bike tour around the western half of the country. Not previously a coffee drinker, Erik started to drink coffee when he was biking down the Oregon coast to stay warm and for a little boost in morale. It was during that trip that coffee became central for him. Now he has a business, Carabiner Coffee, and slings coffee daily out of his 1971 VW Type 2 Transport van.

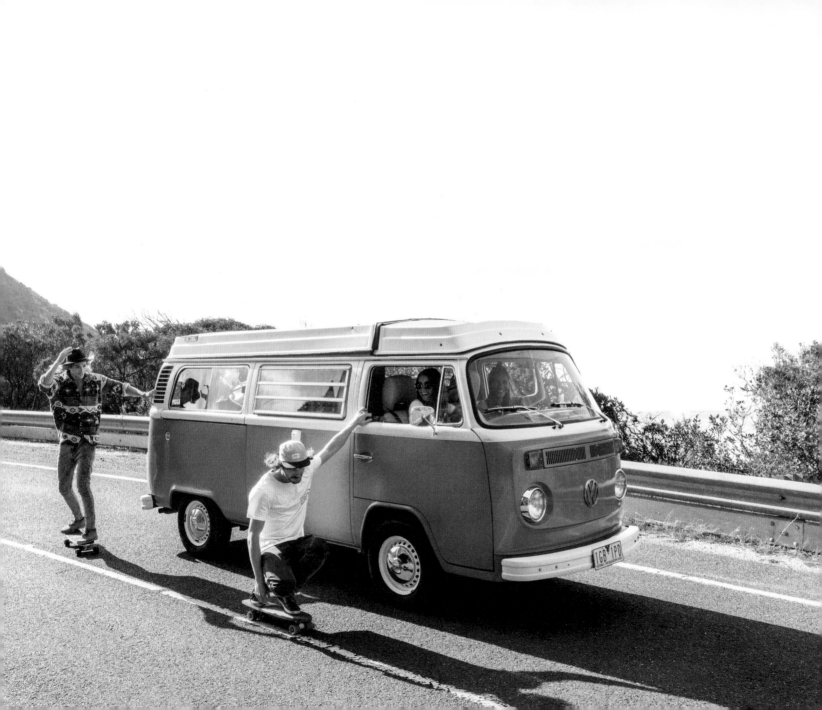

If there's a community that knows how to play hard, it's the vanlife community. From climbing to surfing, cycling to mountaineering, or just plain old barbecuing on the beach in Baja, a commitment to play runs deep. And to make sure they can play wherever they go, vanlifers design their rigs with gear garages, built-in storage units, and racks for carrying outdoor equipment.

On top of vans, we've seen everything from surfboards to kayaks, bikes to skis and skateboards. Inside, we've seen customized storage areas filled to the brim with hula hoops and fishing poles. Having everything we need with us at all times allows us to play wherever we go.

for Play

Sean *in a* 1995 GMC Van

@seanrcollier

The salty scent of a freshly soaked wetsuit drifts forward to the driver's seat as full-time college student Sean Collier flashes his blinker to merge onto California Highway 101 to find the next break in the waves. Unlike unchangeable mountains, the watery peaks that Sean surfs move constantly, and today's best swell may have moved down the coast come tomorrow. With his van, Sean can be there and escape the stresses of academic life.

While some people search out the vehicle they want to own, Sean never expected to own a 1995 GMC Vandura van or that his mom would be the one to tell him about the man selling it.

"She sent me photos, his phone number, and after an exchange of a few text messages, I drove out to the owner's house with $2,000 in the glove box," Sean remembers. "It was love at first sight. Although I was intending it for something with better gas mileage and not as big, the van checked out on my needs, and there was no looking back. I got the thing for a steal because the old man just wanted to get rid of the thing in perfect condition, and was stoked that a young guy like me wanted to travel in it."

For three years, Sean has been living and traveling out of his van part time while he finished his degree in communication studies at Westmont College in Santa Barbara.

Getting an education has been Sean's top priority, however it's been tough for him to focus when he's a stone's throw from some of the best swells. If the waves are flat at local spots, a 20-minute drive down to Ventura is usually pretty promising. Oftentimes, he will check surf reports online and drive up to Big Sur and surf away from the crowds.

When Sean first got the van, he welded and custom-built a roof rack on top to store his longboards,

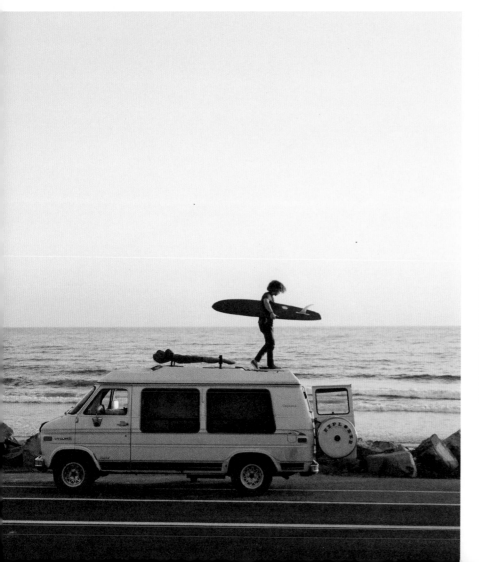

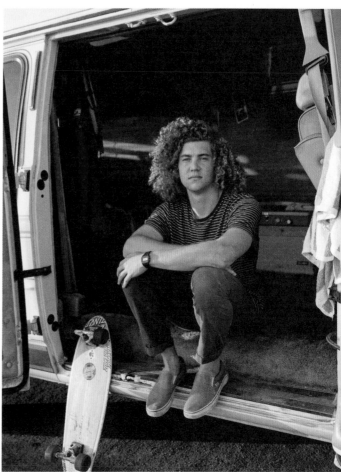

In addition to making it easy for him to catch good swell, Sean's van facilitates other kinds of play, like swimming in the Santa Barbara foothills. Swimming holes work wonders for cooling down during the summer while also offering a free shower on the road.

a 9'2" single fin and a 6'5" midlength fin. For his shorter boards, like his 5'5" quad board, he created a two-strap pulley system on the ceiling to keep his boards secure and dry. Even with a board or two hanging from above his head, he still has plenty of room to sleep, cook, and watch movies inside the van.

"One of my favorite things to do to make my mobile home a little more homey is setting up my pop-up table behind the front seats, folding the bed up into a bench, and using my computer to play some films at night. My friends and I have had some rad Western movie nights in the middle of nowhere. But usually evening entertainment consists of climbing the back ladder with a blanket and laying on the roof to stargaze."

Inside the back doors, he has a hanging rack with a large Tupperware container below. It was a setup he designed so that he could take his wetsuit off while standing in the Tupperware container to avoid getting salt water on everything. If he's hanging out on the beach for a while, he'll throw his wetsuit over his side

mirrors or hang it from his roof rack. If he's on the move, he'll hang his suit from the backdoor coat rack and roll down the windows to dry it out on the way to the next place.

Sean built out his interior to have a kitchen cabinet that holds all of his cooking gear, food, and coffee supplies. It also makes for a perfect stove as he keeps his two-burner Primus grill right on top. As far as refrigeration goes, Sean has a Coleman cooler that keeps ice in good shape for several days.

This setup works for an off-the-road, on-the-road approach, but it doesn't work for Sean full time. His van is not his permanent home but instead a transport vehicle for the hobby he loves the most.

"Vanlife is a means to an end," Sean says. "It's a means to live the life I want, which is living simply and doing the activities I love like surfing and hiking."

The surf culture has been revolutionized by the vanlife movement. During surf competitions, beaches are

175

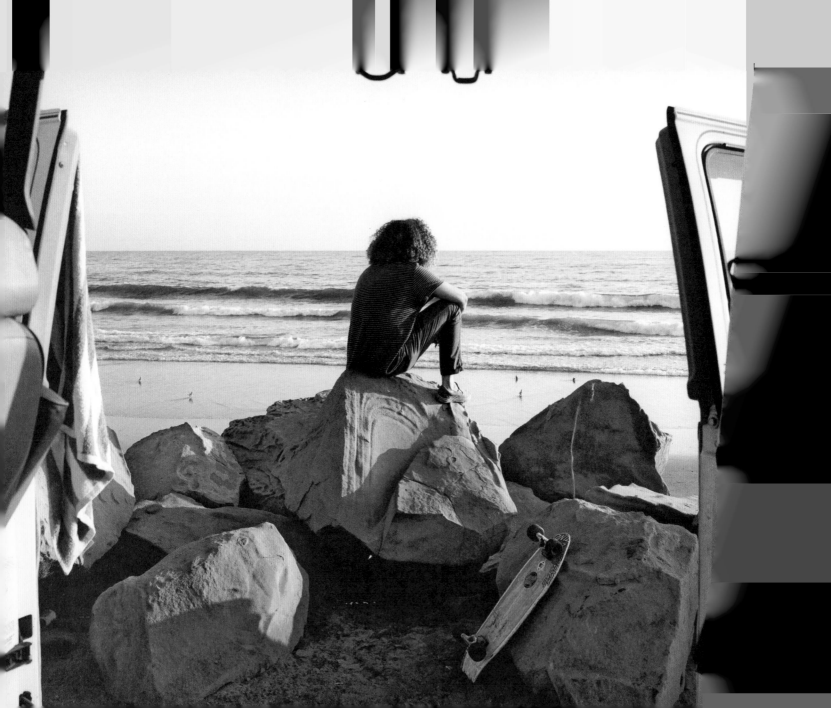

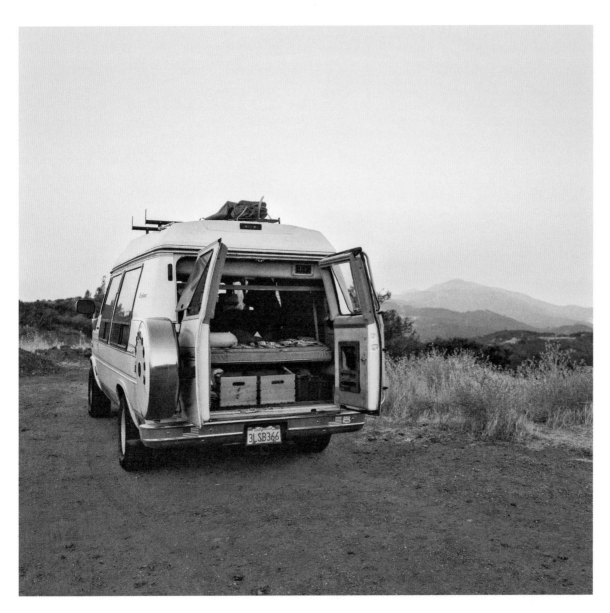

SEAN'S GO-TO ITEMS

French press: For coffee. Sean stores his coffee grounds in Mason jars.

Wrist Rocket slingshot: For downtime in the van. Sean's other form of play besides surfing involves nailing some targets when he's out camping with friends.

Tools: Sean carries a bag of basic tools and wrenches. Since Sean's van is aging, he's been working on it quite a bit.

178

peppered with stoked surfers and vans. And Sean's van is always there, parked close to another one, wetsuits dangling like flags from rearview mirrors and roof racks. He never tires of opening the back door to the ocean and meeting new friends to share sunrise coffee in the sand.

"It's been a gateway to make a lot of new friends and build relationships. I've been surrounded by a lot of people living a similar lifestyle," he says.

One of Sean's earliest inspirations for traveling came from his great-grandfather, who lived to the age of 96. While his aunt was going through his great-grandfather's home, she found a journal filled with his stories from the early 1960s, when he was cruising around in an old pop-top camper for weeks at a time in the Sierra Nevada Mountains that was breaking down all the time. His aunt typed up the memories, printed them into a booklet, and handed them out at his memorial service. Three years after he died,

Sean finally got around to reading through his great-grandfather's memories.

"All of his writings were about him traveling around the Sierras, inside and outside Yosemite, Mono Lake, and Mammoth," Sean recalls. "He started by taking my grandma and her sister up there. Then my mother and her two sisters got dragged into it. The tradition was passed along until my sisters, cousins, and I started making trips up there as well. It was the ultimate adventure with his family and his old camper. It hit me that I have such a long tradition of being in the mountains and a love for it. It's ingrained in me."

Some things are meant to stay in the family, and Sean intends to tell his van stories to his family someday. He's replaced his great-grandfather's pop-top camper with a GMC, but he still shares the same fears of breaking down somewhere. During a recent spring break, when he drove to the mountains to camp for the week, he was caught in rainstorms, snowstorms, and high winds.

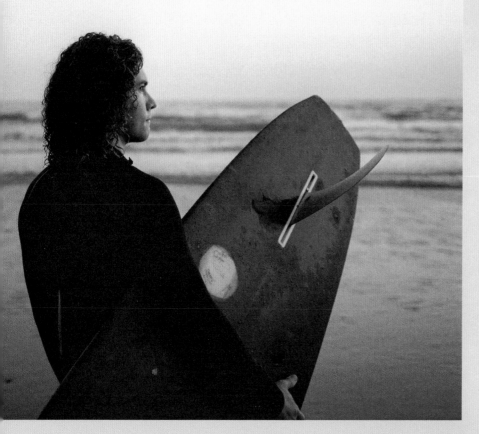

"I had this fear all night of of getting snowed in and not having enough traction to pull the van out, given that I don't have a plethora of off-road equipment. It's hard to get help back there. The van does great on backroads but doesn't have four-wheel drive. There's always this fear of getting stuck somewhere. Luckily, I could cruise out of there, but some situations can be rather unsettling."

Vanlife sustained Sean's outdoor lust during his college years. Next, he plans to transition into the van full time while pursuing a photography career.

"I'm still trying to figure out what my plans look like," he says. "It's scary to be a graduate and be doing your own thing. I'm still looking at making the van a full-time thing. I'm in a long-term relationship, and she loves the van. We're trying to encourage each other to do the things we want to do, and we're waiting to see if the van fits that."

179

These owners still find space in their tiny homes to store their outdoor gear.

Jose Romero digs around in his "garage." This storage area can hold two bikes in addition to what the rear rack can carry.

A van allows you to park at the crag and be the first to hit the wall when the sun rises. Above, Denise Elbel organizes her draws to prepare to climb the Pyrenees, a mountain range in southwest Europe that forms a border between Spain and France.

Brian Wood tries his hand at catching dinner in Baja. "We're starting to get the hang of this fishing thing, and on days we don't catch anything, neighboring campers always offer up some of their catch. Maybe we can stop buying food and live off the land? Other than chocolate and beer of course."

VANLIFE GUIDE TO STORAGE SOLUTIONS

—

The longer you live on the road, the longer your wish list of things you want to add to your rig. You might get ideas from eyeing how other people get creative with their space and how they choose to store the things that are important to them, or you may find out you're missing something you didn't know you needed. It can be hard to know what you need to make your rig feel more like home until you've spent some time living in it. It wasn't until I'd spent four months in my most recent van that I had a curtain setup that I was happy with and lights exactly where I wanted them. You can learn as you go by experimenting, or you can find a van builder who can give you some tips. Here are some things I've hit on after living with a lot of lesser solutions:

Cook Out the Back

All vans are small, but if you're like me and live in one of the smallest vans you can own, you may not have room to set up a permanent kitchen inside, next to your bed. You may also not want to have all the cooking smells and scraps near where you sleep. I found that the best way to maximize my 40-square-foot Toyota van was to design a cooking setup that allows me to make my meals outside and also keeps everything compact and organized in one area. If you open the back of my van, you'll find two slide-out drawers—one that houses my solar-powered fridge and one that fits my two-burner camp stove on top, while all my cooking supplies sit underneath the stove. They consist of a cast-iron skillet, a collapsible cooking pot, spices, coffee, dog food, and any other dry goods that might fit. In rainy weather, the back door acts as an awning, and I'm still able to cook outside and be sheltered

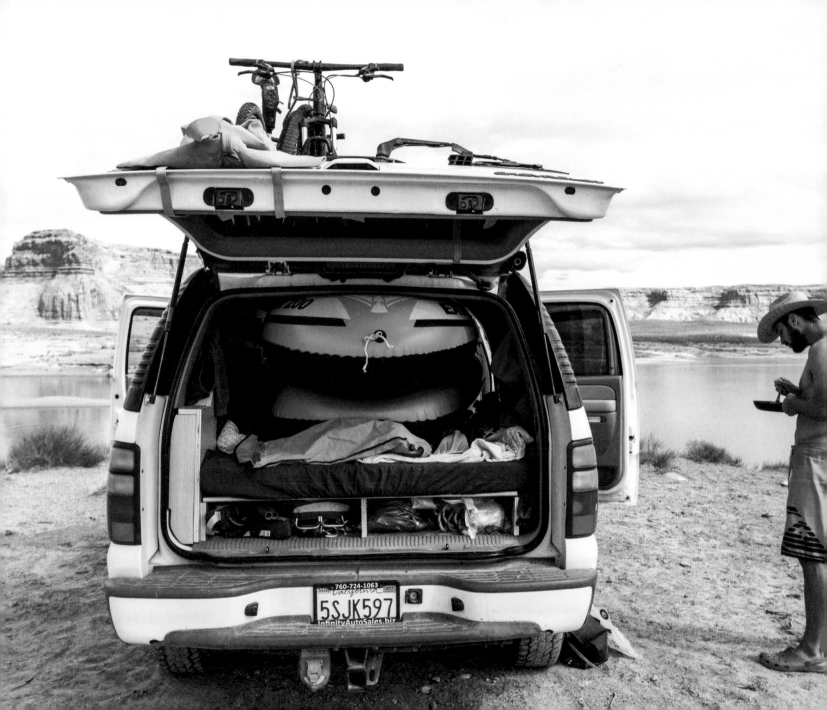

from the elements. I also have a few dry goods that I store on a shelf inside the van (like granola bars and oranges) so that if I don't want to go outside, I am still able to find something to eat.

Use Magnets & Hooks

Magnets and hooks can give you easy access to things that you need every day. The stronger the magnets, the better for keeping items secure when you're on the move! The same goes for hooks. If you have metal around the insides of your van windows, you can sew magnets into the edges of blackout curtains to hold them up near the glass. If your rig has a metal ceiling or walls, you can use magnets to secure decorations and hooks. Instead of shoving them in a bin or a drawer, Naomi and Dustin of @irietoaurora use magnets on their spice containers to secure them to their fridge inside their VW van. Travis of @travywild hangs his surfboard inside his Sprinter van using a pulley system made out of U-bolts that are drilled into the roof of his van and act as hooks for a rope and carabiner to latch onto.

Create Your Own Indoor & Outdoor Water Station

When you buy a house, you're almost guaranteed access to running water. When you buy a van, that's rarely the case. But rest assured; it's fairly easy to create a setup that will provide drinking water and a place to wash dishes. At the very minimum, I recommend buying a seven-gallon water container that you can use to fill up water bottles. And if you're traveling through places where you can't drink the running water, buy two or more so you won't run out. As a solo traveler who's also sharing drinking water with Peaches, I find my seven-gallon water tank lasts me about four or five days. I'm using my water supply for drinking, making coffee, cooking meals, soaking grains, washing dishes, and sometimes unpredictable events like rinsing off Peaches' muddy paws. You can also take one of those water containers, or one in a smaller size, and fasten it to the inside wall of your van (depending on how big your interior space is). Then position a bowl underneath the container to prevent water from dripping onto the floor and capture the excess for reuse in washing dishes.

185

Design a Mobile Office

If your work requires you to be sitting down with your computer on a regular basis, it's worth creating a dedicated workspace in your van. One of the coolest ideas I've seen that mixes work and play into vanlife comes from Cyrus Sutton (@cyrus_sutton), who owns a Sprinter van. He created a hammock workstation. With the hammock mounted between the front and back of the van, he hangs in the middle. Between one wall that houses a foldaway bed and another wall that holds his kitchen storage, he's able to slide a piece of wood that acts as his desk. On the other side of his foldaway bed, he has a whiteboard for jotting down important notes. If that sounds too high tech, it's easy to create a fold-down desk attached to hinges, chains, or climbing rope. It's nice to take it a step further and buy a shade awning so that you can bring your workspace to the outdoors. Use either a camping chair or a stump if you want to feel more connected to the earth.

Install a Roof Box or Hitch

If you don't have a gear garage to store bikes, surfboards, or kayaks, look into putting what might not fit inside your van on top or in back of your rig. Kristen of @bearfoottheory installed a roof rack on the top of her Sprinter van, along with a storage box on her rear bumper. Even though there wasn't room to store them inside her van, she wanted to bring a stand-up paddleboard or kayak with her, as well as a camp table, a portable grill, and other things to make camp and road tripping a little more luxurious. She also puts her spare tire on the back of the van since she uses the van's undercarriage to store her heater. If you're doing a lot of climbing to grab gear from the top of your van, consider adding a ladder. No one wants to throw gear up top and then have to figure out how to get it down without falling or breaking something in the process.

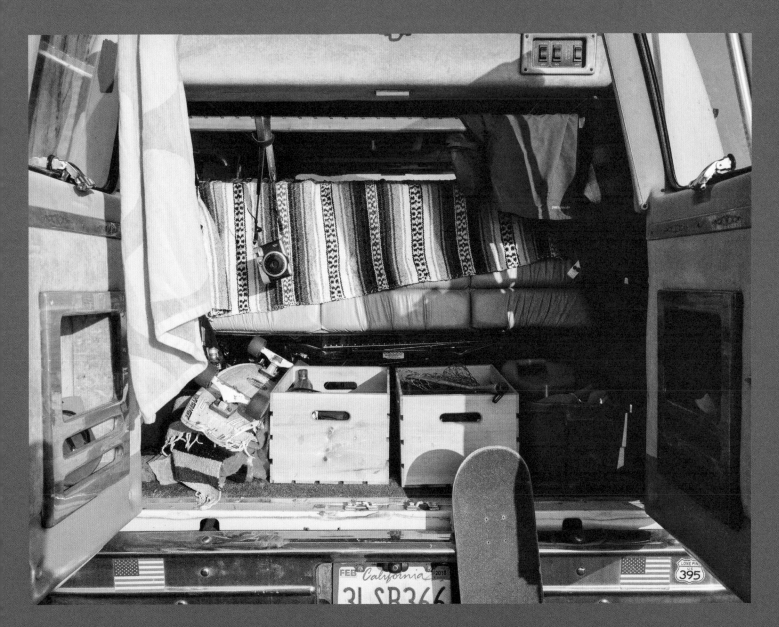

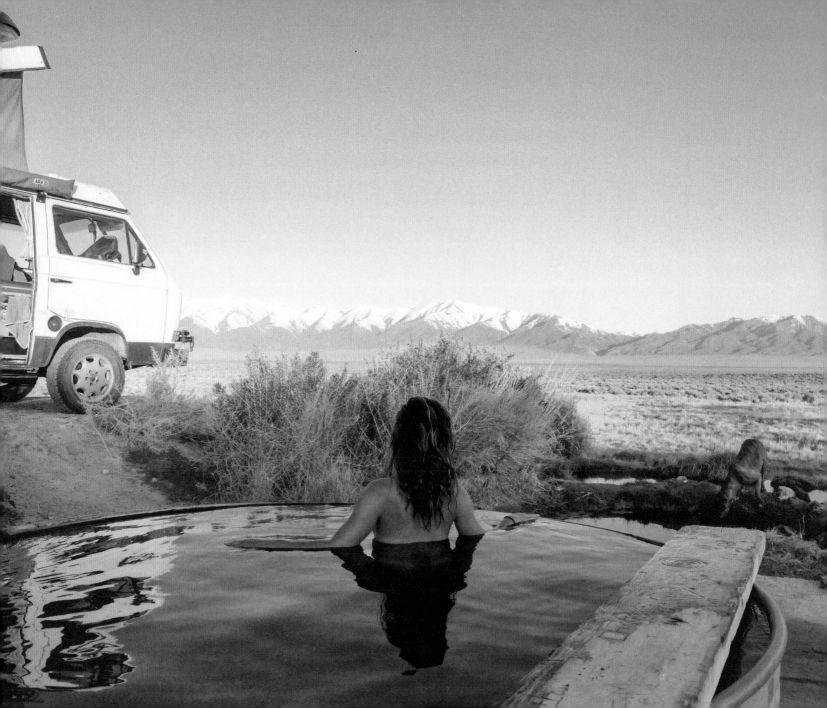

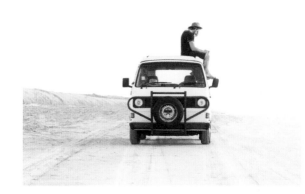

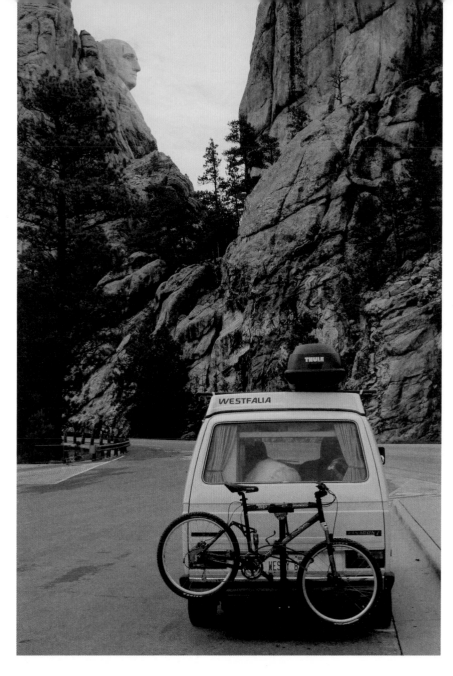

From hot springs, to desert roads, to canyon drives, variety is the appeal of vanlife. Geotagging locations has been a topic of discussion within the traveling community. As more people see these locations posted, there's been a rise in people to the areas who don't know how to respect them. What was once hidden can be exposed through the lens of social media. More vanlifers are keeping locations a secret to preserve them.

Vanlifers enjoy walking through rock pools to an epic surf spot for breakfast. When your vehicle is parked on the beach, you are able to catch the waves before others arrive. In Morocco, Stephanie Rhodes has a beachfront property with a large pool in her backyard.

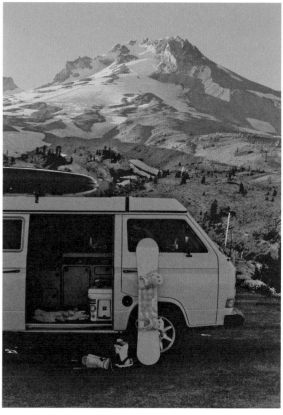

For some vanlifers, having immediate access to the outdoors provides a playground for activity and an incentive for physical fitness. But for others, staying stationary during long drives or unpredictable weather can create the desire for a more consistent workout routine. Whatever your mode, how to stay healthy on the road is a topic of passionate debate in the community!

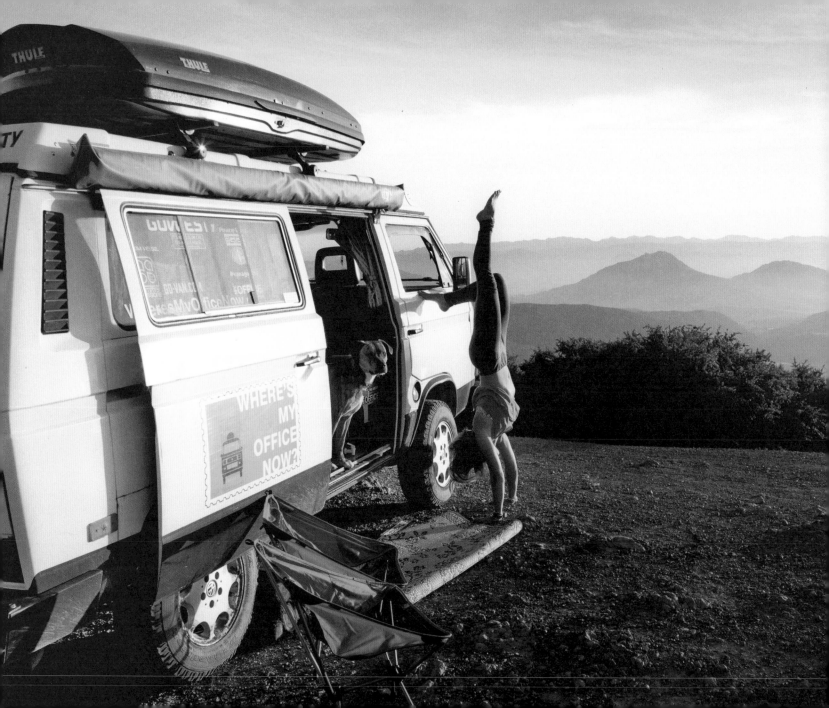

194

Right: Meeting in the parking lot to catch the surf break. Finding like-minded people is fairly easy when you're "neighbors" with others who enjoy the same activities.

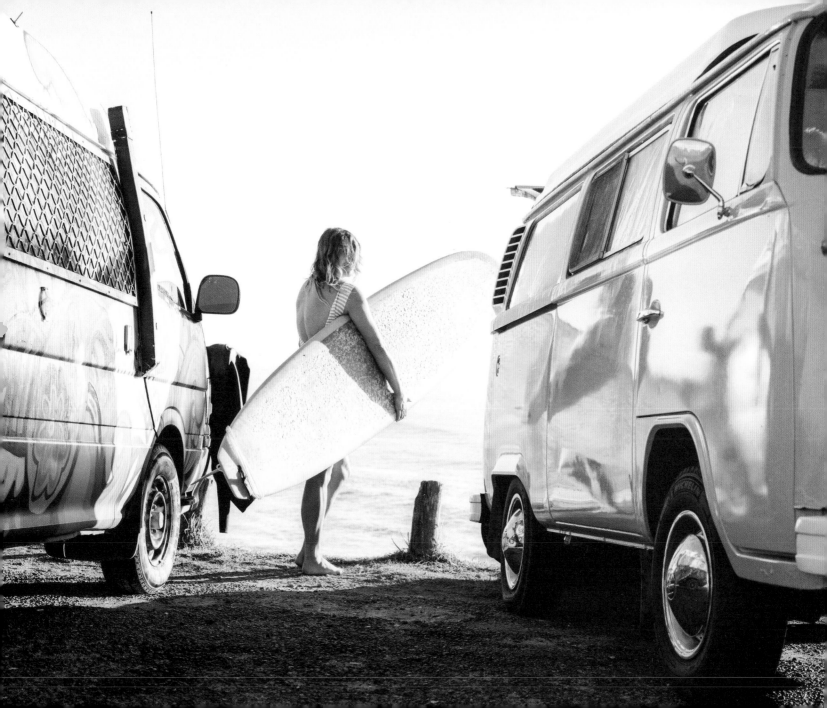

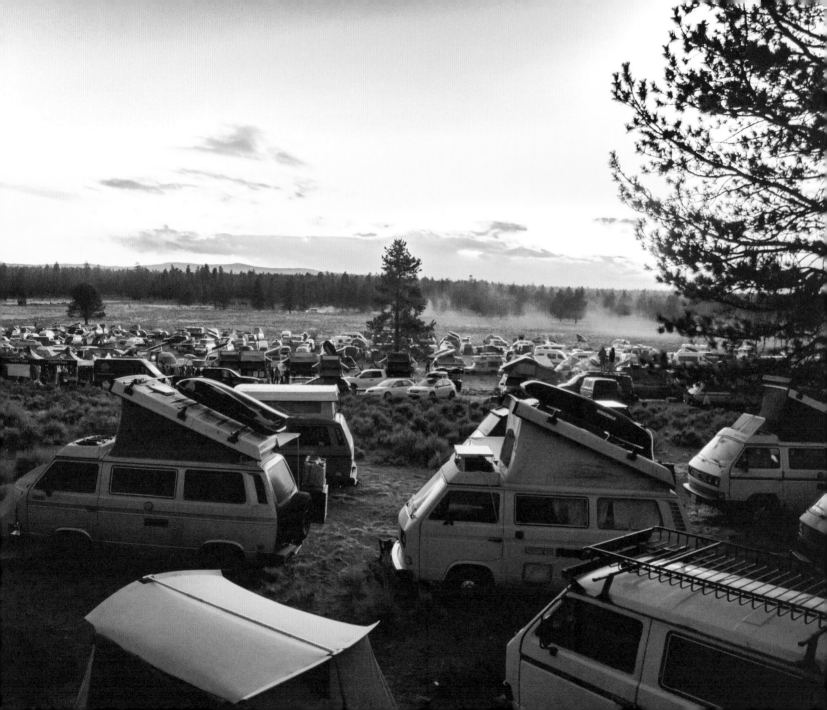

Nearly everyone is longing for deeper connections with their environment, other people, and themselves. When you allow yourself to love and be loved in return, you break down walls.

Having access to the internet has helped millions of people connect to one another. And through Vanlife Diaries, we've created a safe and supportive space for people to gather, not only digitally, but in real time. These gatherings are designed to allow people who might not otherwise meet to strengthen their connections. Through a shared bond, gatherings give nomads a united sense of belonging.

for
Community

Finding Community
in Vanlife Diaries

198

"There are no words that express the reality of human connection. As I sit here, I am pouring tears. Tears for the immense and sudden loss that comes directly after you are brought to a level of existence you had never experienced before, but your soul has been searching for since as long as you can remember. The yin and yang so intricately woven into all we experience. It is a lesson of love, that when you let go of your expectations, and you bring only love and your own heart to share with others, that is the moment when ignition happens. And if you're lucky, every once in a while, you enter a place where everyone around you showed up and their walls are down, too. It's safe to bare your heart, and instead of receiving rug burns and bruises, it is embraced, nurtured, and joined by the hearts of others. Instead of requests to cover it up, more layers are asked to be removed, to see farther inside. We perform surgery on each other's hearts. And now they beat strong, rhythmically, and openly. So now healed, we scatter to the wind, pollinating new places with the healthy love we've just received." Melissa Thayer wrote this after meeting up with five other travelers outside Sedona. Melissa previously lived with her husband on the road, but now lives solo out of a cargo trailer she pulls behind her truck.

Imagine being the only nondrinker at a brewery or the only single person in a room full of couples; that's what it can feel like to live in a van sometimes. And even though vanlife is becoming more popular with the rise of remote work and social media travelers, being on the road constantly can create a complicated picture for forging long-lasting connections.

Making plans looks a little different when you're always moving. When someone asks what you will be doing three months from now, it can be a bit hazy. It can be difficult to predict future job opportunities, what the weather forecast might be like, or whether someone you meet might steer you toward an unforeseen destination.

199

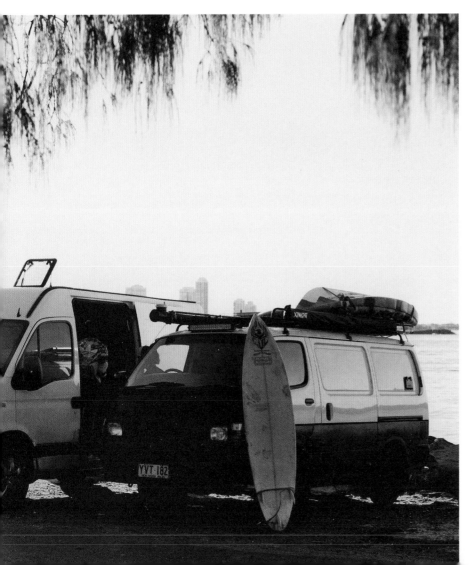

Born and raised in Sydney, Australia, Hayden Warner finds his community on the beaches that offer free camping. Of vanlife, he says: "[it] has never been about just owning a van and living out of it. I find the humans who choose to live their dreams, explore their passions, to chase a fulfilling and meaningful life normally find themselves in a van, however this can be achieved in a car or a tent or a motorbike, through music, art, photography, hiking, or backpacking."

Above: Everything got a little brighter when J. R. Switchgrass and Kit Whistler arrived at the Colorado Vanlife Gathering in 2017. Here I am between two people who greatly inspired me in living more intentionally and sustainably. It's always such a gift to be around people who encourage and support you in your journey.

Right: Mary Ashley Krogh and Owen Chikazawa have been through a lot in the few years they have been living mobile. Pictured here in their first vehicle, they have since built out two other rigs. They've been through several break-downs and obstacles. Having a support system in the form of their vanlife family has helped them get through those situations, secure resources, and find the beauty in the lows.

Social media has also given us the ability to follow travelers and know where they are headed. Before Instagram, you might run into someone by accident, but now you can organize an impromptu meet up or change your plans when you open up an application.

When I worked a full-time office job and had two weeks of vacation, organizing an extended trip required considerable planning, preparation, and attention to detail. I would message friends ahead of time, and we would coordinate our vacation schedules to align. Planning took up the biggest amount of time. We grappled with the added stress of picking somewhere new and a setting with enough options to keep us occupied, a mix of city and outdoor activities that didn't require too much driving. I realize this isn't how everyone with a nine-to-five job manages a vacation. But when you take two weeks of vacation at one time, making all the preparations can be overwhelming . . .

especially when you have to wait another year to take another vacation.

Vacation looks different when you live in a van. In some ways, life on the road is a perpetual vacation. Even those of us who work almost every day still have flexible schedules and can choose when we need a break. A full-time job requires you to be in one location and surround yourself with friends who also live there. Vanlifers, by contrast, choose where they want to be but also push away other opportunities, other choices. The uncertainty that you'll never be in the same place or with the same people again makes vanlife stimulating yet also uncertain. There's something exciting, yet sad, about knowing this and still making the decision to come together at a particular time and place.

Vanlife relationships inspired Jonny and Jared to think about how they could make others feel their magic. Three years ago, on a beach property near Byron Bay

in New South Wales, Australia, they hosted their first gathering to rally the community. A week before the event, they posted an announcement on social media and asked for volunteers to share their skills. Thirty people showed up in their vans for the weekend, including a couple from France who were traveling internationally. An artist living in her van drove eight hours to connect and lead an interactive arts workshop. A chef from a local restaurant demonstrated how to cook Japanese- and Australian-inspired food. Jonny and his band Dusty Boots shared music, and set up an open mic to encourage others to perform.

Vans were parked close to one another with the doors open. Participants welcomed each other in to tour their houses and offered food and gifts. Around the fire pit, they sat on blankets and talked about the tallow trees they were sitting under, the moss that was on the ground, and the ocean that was just a few yards away.

In an effort to play a role in eco-conservation, they organized a beach cleanup with Take 3 for the Sea,

a nonprofit organization that encourages people to pick up three items of trash when they leave a beach or waterway. The group cleared the beach and surrounding area of trash and discussed how they could be more environmentally conscious.

After that successful first gathering, there was a frenzy of interest. Vanlifers were telling their friends, and Jonny and Jared rushed to organize the next event. They added three more gatherings across Australia: one in Daylesford, Victoria, and two in New South Wales, with one in Crescent Head and one in Bellbrook. Like wildfire, each successive event grew. While several vans were always in attendance, other vehicles started to surround them. Truck campers, cars with rooftop tents, and Airstreams joined the scene under the unified banner of #vanlifediaries.

Jonny and Jared began partnering with other nonprofits that aligned with traveling, self-discovery, and social responsibility. Because of Jonny's own struggles through bouts of depression and anxiety, he and Jared reached

In Saint-Raymond-de-Portneuf about 45 minutes from Quebec, 100 different rigs gathered to celebrate alternative living. Go Van has been hosting meetups in Canada. "What struck my mind was how this event was different from the usual van gathering, and it's probably because I've never attended such an event myself! I realize that many people who came don't really attend the usual Westfalia meet ups and enjoyed the fact that everyone was welcome at El Campo. There's really a modern vanlife movement out there, and we're proud to be a voice for these travelers and alternate living enthusiasts."
—Julien Roussin Côté.

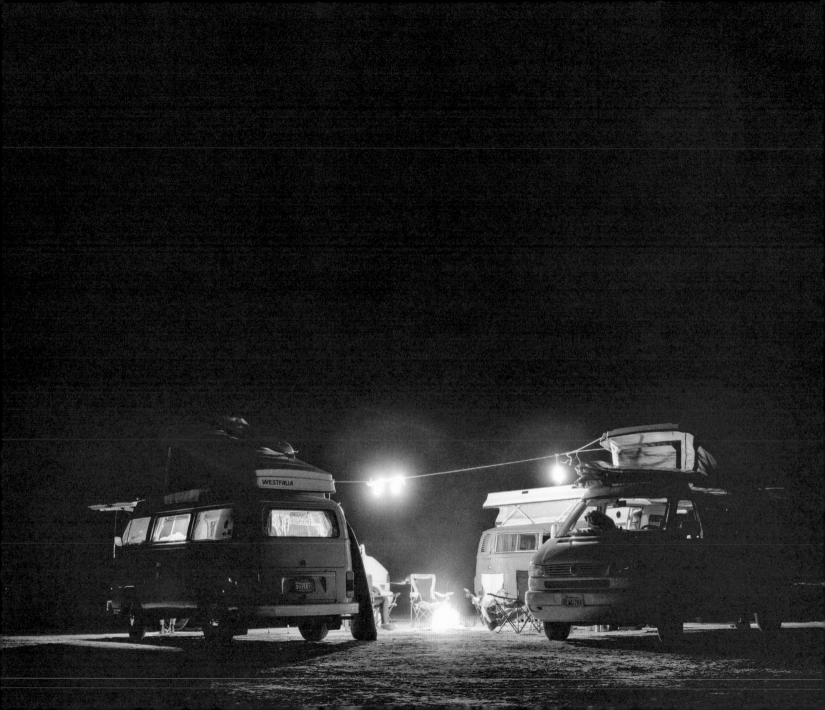

out to One Wave, a nonprofit community tackling mental health issues with saltwater therapy. Together with members of the organization, they hosted a talk on the beach and prompted others to share how they were coping with their own challenges. This set a tone of communal acceptance about sharing personal issues that is lacking in many social settings.

Jonny and Jared felt it was important to find meaning in the places vanlifers visited. They knew there was a historical divide between Australia's indigenous and nonindigenous citizens, and they wanted to find a positive way to bring them together. Jared resonated with the nonprofit group Yarn Australia, which builds these connections between Aboriginal and Torres Strait Islander groups and nonindigenous Australians. Warren Roberts, a member of Yarn Australia, facilitated a conversation about relationships and the meaning of the word *community*. Around the campfire, as the shadows grew long, participants called out words like *respect, culture, diversity, being present, communication, food,* and *friendship*. All of these

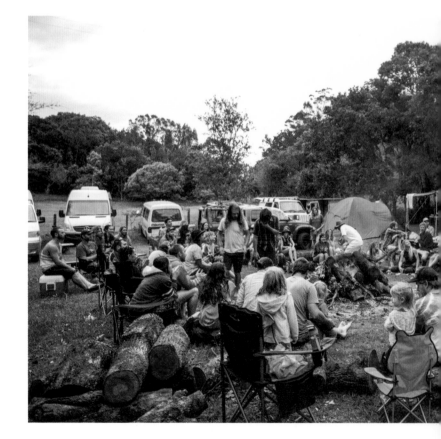

qualities reinforced the theme of the weekend and demonstrated why the gathering was needed. It was a reminder to Jonny and Jared that even though we all come from different backgrounds, we share a common link.

As the following for Vanlife Diaries grew, word of the Australian gatherings spread internationally. Vanlife Diaries started receiving Instagram messages asking if we could host similar gatherings in the United States.

Two years ago, I had never been to a gathering in Australia, let alone anything similar in the United States. At the time, I didn't know many people in Colorado, my home base, who were living in vans. I started driving around on the weekends, looking for a

flat area where I could invite several vans to converge, while also keeping it within a two-hour radius from Denver. I knew it had to be an area that didn't require four-wheel drive roads or steep grades as some of the older vans might not be able to travel there.

On one of those scout missions, I found a designated camping area in Pike National Forest that could fit a large group of people. I posted a weekend date on social media and asked people to fill out a form and offer to volunteer to set up. As the planner of a gathering on national forest land, I didn't know what to expect. I had to cross my fingers that someone who wasn't a part of the gathering would show up and take the area I wanted to reserve.

When I drove up the Friday afternoon of the weekend gathering, I was shocked to see about ten vans had already arrived. Some of the volunteers had camped out there for several days to reserve the space. Throughout the weekend, 60 people showed up in vans and truck campers.

Vanlife Diaries has been hosting gatherings in Australia since 2014. Pictured here is the gathering in Crescent Head in New South Wales, Australia in November 2015.

At dusk in a wide field surrounded by towering mountains, a drum sounded. Across the way, a few people sat by the fire, improvising on guitars to the drum beat echoing from the other side of the meadow. Children ran around without shoes or clothes but with plenty of giggles and full bellies. Strangers put their arms around each other and shared beers and stories from the road. Twinkling lights scattered like stars and illuminated the scene of vehicles in an open field.

It can be surreal to find yourself in the middle of a van gathering, letting people into your home and embracing newcomers like family. But that's exactly what happens in this community. And it's driven by people from all walks of life, who go out of their way to travel to one location for a weekend. The Colorado gathering— the first van gathering of its size at that time in that region—gave solo travelers an opportunity to feel included among couples and families of all ages.

"Meeting everyone there reminded me that the folks going out and hitting the road aren't running from something but searching," says Colby Thompson, a 25-year-old who travels around in his built-out 1975 VW bus. For Colby, a van gathering was a way to put a face to some of the people he was following on social media. It also gave him the opportunity to have deeper conversations with others that didn't involve justifying why he chose to live this way—a common theme when he spent time with people outside the vanlife community.

Now, people like Colby can find community in gatherings around the world. With the success and enrichment of these communities collaborating, the future is blossoming with endless prospects of social change and community initiatives. Vanlife Diaries will continue to use social media as a tool to help us come together as one.

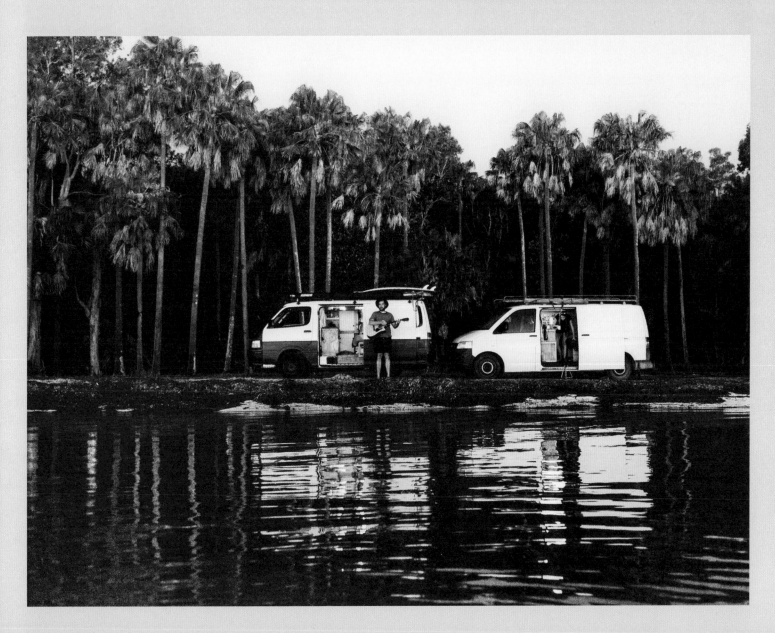

We want you to know that
you are unique and valued.
With or without a van,
you're all welcome to join
this community.

The friends made at vanlife gatherings become family, and having strong personal connections all over the world brings a new perspective to traveling. Having your home with you and freedom of movement encourages people to take risks they might not otherwise take, and it's increasingly common for folks to meet up and travel with people they barely know because they can easily part if they choose.

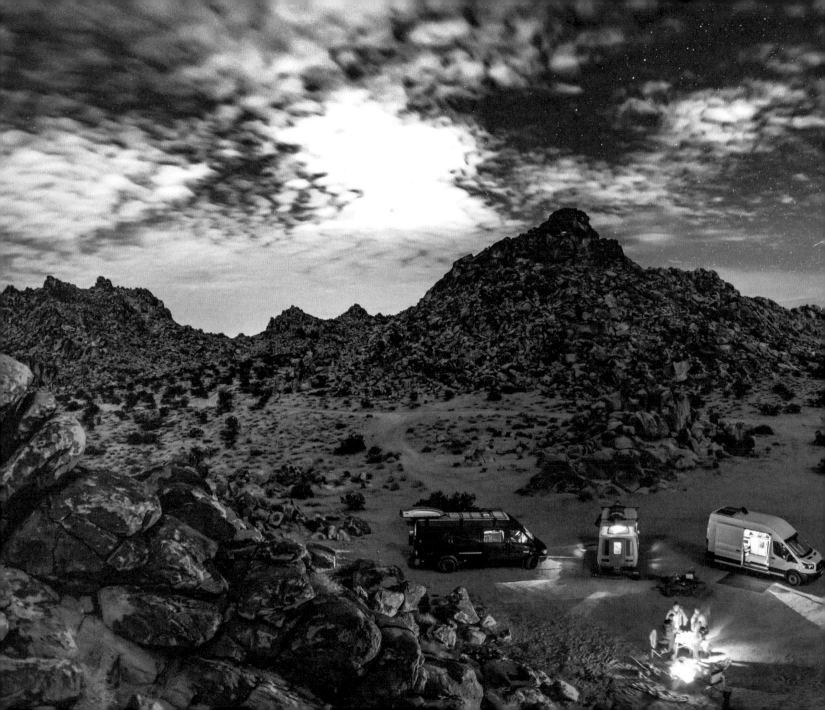

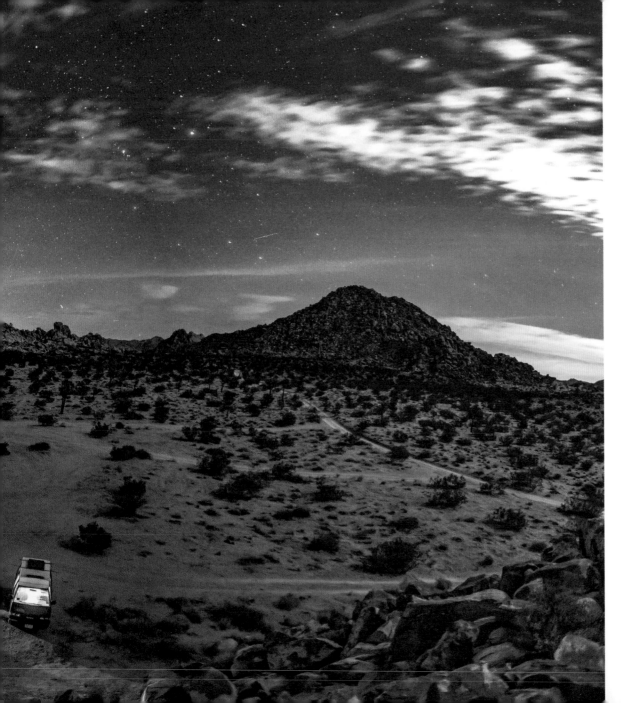

Travis Wild stays up late to photograph Christmas Eve in Joshua Tree. While some spend the holidays with their families, this group of vanlifers headed to the desert to be with their road family. In the morning, Travis put gifts outside each of the vans as a way to replace putting gifts under the tree.

VANLIFE GUIDE TO AVOIDING BREAKDOWNS

It's one thing to have your vehicle break down and have to take a cab or hitch a ride back to the place you sleep. It's another thing to have your broke-down vehicle and your home be the same thing. You might be stuck in an area without cellular service or have to sleep for a few days in a mechanic shop's parking lot while waiting for a part to come in. Parts can be expensive and hard to come by for older rigs. And if you're in a foreign country, auto shops may not have the parts you're looking for as readily available or convenient to order as they might be in the States. Here are a few things you can do to avoid being stranded on the side of the road—or at least limit the number of nights you're there!

Be Your Own Mechanic—or Find a Go-To Shop

Even if you don't know all the ins and outs of your machine here are a few things you can do to help keep it in good working condition: In older vehicles, it's important to check fluids regularly and to be aware of how your van

is running by paying attention to dashboard lights, unfamiliar noises, or odd smells. Even if you can't fix something yourself, knowing what parts you need will save you time and money. Buying parts online or at an auto parts store is often cheaper than having a mechanic order them. It will also get you back in your van faster, shortening the wait for a particular part. Several mechanics were impressed that I know how to diagnose my van's problems, and they charged me less because of it. It also helps if that mechanic is your friend or someone you trust who knows your particular rig.

Carry an Air Compressor & Tire Patch Kit

Sometimes it takes a trip to a new place to realize what's missing from your repair kit. For me, it was a trip to Baja with some friends. I learned that the roads in that part of Mexico may be more unforgiving than what I had encountered on my usual routes around the western United States. There are highways filled with potholes and sandy

roads that lead to the best surf breaks. I had watched others deflate their tires before heading down backroads by placing a small rock on the side of the valve and pushing downward. Letting the tire pressure out by around 10 psi can help your tires navigate dirt roads better and reduces the likelihood that your tires will get punctured by a rock or other debris in the road. Once you're ready to get back on the highway, you can use a small portable air compressor to inflate your tires again. If you find your tires leaking air, a tire repair kit is your go-to resource to plug holes before you are able to get to a tire store. Take care of your tires by watching their tread and air pressure, and by switching them out if you know your tires aren't made to handle certain conditions.

Own a Socket & Wrench Set

Socket and wrench sets are crucial for a lot of automotive repairs, but they come in handy for everything from changing your tires to fixing your solar panels to installing lights and curtains. Invest in these tools before the need arises, and you will be glad you won't have to run out to the store in an emergency. I would go a step further and add that if you can buy a power drill and drill piece set, you can do your improvements without asking around to borrow tools from van friends. The more you get to know

your van, the more you can familiarize yourself with what particular tools might be helpful. And having a vehicle owner's manual and maintenance guide will prove to be a godsend if something goes wrong and you don't have cellular service. If a manual isn't included with your older vehicle, you can usually find a version online or buy a copy on Amazon.

Invest in a Roadside Assistance Plan

I once broke down twice in the same city in the same week, and I needed a tow to the nearby mechanic. Needless to say, the van was in rough shape to begin with, but without my AAA Premier Membership, I would have had to pay for a tow or push the van several blocks down the street to the shop's parking lot. Roadside membership costs vary, but the one I own runs around $100 annually, and it includes a couple hundred miles of towing. Even if you're in the middle of nowhere and the nearest mechanic is nearly 200 miles away, you can call roadside assistance, which will take you there. I have heard of van owners using their roadside account for non-breakdown situations because they didn't want to risk driving the mileage in case something worse happened to their rig along the way.

Ask for Help From Social Media & Friends

Not a lot of people in vanlife talk about breakdowns on Instagram. But for Brianna and Keith of @briannamadia, the raw side of their adventures is something they share openly. In turn, they receive support from their followers. While they were in Spearfish, South Dakota, to meet up with a guide to go mountain biking, they heard something dragging on their 1990 Ford E350 van. They looked at their passenger wheel and noticed that the calibrators had fallen off and were hitting the inside of the wheel bearing. Brianna went on Instagram to record some stories, and within 20 minutes a pickup truck burning rubber came straight for them. A few college students who followed them on Instagram saw their stories and wanted to say hello. One drove Keith to AutoZone to get new calibrators, and after a few hours, Keith and Brianna were cruising along again. Many vanlifers want to help in any way they can to get you on the open road and make sure you have a safe experience.

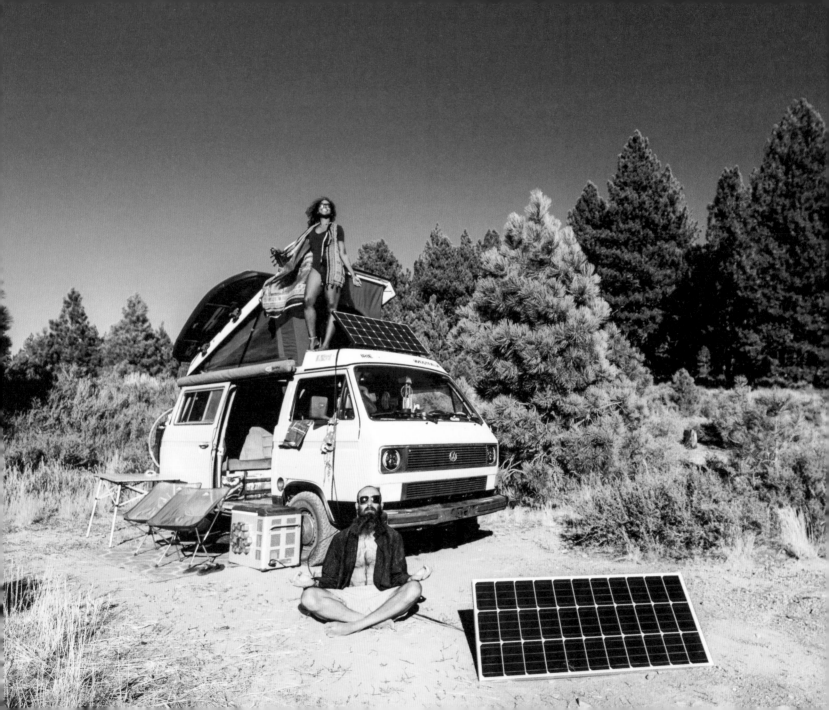

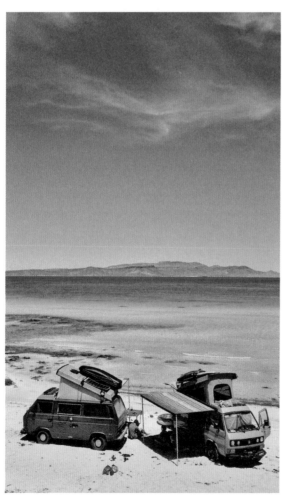

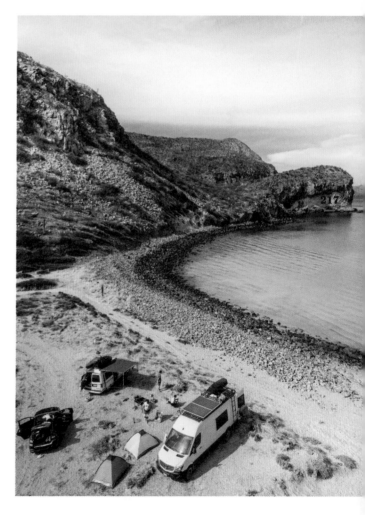

A popular destination for van dwellers is Baja, Mexico. Every winter, van caravans assemble to head down the coast, escaping cold temperatures and seeking swell and fish tacos. For many, this is an annual reunion—a chance to travel with friends that may have different routes for the rest of the year.

Van gatherings bring a community of travelers together to share stories, music, and talents. Over the past three years, the Colorado Vanlife Gathering has seen a huge growth in attendance, which speaks to the enthusiasm and need for these community events. Even the most seasoned solo travelers need social time now and then.

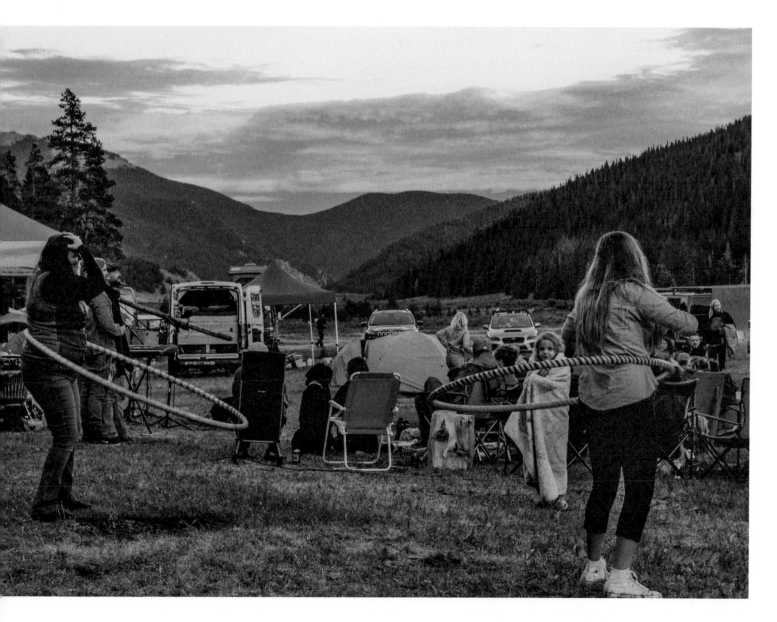

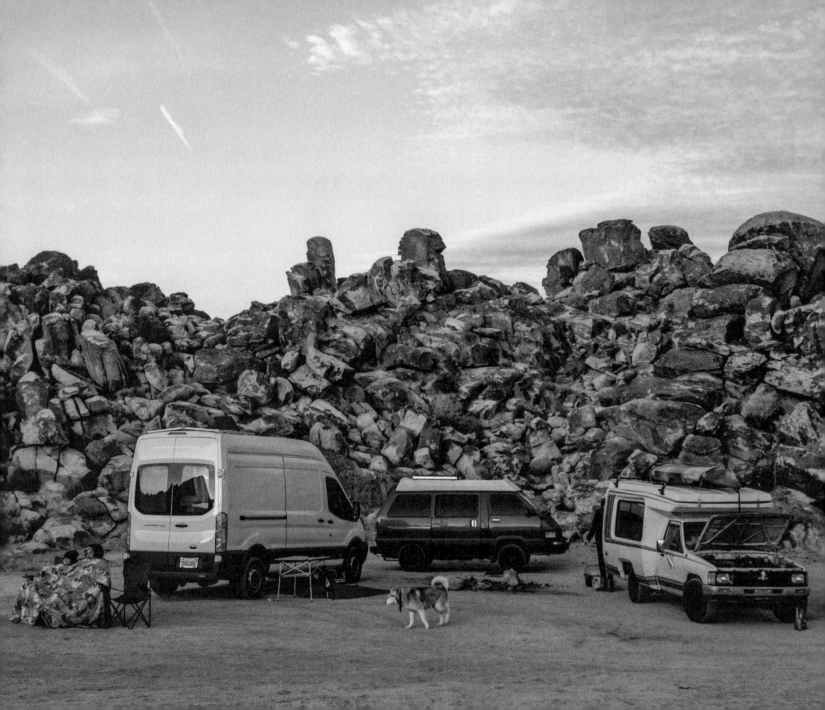

Left: Women on the road in Joshua Tree National Park. This group of rigs belongs to four women: the Ford Transit (left) to Bre and Lacey, the Toyota van to me (middle), and the Toyota camper to Genevieve Jahn (right). We gathered together in December 2017 as a way to spend time together around the holidays.

Below: When Naomi and Dustin first got on the road, one of their top priorities was to be completely self-sufficient. It took them a couple of years to figure out their needs, but now they no longer rely on the grid for energy. Thanks to solar panels on the roof of their van, they can efficiently power their digital nomad lifestyle from anywhere.

Below: Before living on the road, these four were all friends (and still are!). Madison & Cees Hofman live on the road part time in a 1989 Toyota motorhome named Vie with their cat Vladimir Kitten. Here they are with Cees's college roommate, Jace, and his wife, Giddi, and daughter, Juni. The family of three has lived in a few self-converted vans, this one being a 2003 Dodge Sprinter.

Right: Vanlifers getting ready for a backpacking trip looks a little like this. While some store their camping gear inside their van like Kit Whistler and J. R. Switchgrass, others like Corey Smith and Emily King put all of their backcountry essentials in a rooftop box to keep it all in one area.

Contributors

Aaron Haack
@run_away_van
Featured rig: 2011 Ford Transit Connect
Photographer: Peter Amend | @peteramend
Page 145

Abbi & Callen Hearne
@abbihearne | @callenhearne | @thehearnes
Featured rig: 2017 RAM ProMaster 2500 Van
Page 68, 91

Alexandra Ulmke
@agirlandhervan
Featured rig: 2000 Eurovan Camper
Page 33

Alyssa & Brian Wood
@northbound.and.down
Page 181

Amber & Keenan Badger & Family
@summerofseventyfive
Featured rig: 1975 VW Kombi
Pages 26–27

Ana & Marco
@roadforgreta
Featured rig: 1987 VW Multivan
Pages 99, 101, 123

Annika & Cam Mang
@borntobeadventurous
Featured rig: 1993 VW Eurovan
Pages 28–29

Anthony Siciliano
@headtotheroots | @lovelymoondrops
Featured rig: 1981 VW Westfalia Vanagon
Page 167

Armando & Mel
@westfaliadigitalnomads
Page 35

Austin White
@austingwhite
Featured rig: 2012 Toyota Tacoma
Pages 100, 102

Kate Oliver & Ellen Prasse
@themoderncaravan
Featured rig: 1994 Airstream Classic
Photographers: Ashley Jennett |
@thestorkandthebeanstalk
Eichar Photography | @eicharphotography
Pages 34, 42–53

Kaya Lindsay
@onechicktravels
Featured rig: 2006 Dodge Sprinter Van
Page 143

Kit Whistler & J. R. Switchgrass
@idletheorybus
Featured rig: 1976 VW Bus
Pages 1–5, 121, 200, 223

Kristen Bor
@bearfoottheory
Page 183

Kyle Murphy & Jodie Morse
@briskventure
Featured rig: 1995 Airstream Flying Cloud
Pages 57, 93, 94, 130

Lace May & Breanne Acio
@theladiesvan
Featured rig: 2016 Ford Transit Van
Photographers: Travis Wild | @travywild
Kathleen Morton | @tinyhousetinyfootprint
Pages 67, 220

Lauren Williams
@willandbear
Pages 12, 86, 140, 157, 170, 189, 194–195, half title page

Mackenzie Duncan
@themackenzielife
Featured rig: 1991 VW Vanagon Synchro
Pages 103, 141

Madison Hampton
@vancraftedstudio
Featured rig: 2009 Toyota Tacoma
Photographer: Amber Sovorsky | @amber_sovorsky
Pages 126–127

Mark & Robert
Featured rig: VW Van
Photographer: Sherese Elsey | @sherese_romo
Pages 72–73

Marlene & Dan Lin & Family
@mali.mish
Featured rig: 2016 Ford Truck Camper
Page 36

Mary Ashely Krogh & Owen Chikazawa
@boundfornowhere
Featured rig: 1985 VW Vanagon
Pages 69, 200

Matthew Jansen
@thehaircutsessions
Featured rig: 1995 Toyota Hiace 4x4
Page 167

Nathan Swartz, Renee, & Family
@wandrly
Featured rig: 1976 Airstream
Pages 30–31

Naomi & Dustin Grevemberg
@irietoaurora
Featured rig: VW Westfalia
Pages 216, 221

Noel Russell
@noel_russ
Featured rig: 2006 Dodge Sprinter Van
Pages 64–65, Back Cover

Parker Hilton & Jenelle Kappe
@togetherweroam | @parkerhilton
Featured rig: 1987 Chevy Van
Pages 6, 105, 119, 129

Peter & Shruthi Lapp
@holidayatsee
Featured rig: 1987 VW Bus
Pages 10, 58–59, 95, 118, 217

Raphaelle Pascale & Mark Coelho
@borealfolk
Featured rig: 2015 Royal Lightning Cargo Trailer
Photographer: Mackenzie Duncan | @themackenzielife
Pages 160–161

Rob & Tracy Morris
@theblondenomads
Featured rig: Jayco Outback Starcraft
Pages 37, 204, 208

Rob Morgan
@this.wild.dream
Featured rig: 1995 Chevy G20 Sportvan
Pages 97, 101

Ryan & Christina Sellmeyer & Family
@poseidonsbeard
Featured rig: 1985 VW Van
Photographer: James Barkman | @jamesbarkman
Pages 18–25, 85

Scott Adamson
@comeswithaview
Featured rig: 2016 Sprinter Van
Pages 94, 142, 217

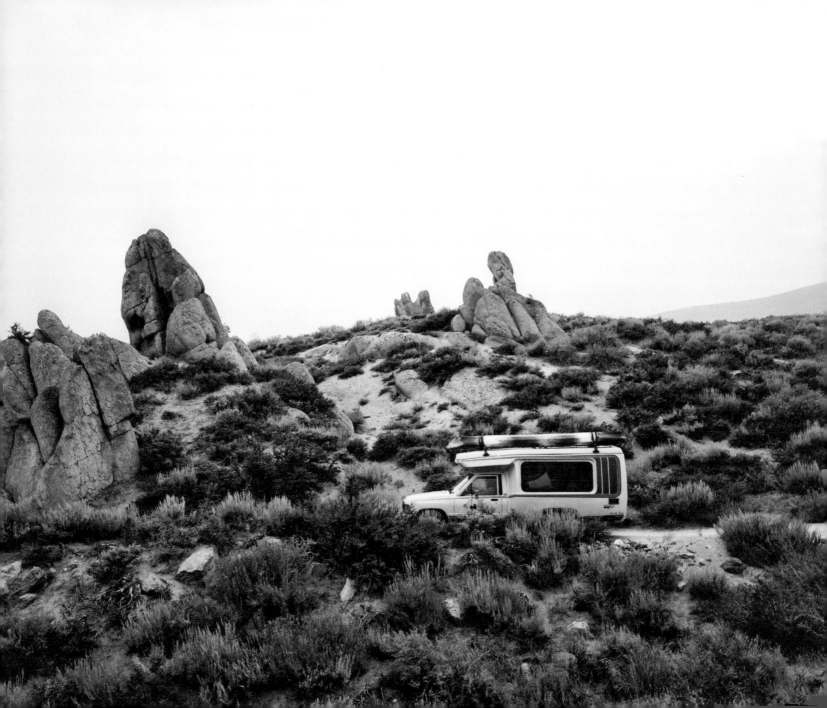

Sean Collier
@seanrcollier
Featured rig: 1995 Chevy Van
Photographer James Barkman | @jamesbarkman
Pages 172–179, 187, 214

Selina & Frank
@pinepins
Featured rig: 2002 VW Transporter
Page 124

Stephanie Rhodes & Matt H-B
@slownsteadylivin
Featured rig: 1996 Iveco Motorhome
Pages: 74, 120, 191, title page

Taylor Bucher & Pete Thuli
@alwaystheroad
Featured rig: 2004 Sprinter Van
Photographer: James Barkman | @jamesbarkman
Pages 110–117

Theo & Bee
@theindieprojects
Page 164

Thomas Woodson
@thomaswoodson
Featured rig: 2015 Ram Promaster 3500 Camper Van
Page 96

Tjerk Muilwijk
@tjerkmuilwijk
Featured rig: 1995 VW Volkswagen T4
Page 145

Travis Wild
@travywild
Featured rig: 2006 Dodge Sprinter 158"
Pages 102, 125, 185, 211

acknowledgments

This book wouldn't have been possible without our community. Just like a van needs fuel to keep it bumping down the road, we have had the support of so many people sharing their photos, time, words of encouragement, and love.

Thank you to everyone featured in this book. This is a van gathering in book form. Thank you for all gathering with us to really spread that vanlife stoke.

Thank you to our photographer, James Barkman, who traveled around during the summer of 2017 to capture on film the interviews featured in this book. Thank you to Kit Whistler for writing an incredible foreword.

Thank you to everyone who we've featured on Vanlife Diaries or who has come to one of our gatherings. There was a time when we were just a small group of ramblers. But now we're a large movement, and we keep getting bigger and bigger. We think you all are the best road life family, and we love you to pieces.

Being first-time authors and working on a majority of this book on the road was no easy feat. Thank you to our family and friends who showed us so much love and kindness. They were continuously our shoulders to lean on when we had writer's block or when we were trying to upload high-res photos with slow Wi-Fi at a coffee shop. They believed in us and lifted us up even when we felt defeated.

Thank you, Ashleigh. Your strength, positivity, and love have kept us incredibly grateful to have you walking this path with us.

Thank you to our beloved van dog, Peaches, who is also a wild coyote and Kathleen's best friend. We love you so incredibly much and are thankful you were there to lighten the mood and listen.

Thank you to Anne Goldberg, our editor at Ten Speed Press, who reached out to us at Vanlife Diaries to author this book. We are grateful you found us and mentored us every step of the way. You know how much of a journey this book was, and we're so thankful that we could get through the struggles together.

Thank you to Kara Plikaitis, our creative director at Ten Speed, for your expertise in taking more than 3,000 images and selecting and organizing them onto pages. There was so much behind-the-scenes work in making sure we featured as many tiny living dwellers as possible. In these efforts we also appreciate the help of Jane Chinn, Natalie Mulford, and Lauren Kretzchmar.

Thank you all for being on this journey with us. We'll see you out there, finding freedom on the open road.

Kathleen, Jared, and Jonny
@vanlifediaries

Published in the United States by Ten Speed Press, an imprint of the Crown Publishing Group,
a division of Penguin Random House LLC, New York.
www.crownpublishing.com
www.tenspeed.com

Ten Speed Press and the Ten Speed Press colophon are registered trademarks of
Penguin Random House LLC.

Library of Congress Cataloging-in-Publication Data
Names: Morton, Kathleen, 1986- editor. | Dustow, Jonny, 1980- editor. |
 Campbell, Jared Melrose, 1979- editor.
Title: Vanlife diaries : finding freedom on the open road / [edited by]
 Kathleen Morton, Jonny Dustow, and Jared Melrose Campbell.
Other titles: Van life diaries
Description: California : Ten Speed Press, [2019]
Identifiers: LCCN 2018046925|
Subjects: LCSH: Van life—United States—Pictorial works. | Travelers—United States—
 Interviews. | Campers (Persons)—United States—Interviews.
Classification: LCC GV198.6 .V365 2019 | DDC 796.7—dc23
Hardcover ISBN: 978-0-399-58114-4
eBook ISBN: 978-0-399-58115-1

Printed in China

Design by Kara Plikaitis
Cover photograph by James Barkman
Back cover photograph by Noel Russell
End paper photographs by Hayden Warner, James Barkman,
Kit Whistler & J.R. Switchgrass, and Tim Buhck & Denise Elbel

10 9 8 7 6 5 4 3 2 1

First Edition

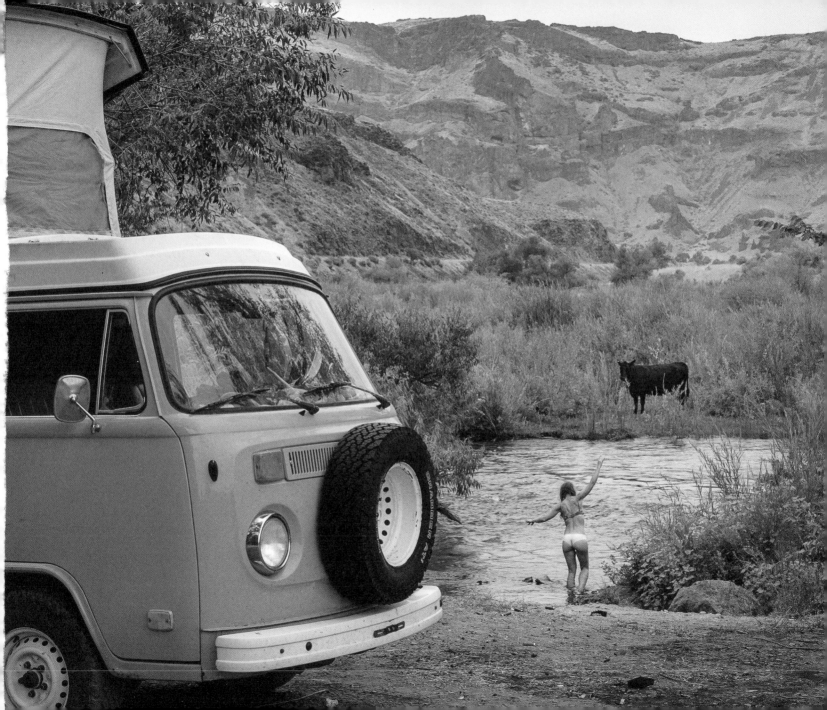